THOMAS DANBY CAMPUS

028559

D0335478

NATALIE DYBISZ
a.k.a. MISS ANIELA

SELF-PORTRAIT
PHOTOGRAPHY

The ultimate in personal expression

This item has to be renewed or returned on or before
the last date below

TWO WEEK LOAN

Library✚
Printworks Campus
Leeds City College
Book renewals & general enquiries
Tel: 0113 2846246 ☎

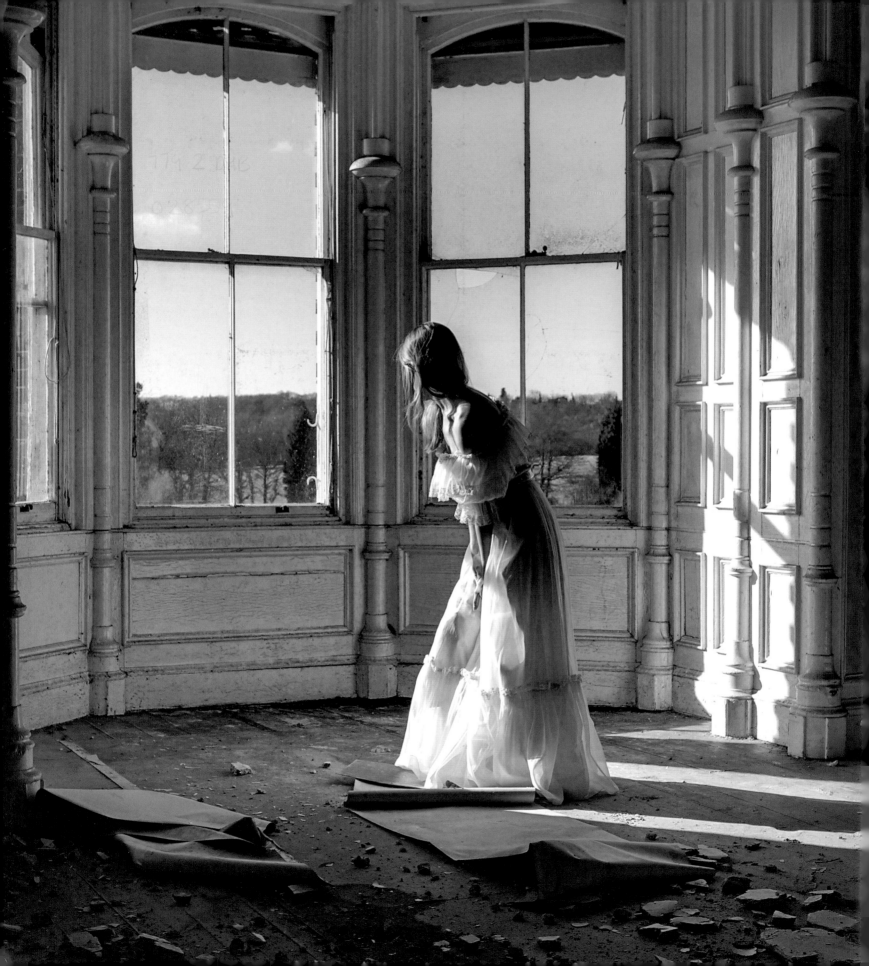

NATALIE DYBISZ
a.k.a. MISS ANIELA

SELF-PORTRAIT
PHOTOGRAPHY

The ultimate in
personal expression

ILEX

TORN 2010

THOMAS DANBY

LIBRARY

CLASS NO. 779.2 DYB

ACC. NO. 028559

First published in the UK in 2011 by

ILEX
210 High Street
Lewes
East Sussex
BN7 2NS
www.ilex-press.com

Copyright © 2011 The Ilex Press Ltd

PUBLISHER Alastair Campbell
CREATIVE DIRECTOR Peter Bridgewater
ASSOCIATE PUBLISHER Adam Juniper
MANAGING EDITOR Natalia Price-Cabrera
EDITORIAL ASSISTANT Tara Gallagher
SENIOR DESIGNER James Hollywell
DESIGNER Laura De Medeiros
COLOUR ORIGINATION Ivy Press Reprographics

Any copy of this book issued by the publisher is sold subject to the condition that it shall not by way of trade or otherwise be lent, resold, hired out or otherwise circulated without the publisher's prior consent in any form of binding or cover other than that in which it is published and without a similar condition including these words being imposed on a subsequent purchaser.

British Library Cataloguing-in-Publication Data
A catalogue record for this book is available from the British Library.

ISBN: 978-1-907579-16-5

All rights reserved. No part of this publication may be reproduced or used in any form, or by any means – graphic, electronic or mechanical, including photocopying, recording or information storage-and-retrieval systems – without the prior permission of the publisher.

Printed and bound in China.

10 9 8 7 6 5 4 3 2 1

CONTENTS

6 **INTRODUCTION**

8 **CHAPTER ONE / Context & history**
10 The history of self-portraiture
16 Introducing the author
20 Why self-portraiture?

22 **CHAPTER TWO / Equipment**
24 Choosing a camera
26 Lenses
28 Tripods, remotes & accessories
32 Exposure & lighting

34 **CHAPTER THREE / Shooting**
36 Clothing
38 Hair & makeup
40 Locations
44 Shooting in Death Valley
46 Planning a shot
48 Posing
52 Shooting with props
54 Shooting in low light
56 Using mirrors
58 Shooting nudes
60 How I made *Girl Dreaming* and *Girl Awoken*

62 **CHAPTER FOUR / Processing**
64 Introduction to digital processing
66 Saving & storing your work
68 Getting started in Photoshop
70 Monochrome conversion
72 Moderate manipulation
76 Multiplicity
80 How I made *Their Evening Banter*

82 Trick images
86 How I made *The Smothering*
88 Extreme composites
90 How I made *Bending Over Backwards*
92 HDR

96 **CHAPTER FIVE /
Self-portrait artist showcase**
98 Annette Pehrsson
106 Rossina Bossio
114 Noah Kalina
122 Joanne Ratkowski
130 Yulia Gorodinski
138 Jon Jacobsen
146 Federico Erra
154 Lucia Holm

162 **CHAPTER SIX /
Marketing your self-portraits**
164 Photo sharing
166 Having your own website and blog
167 Self-employment
167 Publicity & image rights
168 Selling stock photography
169 Selling your work as art
170 Exhibiting
171 Other ways to make money from your self-portraiture

172 Glossary
173 Artists' directory
174 Index
176 Acknowledgments

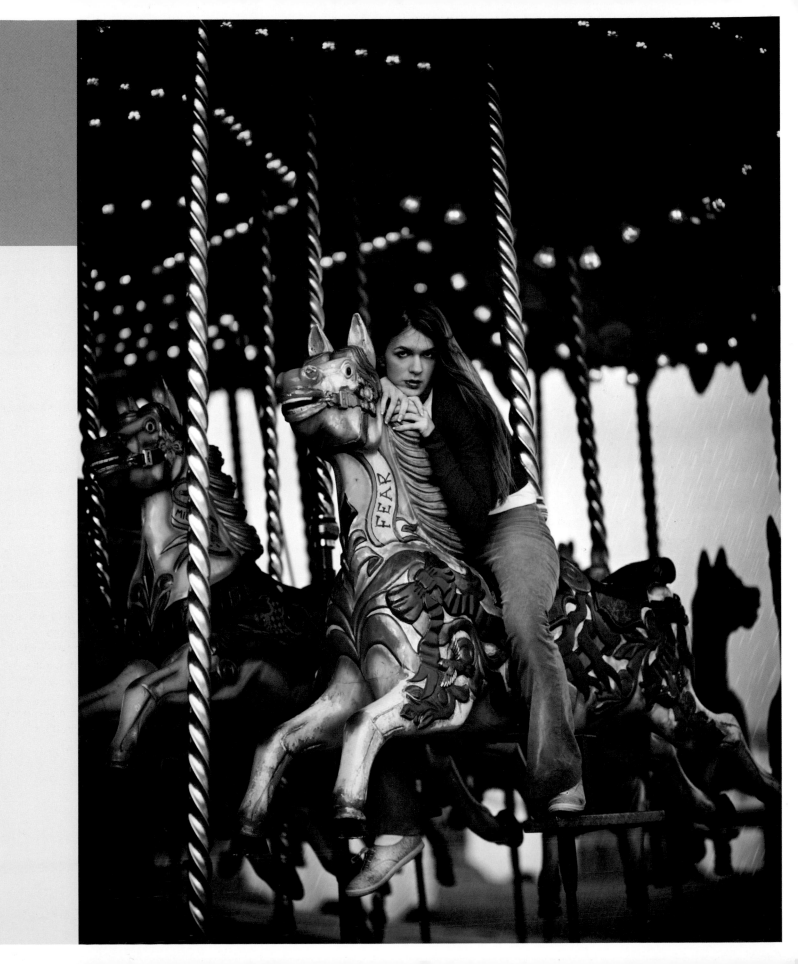

INTRODUCTION

Why would you want to take a picture of yourself? Why would you use yourself as a model in photographs, when it is much easier to shoot subjects in front of you? Crucially, at what point does a self-portrait transcend "snapshot" and become "art," especially for someone who does not witness the clicking of the shutter from the conventional side of the camera; someone who can only compose the fixed surroundings and then briefly abandon that control in order to enter the frame themselves? Playing the role of model, and actor, while also being the photographer is an experience that can be frustrating, challenging, and immensely satisfying.

Throughout the history of art, artists have created self-portraits for various reasons: for convenience and lack of models, to demonstrate their artistic prowess to potential clients, to document their existence and their aging process, and as a form of artistic psychotherapy to explore their inner selves. These reasons may well be among the incentives photographic artists have today, and certainly ring true of my own experiences so far as a self-portraitist. Photographic self-portraiture has the advantage of privacy in which to hone one's skills, but if you go on to produce an entire portfolio of images of yourself, it becomes apparent that the prime motive for shooting self-portraiture goes beyond mere convenience.

This book uniquely addresses self-portraiture and its rapid proliferation as a genre, to present the aspiring photographer with valuable advice and tips on how to go about photographing oneself. Chapter One looks at the history of self-portraiture, the genre today, and introduces my work and story.

The following three chapters extensively set out the tools you need to consider when approaching self-portraiture. Chapter Two looks at how to choose the right equipment, while in Chapter Three we move onto the practical elements of shooting, from locations to lighting, and photographic specialties such as shooting nudes, shooting in low light, and using props and mirrors. Chapter Four takes you into post-production, from the very basics of Photoshop adjustments, through to minor manipulations and then to the more complex world of trick compositing

and HDR. Along the way I hope to inspire you with dozens of examples of my own self-portraits.

Chapter Five showcases the work of eight other self-portraitists. Here successful artists such as Noah Kalina, Rossina Bossio and Annette Pehrsson share their work and discuss the motives behind their self-portraiture. I have chosen a purposefully diverse selection of artists, both men and women, of different backgrounds, nationalities and ages. Some of the contributors have studied art, others are self-taught. Both digital and film photography are presented. One artist is a fashion photographer, one is also a painter, another is a clinical psychologist. Another had his self-portraits famously parodied in an episode of *The Simpsons*. After I introduce each artist, they are given several pages in which to discuss their background, their artistic intentions, and the process behind the creation of their images.

Chapter Six presents a wealth of information and advice on where to go next with your work. Hinged on social networking, an increasingly crucial part of any photographer's livelihood, this chapter starts by covering everything you need to consider when sharing your work on the Internet. It then explores that crucial transition from amateur to pro, how to protect your image rights as a photographer, and how to make money from your work: selling art prints, exhibiting, licensing, and self-publishing your work.

I hope you will find this book useful in terms of its instructional content, but that you will also find inspiration in the abundance of visual imagery, showcasing some of the best modern emerging artists. This book is no ordinary photography manual. It sets out the tools to help you achieve your own photographic artistry and offers a wealth of visual references along the way.

All images in this book are by myself, Miss Aniela, unless otherwise indicated by the name of the appropriate contributor. It has been a pleasure and honor to write this book, and to represent this new wave of contemporary artistry.

Natalie Dybisz, London, 2010

UNTITLED (*above top*)
By contributor Yulia Gorodinski (see pages 130–137).

MANO AJENA / ALIEN HAND (*above*)
By contributor Jon Jacobsen (see pages 138–145).

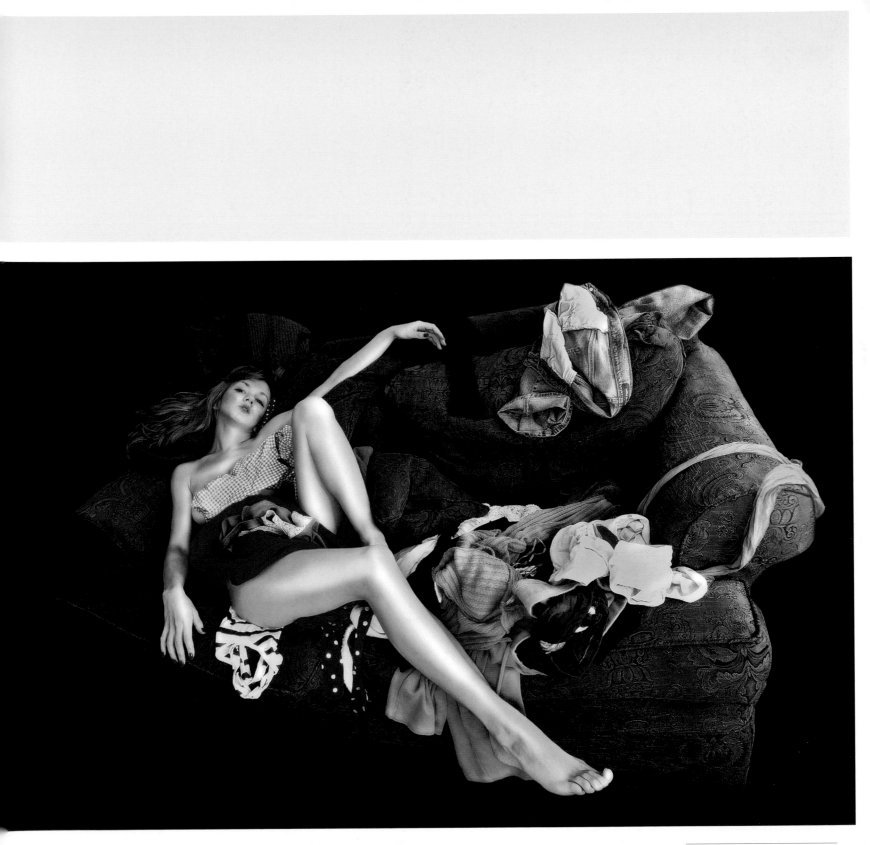

MEMOIRS OF A WOMAN OF LEISURE
(above)

A ten-second timer dash showing
the ungainly laundry in my student
accommodation has become a signature
image for my exhibition flyers and self-
published books.

CHAPTER ONE
CONTEXT & HISTORY

For me, self-portraiture is at once self-expressive and a form of acting. Though my own likeness will appear in the image, it will be shot in a certain way, specially selected, and processed in a particular manner that elevates the photographed self into a higher realm than my actual physicality. It's no surprise then, that the thing I am most often told by people who meet me for the first time after having seen my artwork, is that they expected me to be 6' tall, not my actual 5'4". In a sense, shooting self-portraiture is in principle no different to shooting any other subject. Taking a picture of another person, or an animal, or a landscape, involves the same process of artistic mediation and embellishment. That is the art of photography, and indeed of all art itself.

Moreover, in response to the detractors who might try to insist there is something abnormally narcissistic or self-indulgent about photographing oneself, one might observe that all art is a mode of self-expression. We bring something of ourselves, our own opinions, experiences, and interpretation of life into anything we shoot. Self-portraiture simply allows us to consult the subject who is at once in tune with our desires, and the purest subject we can choose to represent them: our own physical self.

This first short chapter looks at the history of self-portraiture and also my own background as an artist and photographer. Though artists have been recreating their likenesses for centuries, it seems that people are still surprised by the notion of taking a picture of yourself, and question what might exactly motivate us to continually explore our own image through the lens. I look at the reasons why photographers gravitate toward self-portraiture, and get you thinking about the possibilities of what can be seen as a genre all of its own.

NOIR *2009*

An image taken at dusk outside a motel near the Grand Canyon. I was inspired by a presentation given by photographer Todd Hido on the use of low-key lighting in his work.

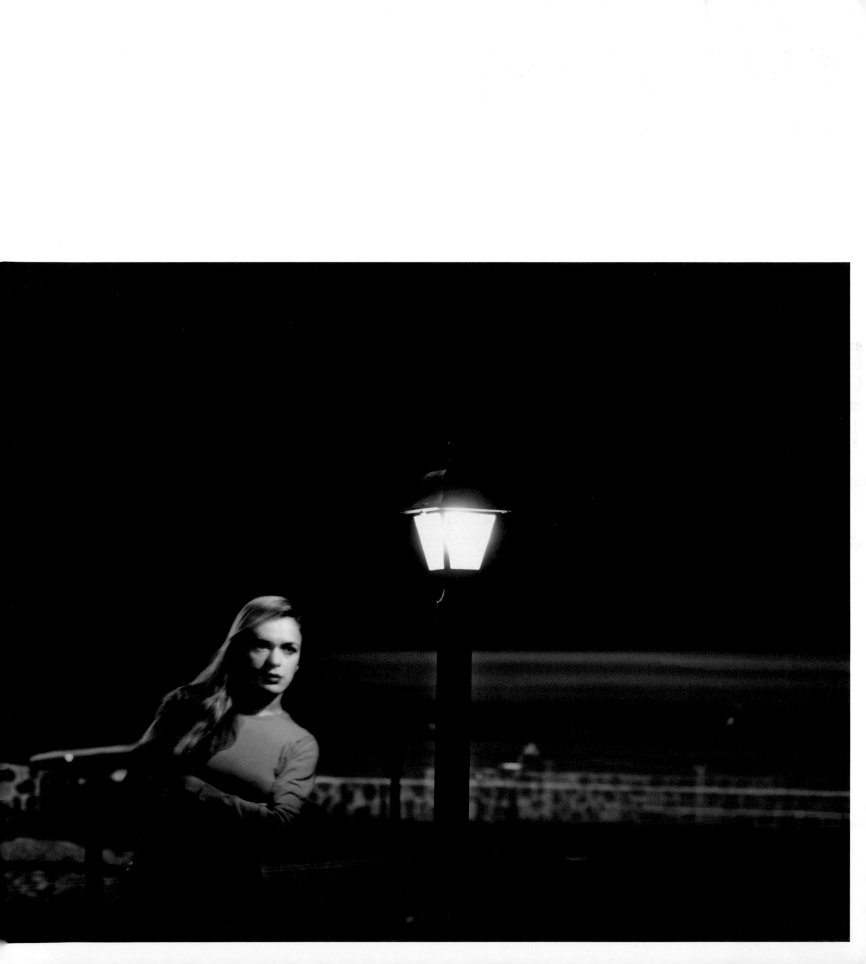

THE HISTORY OF SELF-PORTRAITURE

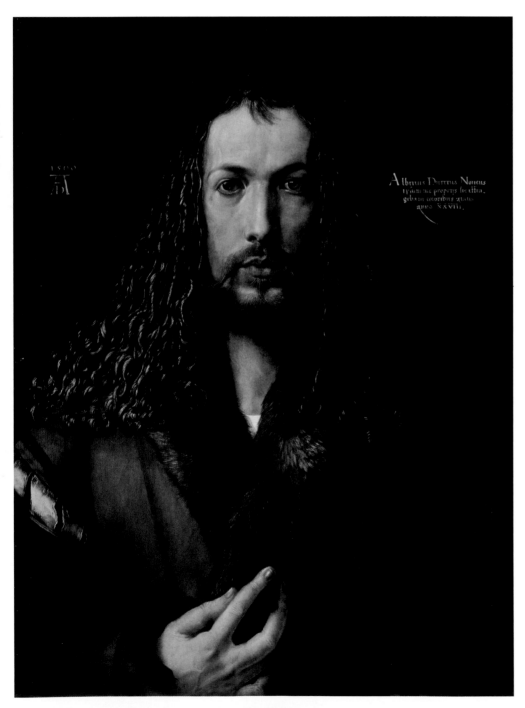

It is not easy to look at the history of art and find answers as to why artists have expressed themselves through self-portraiture. Most art literature swallows up self-portraiture as one facet of an artist's practice, and does not isolate the subject as poignant in itself for scrutiny. In the past few decades, however, there has been more attention placed on self-portraiture and on charting its development as an art-form through the centuries.

Self-portraiture can be traced back to the times of Ancient Egypt and Ancient Greece (c 1365 BC). Historians' evidence shows that Pharaohs portrayed their own face and body in the form of sculpted monuments, some of which were of huge dimensions. Traveling forward to the Middle Ages, architects working on great cathedrals incorporated their own likenesses into their sculpted decoration. Ultimately, self-portraiture became popular with the rise of individualism during the Renaissance, a cultural movement that spanned the 14th to the 17th century.

One of the most notable figures in the history of self-portraiture is Jan van Eyck, a 15th-century Flemish painter, whose works include the famous *A Man in a Turban* (1433), said to be a self-portrait. It is evident that throughout the ages, self-portraiture in its simplest sense of motive was to give potential sitters trust in the artist's ability. Caterina van Hemessen's *Self-portrait* (1548) is an example of one of the earliest noted female painters' depiction of the artist at work. The work of Jan de Bray, a notable self-portraitist painter of the 17th century, was an example of the hybridization of portrait and history painting. He would include his own likeness within a group of figures, sometimes using his family as models. Moving forward, some of the most famous female painters of the 18th century include Élisabeth-Louise Vigée-Le Brun and Angelica Kauffman, portrait painters who are reputed to have created self-portraits to advertise their skills.

The first artist noted to have made self-portraiture a major part of his conceptual activity was Albrecht Dürer (1471–1528), whose use of religious imagery steered the trend for self-portraitists to appropriate themselves as important individuals, rather than artisans in the merely mechanical sense. The rising social status of the artist from

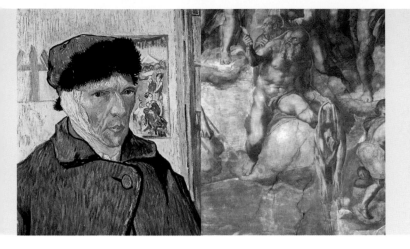

the 15th century onwards meant there was a heightened curiosity in exploring and depicting the human personality. Dürer's Christ-like *Self-portrait at the Age of Twenty-Eight* (1500) conveys the notion that an artist's creative power is a divine gift separating them from the rest of mankind.

Imagery of death and decay in self-portraits was prominent in the work of artists like Michelangelo and Caravaggio. On the ceiling of the Sistine Chapel, Michelangelo depicted himself on a piece of flayed skin held by St. Bartholomew in *The Last Judgement* (1538–1541), and Caravaggio as a severed head in *David with the Head of Goliath* (1609–1610). Both these representations of self-debilitation can be seen to influence artists three centuries later, such as Van Gogh.

Documenting the self

Another of the most well-known artists associated with self-portraiture is the Dutch 17th-century painter Rembrandt, who created at least 90 self-portraits in total, over 42 years, from the age of 21 to 63. In sequence, the paintings almost come to stand for the story of man, of life and age. Mainly head-and-shoulders portraits, Rembrandt's paintings were simple in their approach, and on face value he did not take creative lengths to depict himself through props and different contexts. However, his work is considered to be highly convincing in its realism.

While the first permanent photographs were developed in the 1820s (though the basic principle of the pinhole can be traced back to fifth-century BC China), the use of photography did not transform portraiture, or even art at all, for a long time. Its function was largely mechanical—pictures were monochrome and small-scale—and although it meant that having one's portrait made was no longer confined to the rich, photography was seen to lack the artistic value considered inherent in painted portraits. Artists did not generally engage in photography as an art form for self-portraits until the 20th century. Artists like Renoir (1841–1919), a leading painter during the impressionist movement, continued to use the medium of paint to produce a lifetime of work; Renoir worked on many self-portraits depicting himself in moments of unhappiness and gloom.

Religion and death

Two highly revered artists of the post-impressionist group are Paul Gauguin (1848–1903) and Vincent van Gogh (1853–1890). Gauguin, like Albrecht Dürer centuries before him, used religious iconography in his work, creating a series of self-portraits depicting himself as Jesus Christ, such as *The Yellow Christ* and *Self portrait in Gethsemane* (both 1889). Like Van Gogh, with whom he spent time in France in 1888, he suffered from depression and this came to be reflected in his self-portraits. Van Gogh admitted that his self-portraiture was a way for him to try and heal, and to tackle his depression. Both Gauguin and Van Gogh can be said to have used self-portraiture as a defence against a society from which they felt increasingly ostracized. *Self-portrait with Bandaged Ear* (1889) is one of Van Gogh's most recognizable self-portraits: he painted his first self-portrait at the age of 32, only five years before he committed suicide.

Edvard Munch (1863–1944), who painted *The Scream* (1893), also faced personal emotional tumult. However, Munch's self-portraits employed a more creative *mise en scène* than the portraits of Van Gogh: he would place his character into context to create meaning through relationships with objects and juxtaposition. The manner in which he painted the piece would also become part of the self-representation. *Self-portrait with Cigarette* (1895) is painted with streams of paint and indented markings that become in themselves a part of the artist's self-depiction. It is interesting to observe how artists began to play with the actual conventions of the process of painting, revealing their psychological state through their art whether the piece was a self-portrait or not.

Clockwise from top left

SELF-PORTRAIT WITH BANDAGED EAR
1889 Oil on canvas

Gogh, Vincent van (1853–1890)

**SISTINE CHAPEL CEILING:
THE LAST JUDGEMENT**

Detail of St. Bartholomew holding his flayed skin, 1538–1541 (fresco), Buonarroti, Michelangelo (1475–1564)

Courtesy of Scala, Florence.

SELF-PORTRAIT AT THE AGE OF TWENTY EIGHT *1500* Oil on panel

Dürer or Duerer, Albrecht (1471–1528)

Courtesy of The Gallery Collection / Corbis.

Into surrealism

The works of Egon Schiele (1890–1918) and Picasso (1881–1973) are examples of the 20th-century trend for psychologically-provoking self-portraits, at a poignant time when Sigmund Freud's first writings were being published. Schiele's self-portraits were distorted and disturbed, a reflection of the influence made by Freud's *Studies on Hysteria* published in 1885, which controversially explored the concept of the human subconscious. Richard Gerstl (1883–1908), Max Beckmann (1884–1950), and Oskar Kokoschka (1886–1980), were all artists of this era who encapsulated 20th-century feelings of alienation.

The cultural movement of surrealism that began in the early 1920s opened up a new world of possibility for self-portraiture. Salvador Dali (1904–1989), Max Ernst (1891–1976), and Remedios Varo (1908–1963) all produced surrealist self-portraiture where intangible aspects of the human mind and experience would be manifested physically in art. Dali, who keenly studied Freud's writings, painted *Self-portrait* (1954) at the age of 50. The painting, showing Dali kneeling naked on a beach with the signature array of objects out of proportion around him, is an example of his eccentricity and his ability to self-stage, at which no other artist of the 20th century was said to outdo him.

Artists like Picasso (1881–1973) and Frida Kahlo (1907–1954) used self-portraiture through a paradox of both autobiography and hyperbole. Picasso produced a wealth of self-portraits throughout his career, representing himself as a variety of characters that revealed a complex range of mental states. In *The Minotaur* (1933), he used a symbolic, rather than literal self-depiction to explore his inner psychology, while a piece from his later life, *Self-portrait Facing Death* (1972), was painted in fragmented cubist strokes, expressing his physiognomy through strange, overtly geometrical shapes. Frida Kahlo produced a lifetime of prolific, and strongly autobiographical work. After an accident on a bus, Kahlo found herself bedridden for months, so she turned to self-portraiture to record her pain and emotions. *Without hope* (1945) (see page 15) shows Kahlo trapped beneath a ladder laden with carcasses above her bed, seemingly stemming from her mouth. Kahlo translated her abysmal and banal experiences into arresting figurative imagery, giving a startling juxtaposition of both reality and surrealism in her work.

Self-portrait photography

Around at the time of Picasso, and a friend of his, was American photographer and model Lee Miller (1907–1977), who is known for her monochrome self-portraits, such as *Self-portrait in Headband* (1932). Andy Warhol (1930(?)–1987) and David Hockney (b. 1937), most noted for their work in paint and print, have both used photography to an experimental degree in their self-portraiture. Andy Warhol produced a series of silkscreen-printed self-portraits in 1966–1967, which had 14 variations in color, produced by printing stencils over one another to transform a photograph into blocks of unreal color. Contrary to the psychological depth of other artists' self-portraits, Warhol referred to his work as purely superficial.

Some of the most famous names in photographic self-portraiture include Lucas Samaras and Cindy Sherman. Lucas Samaras (b. 1936) works with Polaroids and multimedia collages. His work distinctly lacks the self-professed superficiality of Warhol's imagery, however, instead it suggests the kind of disturbing self-representation apparent in the work of Francis Bacon (1909–1992), who painted a ghoulish self-depiction, *Self portrait* in 1970. Samaras' equally repellent facial distortion in his own self-portraits, which use Polaroid in what he calls "photo-transformations," similarly provoke questions concerning the wellbeing of the modern psyche.

Cindy Sherman (b. 1954) is highly esteemed within the scene of female photographers exploring various identities and characters. Her series *Untitled Film Stills* (1977–1980) features herself as the model in a variety of scenes presented to us as movie frames, using her own or borrowed props, calling to mind the representation of women in the media. However, Sherman has always insisted that her work is not necessarily of a "feminist" intent, and has never been keen to urge a certain interpretation. The paradox she presents in her work, of being both exposed and arcane, actress and "self," suggests a certain post-modern ambiguity, and a need for the viewer to make their own reading. Sherman also challenges the notion of high art and its elite availability to the rich, aiming her work at a wider audience.

The self-portraits of British photographer Jo Spence (1934–1992) employed a sense of self-documentation to record her battle with breast cancer, comparable to the way Frida Kahlo used self-portraiture as a form of release or catharsis during a time of bodily trauma. Spence created a body of work entitled *A Picture of Health?* when she was diagnosed with breast cancer in 1980, which documents her response to the disease based on her research, and experiences of treatment. Her work was a kind of "phototherapy" for herself, but also a comment on representations and attitudes concerning the female body. Unlike Sherman, Spence advocated for feminist readings of her work, and was concerned with actively broaching political and social issues particularly concerning gender and western medicine.

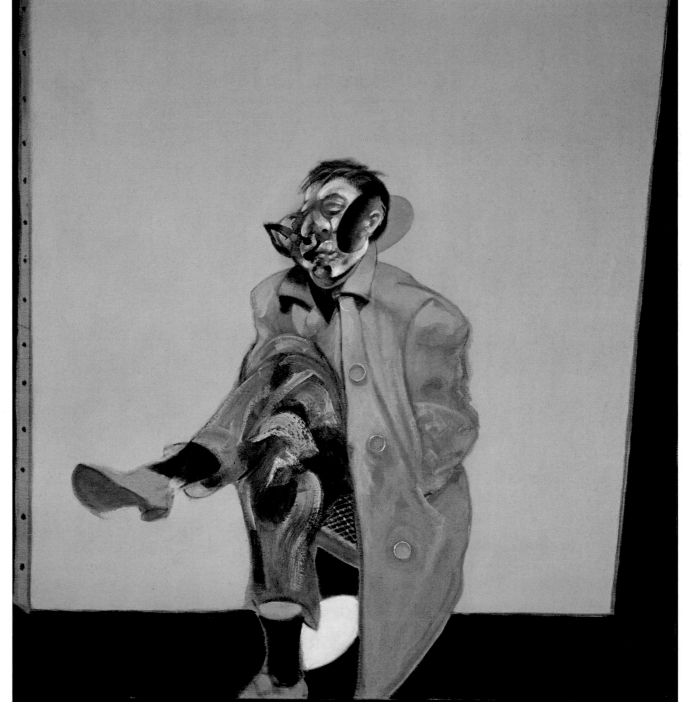

SELF PORTRAIT *1970 (right)*

Bacon, Francis (1909–92)

Courtesy of Scala, Florence / © The Estate of Francis Bacon. All rights reserved. DACS 2010.

A MAN IN A TURBAN *1433*
Oil on oak (below)

Eyck, Jan van (c.1390–1441)

Courtesy of AKG Images / Erich Lessing.

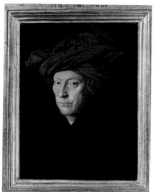

UNTITLED FILM STILL *1980*
Black-and-white photograph
8 x 10 inches (left)

Sherman, Cindy (b.1954)

Courtesy of the Artist and
Metro Pictures.

WITHOUT HOPE *1945*
Oil on masonite (right)

Kahlo, Frida (1910–54)

Courtesy of Art Resource / Bob
Schalkwijk / Scala, Florence / © 2010
Banco de México Diego Rivera Frida
Kahlo Museums Trust, Mexico, D.F. /
DACS.

American photographers Hannah Wilke (1940–1993), Francesca Woodman (1958–1981), Sally Mann (b. 1951), and Nan Goldin (b. 1953) produced notable self-portraiture, involving themes that included social angst, the taboos of death and religion, and the borderline between femininity and masculinity. Through the ages, it seems that self-portraits have come to document the gradual crumbling of the social masks both men and women wear, and the self-portraitist over time has unleashed an increasing audacity to visualize the real, naked, and often troubled "self." The 18th-century female self-portraitist, for example, would paint herself full of composure and ambition, which is of stark contrast to the 20th-century female photographer like Woodman, who used blurred, in-camera movement through slow shutter speeds, sometimes modeling nude, with her face obscured, often within disturbing or ghostly scenes. The images of Goldin range from the sublime to the controversial, with themes of gender, violence and sexuality, where the viewer is invited into a personal, domestic space to experience the private drama of the subject, the photographer herself.

British artists Helen Chadwick (1953–1996), Sarah Lucas (b. 1962), Tracey Emin (b. 1963), and Jenny Saville (b. 1970) have all produced work that is prominently conceptual and challenging, referencing women's liberation, motherhood, and death and decay. Common across these different women's artistic livelihoods is an attempt to explore their own identity as women beyond social expectation, and self-portraiture can be seen as their way to externalize their inner conflict between their "real" self and societal self.

The work of Sam Taylor-Wood (b. 1967), a film-maker, photographer, and conceptual artist produced a series entitled *Suspended* (2004). She uses cables and photographic trickery in her images to suspend the illusion of her body hanging mid-air from balloons, and precariously balancing tiptoe on chair backs in *Bram Stoker's Chair* series (2005). Her work can be cited as an influence for many artists working with illusions in photographic self-portraits.

In the past few decades, there has been more attention placed on self-portraiture as a genre, in special exhibitions at the National Portrait Gallery, for example, including a 2001–2002 exhibition entitled *Mirror Mirror* exclusively showcasing female artists' self-portraiture. I would most certainly guess that the rise of modern photographic self-exploration, as represented in this book, has been instrumental in stirring this interest in recognizing self-portraiture as a viable genre of art.

Self-portraiture today

There is no doubt that self-portraiture has become a bigger genre today than ever, and its growth is directly correlated to the proliferation of photographic equipment. Today, at least in the western world, anyone can own a camera, and even with the simplest point-and-shoot or phone camera, we can all create an image of our own likeness. This does not make everyone an "artist," nor every image of ourselves a "self-portrait." Look up "self-portrait" on a search engine and hundreds, thousands even, of amateur images will emerge, cameras handheld toward the photographer's face. However, self-portraits with a camera are no easier than with a paintbrush or a pencil, if the necessary artistic intention and thought goes into its production. Just as painters need to consider how they are contextualizing their "self" into a meaningful *mise en scène*, the same elements are required in photography: the framing, lighting, props, location, tone, and mood create the overall message. The difference with photography, of course, is that the elements in the image generally have to be literal, to be tangible, in order to be photographed. The idea has to be played out for real. This is a considerable factor that makes self-portraiture photography challenging: how do we make the literal sight of our banal everyday outer shells interesting enough to become art? As artists over the centuries and through to the present day have shown us, we need to be able to exit our own perspective to visualize how we appear from the outside, and be able to successfully translate the image we see in our mind's eye.

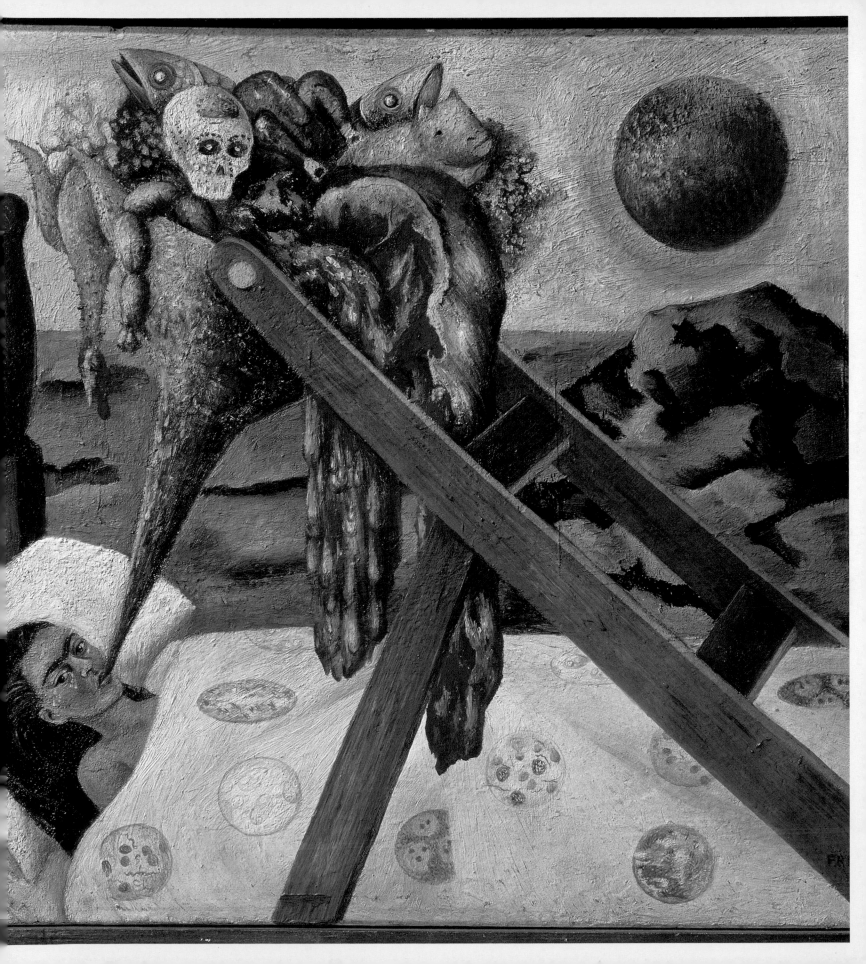

INTRODUCING THE AUTHOR
Miss Aniela

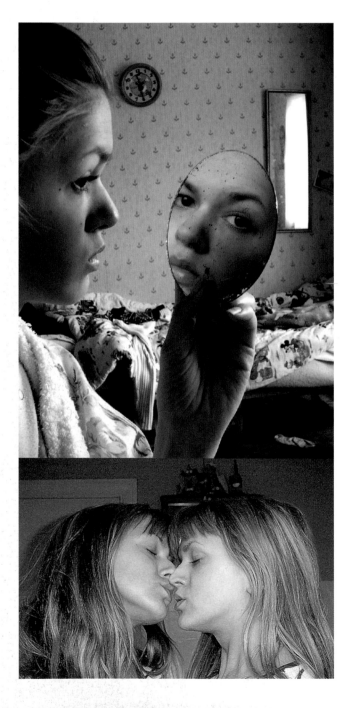

My beginnings in photography are somewhat unconventional, in that I've had no formal training and my interest in photography started to form when I discovered photo sharing online.

My first attempts at self-portraiture were in my teenage years, and mostly involved holding the camera out at arm's length in front of my face. With the amateur film camera or disposable cameras I first played with, these mostly turned out to be disastrously blurred images once they'd been developed. At college, however, I borrowed a small compact Sony digital camera from the art department. Being able to take it home and take pictures at my own leisure was a huge novelty. I relished taking close-up, higher-quality pictures than I'd done before, and just as importantly, to be able to transfer them onto my computer (which I'd just been given by a friend), and play around with the images in Photodraw. It wasn't long before I'd saved up the money to buy my own camera—a Sony DSC-P52. The pleasure in shooting digital was immense: the relative quality, the lack of running costs, and the control available in post-processing, which became an even more substantial stage once I invested in a copy of Adobe Photoshop. The tools I now had to hand instigated the idea of one day "cloning" myself in an image. I took two photographs of myself at opposite sides of the frame, and then brought the two head profiles together to make it look as though I was about to kiss "myself." I wanted to create images that celebrated my feelings of autonomy and the introspection I felt at the time. The pictures I took of myself, however, were confined to private folders on my computer. I didn't think it was a normal or dignified thing to do, and I thought people would think of me as vain if they saw them.

Clockwise from top left

MIRROR, MIRROR *2005*

An early self-portrait taken in my bedroom when I was a teenager.

CLAMBER *2006*

Cloning myself in the garden during my student days.

TWINNING *2005*

My first attempt at bringing together two images of myself to make it appear as though I am interacting with a "double" of myself.

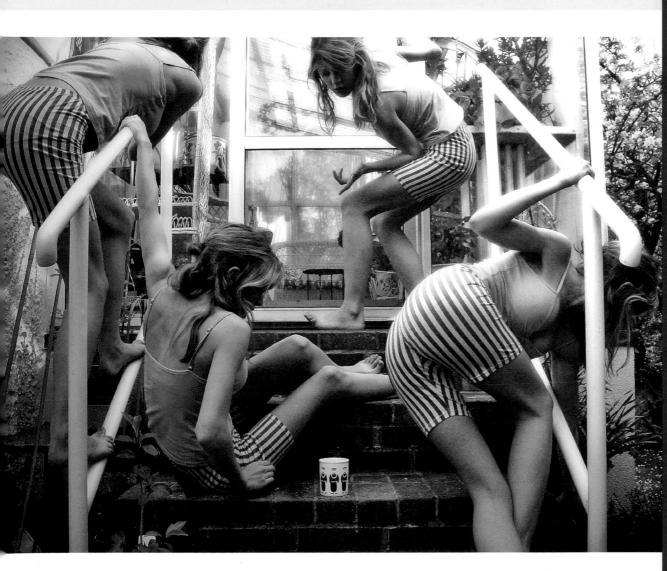

"One of the most wonderful things about Miss Aniela's artistry is her willingness to experiment. She is constantly evolving and dabbling in different styles, never falling back on tired clichés. Not only is she an excellent photographer, but also a fantastic mentor to any up-and-coming self-portrait photographer. Her willingness to give insight into the business, as well as express her thoughts and concepts in such a thought-provoking manner makes her a fabulous teacher as well as an artist. She is an inspiration to female self-portrait artists everywhere." **Leah Johnston**

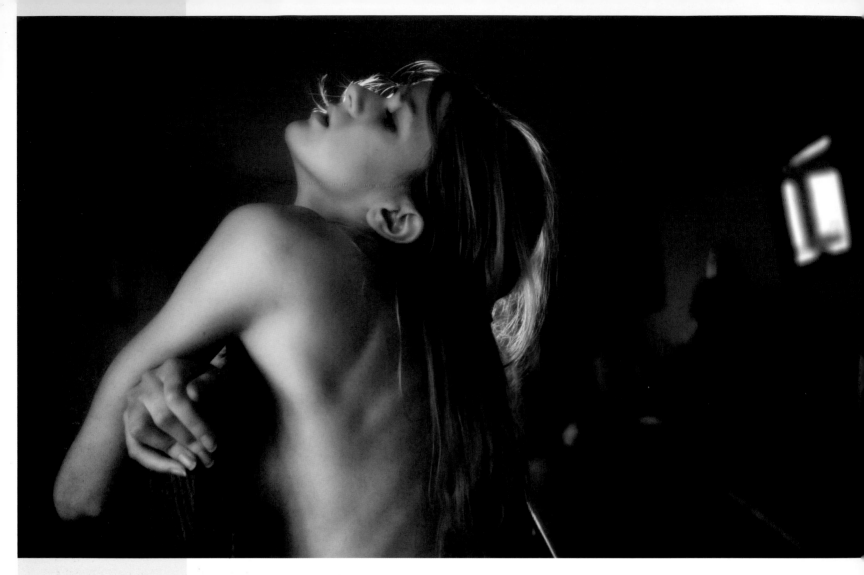

Discovering self-portraiture

It was in 2006, while studying for my degree—a joint honors in English and Media at the University of Sussex—that I felt a real engagement with photography begin. My degree was mostly theoretical, but one practical course I undertook in my first year led me to discover flickr, an extremely popular photo-sharing website. I was attracted to the site and set up my own account with the whimsical alter ego "Miss Aniela," Aniela being my Polish middle name. Browsing the work of other users over the next few days, I soon saw that many people were taking pictures of themselves. Self-portraiture, I realized, was a substantial and dignified genre of photography, and of art itself.

Inspired by what I saw on flickr, I decided to start taking some self-portraits again. This time, however, I wanted to bring more creative context into my images beyond the head-and-shoulders snapshot. I also decided to incorporate the cloning theme again, or *multiplicity* as people refer to it on flickr, and bring more than one of myself into the frame, such as in *Clamber* (page 17). With lots of spare time in between my lectures and seminars, I was able to change into a different combination of clothes from my wardrobe and go out in my car to select an appropriate, and isolated rural scene, and pose in different corners of the frame, keeping the camera in a still, fixed position. My equipment at the time was minimal: I had upgraded my Sony camera, but I had no tripod, so I had to balance my camera in position on the ground or prop it up against something. Many images therefore had a bug's-eye view, with the lens peering through blades of grass, giving them an interesting and almost voyeuristic take, something that characterizes these early attempts.

Flickr and beyond

I shared a new image on a daily basis on flickr, gaining an increasing number of comments from users online, and gradually, more encouragement from this growing community. Looking back, I see that the desire to keep creating images was largely motivated by my passion for photography, an increasing curiosity, and a desire simply to produce one pleasing composition after another. I did not have a conscious, ostensible goal of what I wanted to

Clockwise from top left

STRETCH *2006*

This self-portrait was shot in my room at university. I used my Sony R1 camera to shoot this image, using the ten-second timer, as I did not have a remote at the time. The image turned out to be one of my most popular images to date. It was used on the posters and adverts for my debut exhibition in Brighton and nearly sold out as a limited edition print.

INTERVIEW

Being interviewed for a TV program at my exhibition in Camara Oscura Gallery in Madrid, Spain 2008.

TRADESHOW

Delivering a presentation about my work on the Microsoft stand at Focus on Imaging, Birmingham, England 2009.

PHOTOSHOOT

Photographing a model during a live photo-shoot in Seattle for Microsoft in 2009.

achieve with the images, and it never crossed my mind that I could ever make the "Miss Aniela" persona into a brand and sustain any kind of living from it. However, it would be fair to say that I have always had a desire to be an artist or writer, and that I was acting on ambitions that were subconscious. A year later in 2007 I was approached by North Laine Photography in Brighton, England offering me a solo exhibition. I had a great many images by that time, so editing the selection down for the show seemed like an impossible task, but never did I feel reluctant or unsure that I should exhibit and try to sell my images. Selecting images for the posters and flyers, deciding on editions and prices, and seeing my framed images on the wall, were all stages of seeing my hobbyist "Miss Aniela" character start to become a substantial, real "artist." It was exciting, but also nerve-wracking, as dealing with galleries and exhibitions is not as glamorous as one might think. It involves a lot of negotiation and a level of risk on both sides. In Chapter Six I talk about things to consider before exhibiting your work publicly.

The North Laine exhibition led to valuable publicity, most notably in *PHOTOICON* and *What Digital Camera* magazines, and a TV interview with the local BBC, which was then uploaded to YouTube. The magazine publicity extended my exposure to a non-internet-based audience, which then led to my next exhibition at fine-art gallery Camara Oscura in Madrid, Spain, and then onto features and shows at photographic fairs. I started to use my own initiative with my work, too, and took my prints to local exhibitions and events.

Microsoft

Shortly after graduating in 2008, I was flown out to Seattle, on the biggest opportunity I'd yet received. A contact from Getty Images, who was also an avid flickr user, had passed my name onto Microsoft and I was invited to give a guest presentation at the Microsoft Pro Photo Summit. I had not done any public speaking before, but somehow I found the confidence to present my 30-minute PowerPoint display to an audience of representatives from various important names in the photography industry. I charted my self-portraiture and how I had used flickr to secure exhibitions, and to gain exposure for my work. I was overwhelmed by the positive response and I was subsequently contracted by Microsoft to present twice daily at its booth at Photokina, Cologne, Germany in the autumn, and then at Focus on Imaging in Birmingham, England, the following February in 2009. Together, we also created a Miss Aniela-themed live photo-shoot at a studio in Seattle and then a series of photo-walks in Seattle, LA and San Francisco. This was when I was officially plunged into the unknown and into self-employment—a scary, but exciting prospect. Another highlight the same year was being on the cover

of *American Photo* magazine in the spring, for an article charting the rise of "12 Flickr Superstars." I continued to pursue local and national exhibitions, and surprisingly, things held out quite well, given that I'd quit my full-time job (an internship in publishing that I'd been doing for five months since graduating) on the brink of an economic recession. I most definitely had luck on my side, in having both the encouragement and opportunities to be able to pursue my passion full time and make a living so soon. While I didn't have a specific goal or intention when I first set out, I also appreciate that the efforts I made to share my work paid off, albeit indirectly. In Chapter Six I talk about how to promote yourself on social networking sites, how to build your own website, and the many possibilities of where to take your work. If you put your work on flickr things might not necessarily happen overnight, but the opportunities that may arise could surprise you.

Picturing the self

Self-portraiture is not my one and only artistic occupation, and it is not an area I merely use to propel myself into other commercial areas. However, I like to think of my self-portraiture as an art in itself, as well as an opportunity to hone my skill to apply to other subjects.

I shoot all my images myself, and particularly when I started out, I was mostly alone with my camera. Nowadays, occasionally I will seek directed assistance from a family member or my boyfriend. Sometimes I will work on a shoot that is more of a "collaboration" with a partner, in that they will help compose the shot and choose settings. As a rule, however, I only call images self-portraits if the ideas and process have been generated by me to a greater extent than by someone else.

I started out with very limited equipment, improvising heavily right down to lighting. For most of my work I used the timer to shoot myself, though now I use a remote. In the past year I have acquired some flash units, but most of my images in this book use available or natural light. Though I talk about equipment in this book, I wanted to mention my modest beginnings because I believe it is really important to emphasize how it was a passion and curiosity for photography that launched me on this career. I was driven by a genuine interest in photographic creativity rather than a perfunctory aim to simply make money. This advice in this book highlights the importance of finding one's creative passion, while also suggesting the profitable avenues available to the modern artist.

WHY SELF-PORTRAITURE?

Being a successful photographer is not necessarily just about being able to take good pictures. You will need other skills, for example, good communication, self-discipline, and the ability to understand new and existing technologies. From my own experience, proactivity can get you far. For me self-portraiture enabled me to take the ideas inside my head and make them real—instantly and often spontaneously.

We spend so much of our lives thinking and planning, that there is a danger that these ideas and ambitions will never be realized. That is why I stress that imagination and initiative are far more important than your equipment will ever be. Ever heard of the phrase "all the gear, and no idea?" There are thousands of people around the world who own more photography equipment than they will ever use. What is important is that you make use of what is available. Even if you own just a compact camera, I encourage you to pick it up and use it today. The chances are you won't have a model or even ideas for locations to hand. That is where the beauty and simplicity of self-portraiture come in.

Spontaneity and simplicity have always been important to me, ever since I picked up my first compact camera to take a picture of myself. To this date, I still value minimalism. Often studio equipment—the sight of many lights, wires and gadgets—is unappealing to me. While I do seek to learn how to use lighting equipment and new technologies, because an open mind is also crucial, I believe in being honest with yourself about what drives you to take pictures, and to strive to discover what ultimately excites you about the process. While you are only going to be able to further your photography by acquiring new skills, I persist with the notion that getting things technically correct is not as important as discovering your passion, as this will ultimately give you the satisfaction that validates your choice of career, as well as helping you to find your unique style when appealing to your audience.

In *The history of self-portraiture* on pages 10–15, the many reasons why artists throughout the centuries have turned to self-imaging is outlined. The introduction of photography did not, as I mentioned, encourage all artists to become photographers; in fact, photography had a long way to go to be recognized as a creative form. Today, particularly in the UK, photography is still not completely accepted as an art form as esteemed as painting or sculpture, for example. Often a self-portrait is expected to be in the form of a drawing, painting, or literary work.

Why do photographers create self-portraits? The most obvious reason is convenience. We are our own instant models, always available, ready, and willing. We don't need to provide verbal direction and we know in our own minds the artistic intention for a shot. Self-portraiture is a vehicle through which to perfect your photographic skills and artistic approach.

Like our artistic predecessors, we can use self-portraiture to showcase our photographic skills to potential clients. This "showcasing" might be a conscious effort, or initially unintentional, as was the case when I started to share my own work on flickr. This is where many devoted self-portraitists, myself included, face the challenge of using other models: it might be difficult to immerse oneself into other assignments as naturally as one does a self-portrait. Having to give verbal direction is new and the whole act might feel perfunctory and superficial.

There are other reasons, beyond mere practicality, why self-portraiture is attractive. Self-portraiture can be a form of introspection, therapy almost, for the artist or aspiring artist. This can either be in the form of autobiography, or a documentation, whereby an artist's motive is to create a record of their life, a time-line of their existence. Rembrandt's lifetime of self-portraits forms a kind of visual journal when looked at in sequence; the portraits become an organic flow of images detailing his progressive ageing—a record of life and death. Noah Kalina's *Everyday* photographic series (see pages 114–117) can be considered a modern-day version of Rembrandt's paintings; a hybrid, one might say, of visual art and a scientific experiment. The work of Annette Pehrsson (pages 98–105) is another example of work that portends a kind of everyday documentation, albeit more romanticized and one might say nostalgic than Noah's. On the other hand, self-portraiture can also be a way of embellishing

THE BALCONY BREEZE *2008* (right)

This is a cropped detail of a self-portrait I made on the balcony of a Victorian hotel in Eastbourne, East Sussex in the UK.

HOT *2007* (far right)

Self-portraiture is a way to freeze and embellish moments and scenes from your own life. This was taken one hot afternoon in a field in Sussex in the UK with the help of my boyfriend.

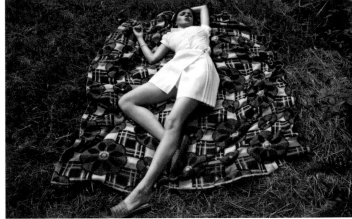

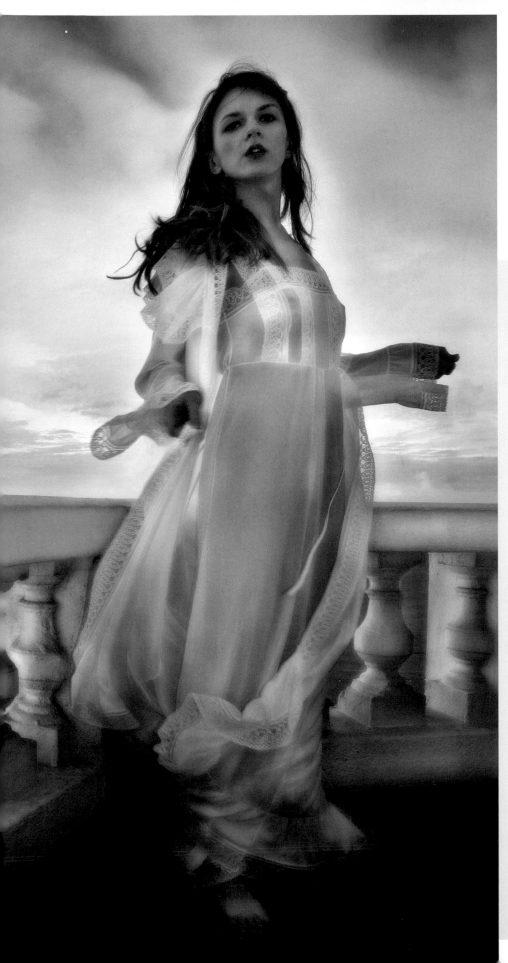

oneself, fixing an ideal state, and elevating your life into a fantastical context. Some photographers purposefully pursue the surreal with the belief that the everyday and the "real" is monotonous and uninteresting. I have been drawn to surrealism in my own work. Contributors Jon Jacobsen (pages 138–145) and Joanne Ratkowski (pages 122–129) have also explored the use of fantasy through post-manipulation in their work.

It is also crucial to consider the modern technological context in which artists like myself exist. Because of the digital age, it is much easier nowadays to access the equipment needed to create images. Digital cameras are easily available, and we no longer need to use a darkroom and spend money on chemicals to create images. It is relatively cheap to obtain a post-processing program and to start out inexpensively in photography. We have also entered a new world with regards to how we share our work. We need only an Internet connection to send our images across the world to a potential global audience, within minutes of having created them. When I conduct my workshops and presentations I mention that self-portraiture is the fourth element of this quadripartite set-up: it completes the control and independence one gets from utilizing the digital camera, digital software and the Internet. It means the process of creating images can be entirely private and without interception of, dependence on, or compromise as a result of other people.

CHAPTER TWO
EQUIPMENT

Whilst technology offers the tools to implement your creativity, your choice of equipment is an important decision and it is worth spending some time thinking about which tools will be best for you. Ultimately, it comes down to budget and how serious you are about your pursuit of photography. You don't need the latest, state-of-the-art camera to take good pictures—you will soon realize that it is the person behind the camera who takes the pictures, and that spending a lot of money on the technology won't guarantee you great images. At the same time, I recommend investing in the best equipment you can afford. Aim to buy a DSLR, a computer and software that will give you the kind of control you need to fully flex your creative muscles.

I look also at the various accessories you can consider as part of your kit: the most useful is the remote shutter, though this is not necessarily essential. Some self-portraitists get by well enough with the ten-second timer—but the affordability of remotes makes them a luxury not to miss. With lighting, don't be under the illusion that you have to pay hundreds of pounds for equipment. I look at the different options for lighting, whatever your budget.

It is important to consider the base use for any equipment you buy and not get carried away with the whole notion of photography gadgetry. A tripod, for example, is only a tool to hold your camera steady, so if you find yourself in a situation where you can balance your camera on a suitable surface, don't neglect the opportunity to try and shoot the image. As a minimalist photographer, I started out with very little equipment and still prefer to go without all the gadgetry and extras. Whichever way you're inclined, be sure to make use of what you have available and get inspired.

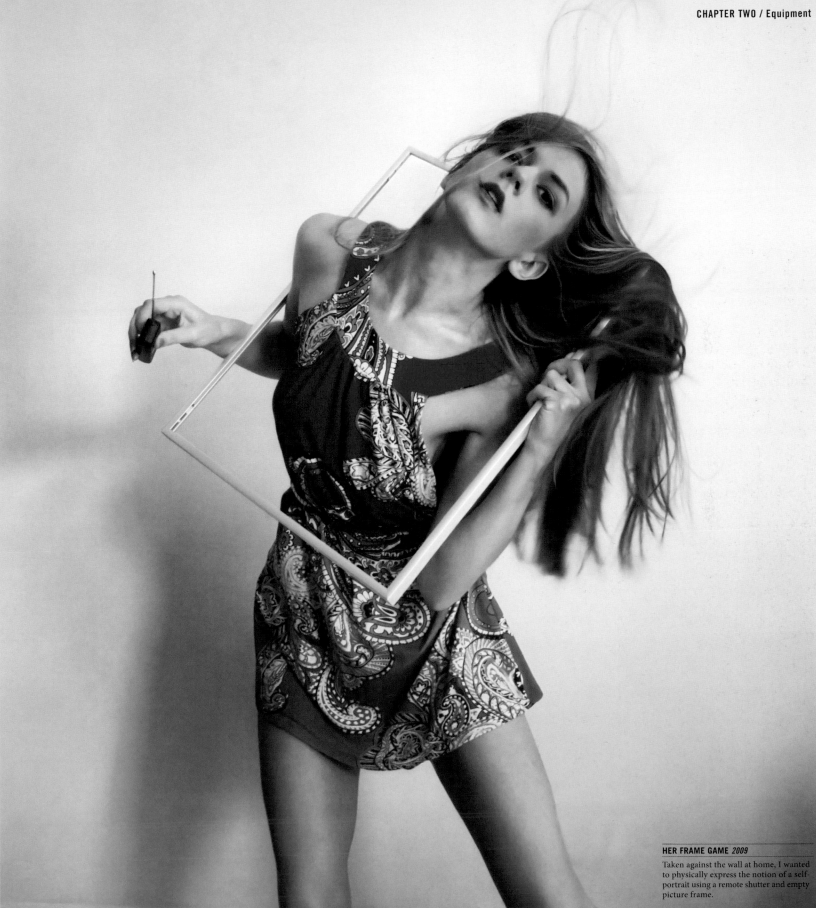

HER FRAME GAME *2009*

Taken against the wall at home, I wanted to physically express the notion of a self-portrait using a remote shutter and empty picture frame.

CHOOSING A CAMERA

Whilst you can easily shoot self-portraits on a point-and-shoot compact camera, there will be a limit to the quality, and the creative possibilities of the end result. There is a huge range of equally affordable DSLRs, which will be much more appropriate if you want a meaningful start in photography. There are several factors to consider and lots of impartial guidance out there to help you.

There are lots of photographers who still enjoy using film. Some have a darkroom background, and may have partially branched out into digital, but there are also young photographers who actively pursue film use, such as Annette Pehrsson (pages 98–105). However, my advice on equipment will be based on digital technology. For several reasons, using digital has advantages over using film. It allows you to shoot continuously without prominent running costs, to view your images while you shoot, and transfer your images easily onto a computer. There are also many features in digital cameras that will aid the process of production, and with camera models becoming cheaper, more sophisticated, and more readily available, shooting digital is an obvious choice for many artists.

The first level of camera available is the consumer-friendly compact or point-and-shoot camera—such as the Canon PowerShot S3 IS or Sony Cyber-shot DSC-H5. Compacts are the most viable entry-level camera from a financial point of view. While these are great for opportunist photography, they're limited with what they allow you to do artistically, and seldom offer much in the way of manual control.

There is a category between a compact and a DSLR known as the "bridge" camera. The bridge camera—such as the Fuji S1600 or Sony Cyber-shot DSC-H20—offers manual control, but with a fixed lens as part of the model. These offer the simplicity of a compact camera, but with adjustable modes, metering patterns and choice of file formats. These can be good to start with, but having the flexibility to change lenses is likely to be a feature you will want from the outset.

The next category up is the lower-end or "baby" DSLR—such as the Nikon D5000, Canon EOS 30D or Pentax K110D. You will probably find that you can buy this level of DSLR for the price of a higher-end compact camera, especially if you look for a second-hand model. Going upward, models like the Canon EOS 40D, Nikon D80 and Sony Alpha 350 are slightly more expensive, but offer a wider range of features, and usually a higher resolution (around ten megapixels). DSLRs up to this level have a crop factor, meaning the dimensions of the camera's digital sensor are smaller than what is considered to be full-frame 35mm, which will increase the focal length of lenses at which the lens performs. This can be an advantage to many shooting situations, but full-frame models are increasingly sought after by both professionals and amateurs, and popularity has recently soared due to their increasing affordability. These include the Canon EOS 5D Mark II, the Nikon D700, and the Sony A850.

At the top end, for serious professionals demanding the highest-league DSLR—usually shooting for high-end fashion shoots and billboards—are models like the Nikon D3, Canon 1DS Mark III and Mark IV. Up from this, the finest technology typical for shooting large-scale campaigns are medium-format cameras from brands such as Hasselblad and Phase One, which are very expensive. If you're a student with access to equipment like this, you might be lucky enough to be able to shoot with a medium-format camera. However, for most professional or semi-professional photographers, including myself and the other contributors in this book, a lower or mid-range DSLR is a good enough tool for the job. As long as you are getting sufficient quality for what you aim to do with the photographs, then your imagination will always be the most important tool when shooting!

Factors

You need to consider your budget and what you aim to do with your images. Bear in mind that you might not have plans to print or exhibit your work now, but you may well want to do so in the future, so it might be worth going for a slightly better model to ensure flexibility later.

You need to consider which brand you want to go for and the compatibility of your camera model with lenses and accessories. Most people find that Canon and Nikon

THE ART OF SELF-PORTRAIT *2006*

It is important to spend some time thinking about what equipment is best for you, and what features you might need, before you spend your money.

are the easiest brands to work with in that respect, for their wide range of equipment and synergy with third-party manufacturers. You are also wise to consider the weight of a camera model for practicality, the size of its LCD screen (which is usually between two and three inches squared), and also opt for a model that has a movie mode. The Canon 5D Mark II heralded a new era of digital SLR with its HD movie function, which has revolutionized many kinds of photographers' practice, especially those working in photojournalism. It could be worth investing

in a camera with an HD movie mode (more cameras are accommodating this technology) to expand your creativity as a self-portraitist.

Most DSLRs will use CF (CompactFlash) cards, which can now come in as high a capacity as 64GB. All cameras should have a timer (some have both two-second and ten-second), and the necessary ports to communicate with a remote trigger, some with an in-built wireless function.

Equipment

A Canon 5D Mark II.

Magazines like *What Digital Camera*, *Digital Camera*, and *Digital Photographer* offer up-to-date information on the latest equipment, and impartial consumer feedback. These are worth looking at if you are contemplating a new camera, or any photographic equipment, and need advice on what to choose.

LENSES

Understanding lenses will aid your creative approach to photography. Buying a camera model is only the first step, and in terms of image quality, your choice of lens is of more consequence than the choice of camera body. Your lenses will last a lifetime, whereas your camera body's life is finite. There are so many lenses available, that a photographer just starting out can be bewildered by choice and even professional photographers looking for their next purchase can be overwhelmed with options. Your budget will often dictate how many lenses you can feasibly use, and there are certain all-round lenses (usually zoom lenses) that can serve a multitude of different functions. It's worth spending a bit of time considering the kind of self-portraits you will be creating before buying lenses.

Focal length

The most common lens choice for conventional portraiture is a focal length of 50–135mm, categorized as a medium telephoto lens. This range enables photographers to capture their model from a suitable distance and to obtain a blurred background, giving esthetic focus to the model. This will produce the best portraits, giving a human-eye interpretation of the face with no distortion. However, this kind of focal length is not always practical for a self-portrait photographer. This is mainly because self-portraitists often make use of wider contexts within a scene. While shooting wide will allow you to incorporate more of a scene into your image, a lens wider than 21mm will likely drown out the human element, and is thus more suited to shooting landscapes and architecture. On the other end of the scale, a telephoto lens of over 135mm, mainly used for sports and wildlife photography, is also unlikely to be appropriate. You will find that a wide angle or a "normal" focal range type of lens (about 21mm to 70mm) will be suited to creating all kinds of self-portrait.

I have found that shooting wide has worked with many of my images, such as *On the Terrain*, but for images with a more conventional portrait approach, a focal length of 50mm is appropriate. 50mm roughly translates to how the human eye views a subject, with no distortion either way.

Aperture

The size of a lens' aperture relates to the type of focus you will achieve in your image. The zone of sharpness in an image, referred to as depth of field (DoF), relates to the focal length of your lens, the aperture size, and the distance between camera and subject. The smaller the aperture of your lens (the higher the f/stop), the larger the depth of field. Using smaller apertures can also increase the necessity for a tripod, as longer shutter speeds can lead to camera shake and blurred images (more about the importance of tripods on the following pages).

In the case of self-portraiture, it is convenient to use smaller apertures (higher f/stops), especially if you are using a timer and cannot position yourself in the image before clicking the shutter. With larger apertures (smaller f/stops) you may find you are out of focus when you step into the image after clicking the shutter. However, with a remote, this issue is usually resolved if you get yourself into position then allow the lens to auto focus on you.

Faster lenses are those with larger apertures, because the shutter speed can be higher for a particular ISO in the same image. A larger aperture will allow you to shoot in lower light, which is a factor to consider especially if you are starting out with little lighting equipment, and using your own indoor environments in the spontaneous manner that characterized my own early work. However, lenses with larger apertures tend to be heavier and more expensive, so this is something else to take into consideration when choosing a lens.

Zoom and prime

You are likely to find that your main decision is whether to buy prime or zoom lenses. Prime lenses are of a fixed focal length, whereas zoom lenses allow you to vary your range. Experienced professionals encourage emerging photographers to use prime lenses, as these lenses do not offer the ability to alternate one's perceived proximity to a subject with the zoom ring. Prime lenses therefore make you think more on your feet in relation to a subject. They also offer superior quality, meaning you can shoot

Clockwise from opposite, top left

NEAR AND FAR

Across my work to date I have used all-round zoom lenses—such as the 17–85mm and 24–70mm. These have enabled me to achieve a remarkably wide scale of view, as in *On the Terrain* (2008, left), which is useful in a self-portrait situation for both practical and esthetic reasons. With the same lens I am able to go closer to myself, as in *Negative Space* (2007, right) for a more conventional portrait composition.

FOR THE 14TH *2008*

In this image the use of wide angle is obvious and creates distortion—my feet are disproportionate in size to the rest of me—but it shows how wide-angle lenses can open up the possibility of using small spaces in the challenging situation of framing yourself from the other side of the camera.

Equipment
Canon 18–135mm zoom lens.

sharper images, in lower light, and with faster shutter speeds when photographing movement. However, zoom lenses offer much more flexibility in being able to make spontaneous decisions on the proximity to a subject, without having to change your lens. When zoom lenses were first introduced, photographers had to cope with a significant loss of quality compared to prime, whereas nowadays, the difference in quality is not as noticeable. Ultimately, zoom lenses allow you to have more focal range to hand, for the price of one lens. I have always regularly shot with a zoom lens. As a self-portrait photographer and on a limited budget, I have found it the most convenient for my shooting process in terms of flexibility, and being able to buy and carry just one lens for a potential variety of situations.

Types

You will need to take into consideration which lenses will work with your camera body. First, the brand will determine the compatibility: Sony has its own range of lenses, for example, while Nikon and Canon are often compatible with each other and also with lenses from third-

party brands, such as Sigma and Tamron. There are also different levels of lenses, for example, it is important to distinguish between Canon's EF-S, and EF lenses. EF-S lenses are zoom lenses specifically designed for lower-range consumer-oriented DSLRs with a different lens mount design, identifiable by a white dot on the lens mount (such as the EOS 300D). EF lenses, available in both zoom and prime, are better performers in terms of sharpness, contrast and aperture size. Canon's L series lenses, identifiable by a red ring around the barrel, and fitting to lens mounts with a red dot, are their top range lenses. Nikon offers a similar tiered range of entry-level and professional lenses.

Investing in a good camera body is not enough: don't undermine your investment by fitting a poor-quality lens. However, it is also important to consider your budget, and give yourself time and opportunity to discover which lenses will be most appropriate for the kind of images you wish to create, and the distance that will be required between you and the camera.

TRIPODS, REMOTES & ACCESSORIES
Tripods

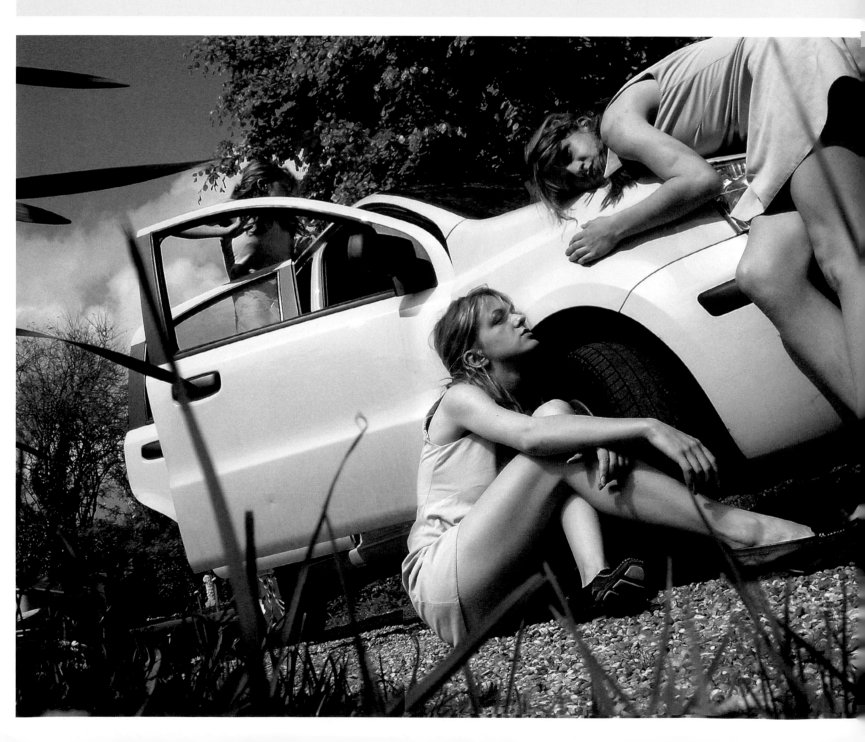

PANDA & I *2006* (left)

I propped my compact camera on a clump of grass to take the shots for this composite. The angle particularly suited the form of the car's doors and wheels, and gave a dynamic edge to an image that would have been very different at human-eye level.

SUNBURST *2006* (right)

I set the timer for this shot and then climbed across the windowsill at a friend's house. This was one of the first times that I felt a single shot, as opposed to a composite of multiple "selves," was substantial in itself.

Whilst some photographers will argue that having a tripod with you at all times is paramount, others will suggest that you don't always need one. I think it is important to understand how a tripod can be invaluable in certain situations, and it can ensure the technical side of your shoot runs smoothly. However, it's also good to seize spontaneous moments during which you might not have access to a tripod.

When I first started taking self-portraits, I did not have a tripod, and so I used my initiative to prop my camera up on whatever was available. This led to interesting "bug's eye" views, such as in *Panda & I*. It also made the task of achieving the "multiplicity" or cloning technique, as seen here, a bit more challenging. However, I believe the images would have been very different had I used a tripod, and I may have ended up shooting the images from a more conventional, human-eye level. Shooting this way also allowed my zoom lens to take in a wider angle making the final image more dynamic. However, for other images, such as *The Smothering* (see pages 86–87), a tripod was necessary to enable exact positioning between the shots.

While I use my tripod on most shoots now, I try not to fix my camera onto the tripod until I have had a chance to scrutinize the scene with my camera handheld. Tripods can be cumbersome and restrictive, so bring the tripod to your camera, not the other way around. It is important to consider the base use for any equipment you buy, and not get carried away with the whole notion of photography gadgetry. A tripod is only a tool to hold your camera steady and still, so if you find yourself in a situation where you can balance your camera on a suitable surface, don't neglect the opportunity to try and shoot the image without the use of a conventional tripod.

There are many types and sizes of tripod available, for all budgets. Some brands to investigate include Manfrotto, Slik PRO and Calumet, but virtually every brand from Canon to Sony also have their own models. A good tripod will have a spirit level, tilt handles and secure leg locks. Some will have foam leg covers to make close contact with your tripod more comfortable, though this might not be such an important feature for self-portraiture. I also recommend investing in a Joby Gorillapod. These are small, versatile mini-tripods that you can use in situations where you don't have your main tripod, enabling you to secure your camera at an angle on the floor or fix your camera up high by wrapping the legs around lampposts or tree branches. Clearly they won't offer you as much security and precision as a proper tripod, and you have to make sure you buy the right size for your camera, and lens otherwise the Gorillapod will droop (buy a size above, to be sure), but it's a simple, fairly inexpensive asset that will transform the control you have during those opportune shooting moments.

Remotes

Probably the main question a self-portrait photographer is asked by their peers regarding personal technique is "How do you actually take a self-portrait?" I'll be looking at shooting methods and the whole technical process later, but I want to mention here the equipment you will need in preparation for this process. There are a few approaches. The first and most basic approach does not require any sophisticated equipment: simply the timer on your camera. Once you get a remote shutter, you'll probably find you won't want to go back to using the timer out of choice. A remote shutter can be cheap and will give you results you might not have been able to achieve otherwise. However, the cheaper the remote, the lower quality build it will be. I have personally preferred to buy cheap remotes that have lasted longer than expected, but you may consider it worth investing in a slightly more expensive accessory to guarantee reliability.

If you have an iPhone, it is possible to turn it into a remote shutter. The DSLR Camera Remote Professional Edition is an example of the kind of application available, although your camera must be connected to a Wi-Fi-enabled computer. The application works with a variety of DSLRs. There are other remote-shutter applications available, and doubtlessly even more will be developed, so keep in tune with the latest technology.

Tethered shooting

One of the most challenging technical aspects of shooting self-portraits is not being able to see a shot until it has been taken. We have to somewhat guess our positioning in the frame and keep checking back, working by trial and error. It can help immensely to have a camera with a swivel screen, the kind found on either a compact or a camera like the Sony R1. However, the higher ranking the DSLR you buy, the less likely it will be to have these quirky features.

Some self-portrait photographers take the guesswork out of the process by shooting tethered. You can connect your DSLR to a computer via a USB cable in order to view the live image on screen. You will need software to read the image, such as Capture One or Adobe Lightroom, or camera-specific software that comes with your camera, like the Canon EOS Utility.

You can even tether your camera to your television (for a potentially huge live image). Check your camera has a video-out port, which you connect to your TV set using the video cable, usually supplied in the box with your camera. The socket and cable will be color coded for convenience, and you will need to tune your TV into the correct channel to view the images.

Of course, shooting tethered requires you to be in an environment where you are able to use AC power. It also requires time and possibly some patience at least first time around. I did initially try shooting tethered, but I wasn't happy spending so much time setting up the necessary equipment for a shoot.

Memory cards

With your media storage, most commonly your SD or CF cards, I highly recommend you buy new, branded storage from a reputable source (Sandisk, Kingston and Lexar are some of the most well-known names). Also, buy a card reader that will download your images from your camera to your computer much more quickly than via a USB cable.

Your computer and software

As a digital photographer it is essential you have a computer to be able to view, process and store your images on. This might be a small laptop or a huge workstation. Generally, if you are going to purchase a new machine and you will be doing a significant amount of post-production, you want to buy the biggest and best monitor you can afford, with the largest amount of RAM and hard disk space. I also recommend you invest in Adobe Photoshop in order to get the most from your images and to perform the post-processing techniques as I describe in Chapter Four.

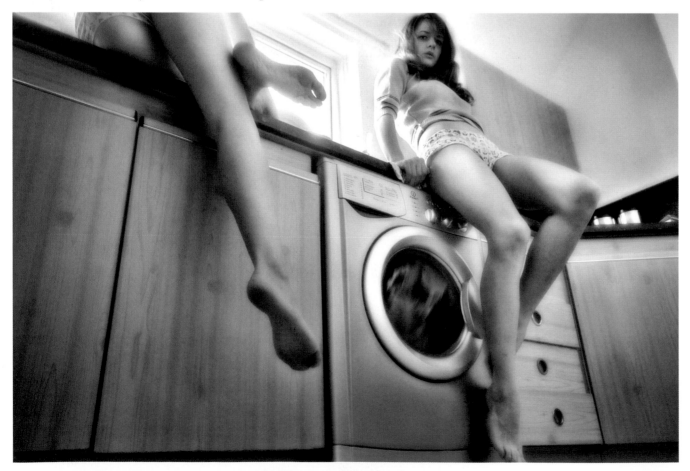

SPIN CYCLE *2007 (below left)*

This image was taken with the ten-second timer and my Sony R1, which I had propped on the floor. The shooting took about ten minutes, followed by compositing two of the shots together in Photoshop.

ONE-WAY MIRROR *2010 (below)*

To take this shot, I had the help of a "human tripod," my partner, who held the camera while I posed in the scene. This was set in an abandoned building.

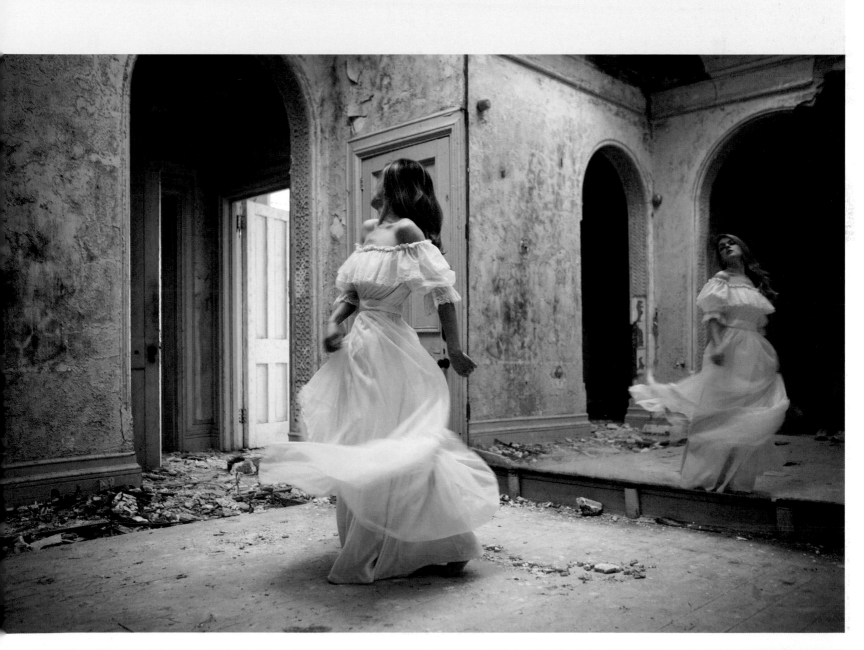

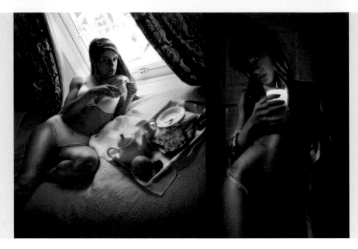

EXPOSURE & LIGHTING

Light is what makes all photographs and the best images will always be those images that use light most competently and creatively. However, you don't necessarily need fancy studio equipment to make an impact. Many photographers start out with basic equipment or even lamps and lights they have at home—what is most important is developing an understanding of light.

I started out with no lighting equipment, and the vast majority of my images to date use natural lighting, without even so much as a reflector. However, since turning professional, I have wanted to better understand how light works and to be able to have more control over a situation.

ISO

The ISO setting measures the camera sensor's sensitivity to light, and the ISO you will require for a shot depends on your other camera settings. In lower light situations, you will either need a larger aperture, slower shutter speed or a higher ISO, and likely a combination of all three depending on the situation. The more clarity with which you want to capture movement in a low-light situation, the higher ISO you will need, and the more digital noise your image will have. There will be a limit to the ISO level your camera can reach, and some of the latest models have extraordinary capabilities—but an absurdly high ISO, like 64000, is useless without there being some light source in the scene for the camera to work with.

Natural lighting outdoors

Shooting outdoors can be a good place to start your self-portraiture. Aim to shoot either early in the day, when the sun is rising or before it has risen, or when it is setting. Shooting at midday causes harsh shadows that are usually unflattering in portraiture. However, you could get around this by shooting in a wooded area, or on an overcast day, when the clouds act as a giant softbox to diffuse the directness of the light.

Don't overlook the ability of a reflector, which most commonly comes as a circular piece of kit in white, gold or silver. A reflector can transform your shots for a fraction of the cost and effort of using lighting, enabling you to fill

in shadows with the light of the sun. It may be challenging to position a reflector working alone as most need to be held by an assisting hand. Remember to improvise—for example, snow, a sandy white beach, a white umbrella or white towel can all be effective reflectors.

Your choice of camera body, lens, location, time of day, and any extra lighting equipment, will all determine the quality, and lighting in your final image. Upgrading my camera body, learning how to make better use of natural light (introducing reflectors, for example), and learning how to use flash lighting have all contributed to improving the quality of my images over time, and making it possible to print them on a larger scale.

Improvised lighting

You can make use of natural daylight indoors by using the light from windows and filling the shadows in the same way with a reflector (or even just some white material like a towel). Photographing by a window can be tricky, as the light from outside will create a difficult high-contrast situation. You can get around this by using fill-lighting against the subject, by auto-bracketing the shots for a HDR image (see page 92), or by choosing a careful angle so the subject doesn't become silhouetted. When light is not good, however, I would recommend improvising with objects you have at home, such as lamps and candles. Flashlights are also handy, instant lighting props that you might already have hanging about the house. They emit stronger light than candles, and can be used effectively outdoors. I used a flashlight in my image, *The Aura* (see pages 54–55), which I shone directly at the camera to create a ghostly lens flare on a beach at night.

In-camera flash

A lot of DSLRs will have a pop-up, in-camera flash. This can be of use, though you may find the flash to be too direct in most circumstances, and to potentially "bleach" the subject. First, try turning down the power of the flash by going into your settings. If that does not make enough difference, try covering the flash with a white gauze-like material or even a piece of thin paper. This will help diffuse

Clockwise from far left

BREAKFAST ON BED *2008*

Controlling the light from a window can be a great challenge. In this image, taken in a hotel room, I positioned myself so that the light was coming in at an angle, and did not silhouette my body against the window.

TESTAMENT OF EXPERIENCE *2007*

This image was shot with both candlelight and the artificial light in the room. I darkened the image in Photoshop to make it appear as if the light were coming primarily from the candle. The glow on my skin is also achieved in

Photoshop. The title of this image was taken from the name of a book by Vera Brittain.

LIGHT-WIELDING *2007*

This image epitomizes the reliance I have had on basic household lighting, especially when I started out. By bringing a lamp towards my face I was able to achieve the effect I wanted, but with the light source unconventionally becoming part of the scene. Together with the table, fruit and plant, I see this image as a sort of still life, with my self-portrait within it.

it. Generally, however, if you are keen to use flash, it is better to invest in an external flash—which is vital if you own a higher-end DSLR as these usually don't have an in-camera flash.

External flash units

External flash units are particularly useful for the photographer who wants quick, easy and adaptable fill-in flash. More powerful than your in-camera flash, the unit will have different settings for the power of the flash, and can be swivelled around to fire in another direction, for example, to bounce off the ceiling or a wall. You can attach the unit straight onto your camera's hotshoe and use it directly, or your DSLR can communicate with the receiver attached to the external flash unit either by infrared or by a transmitter attached to the hotshoe. The size and versatility of the units means they can be propped in various places as fill-in flash, often without even the need for further stands or aids. It can also be used as a trigger when you use other lights set as slaves, which conveniently eradicates the need for a cable. This piece of kit is a good investment, and can be used in a variety of photographic situations.

Building a professional lighting set-up

You can use further equipment with your external flash unit in a lighting setup, attaching a stand, umbrella and even a softbox to vary and diffuse the light. A softbox is one of the most useful pieces of kit for transforming harsh lighting. You may choose to progress onto hiring or purchasing studio flash heads for further control and power in a lighting set-up, and explore the use of grids, snoots, beauty dishes and gels. However, it is possible to create amazing images without breaking the bank, or ever entering a studio. Focus more on understanding the way light works and experimenting with it, and don't assume you have to spend a lot of money. See the work of Lucia Holm (pages 154–161) for her use of strobes, and see Annette Pehrsson (pages 98–105) and Federico Erra (pages 146–153) for their use of natural and improvised lighting.

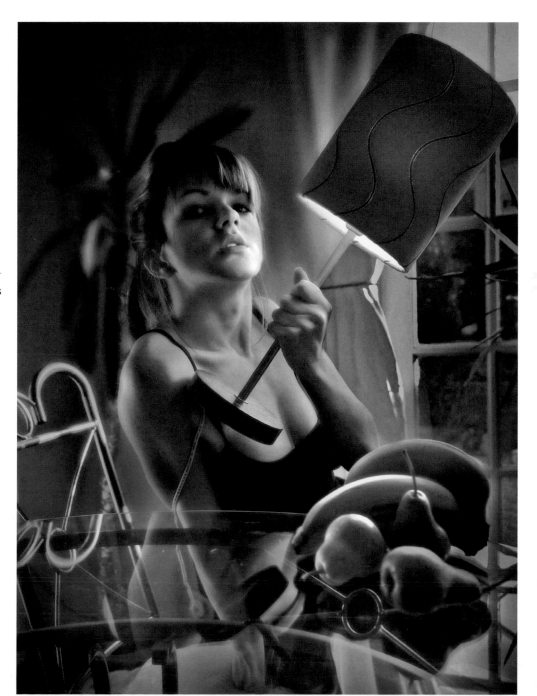

CHAPTER THREE
SHOOTING

One of the most famous names in self-portrait photography, Cindy Sherman, said: "if I knew what the picture was going to be like I wouldn't make it… the challenge is more about trying to make what you can't think of." While forethought and planning are important to many photographers, especially for a commissioned shoot, in other contexts you have the leisure of allowing for spontaneity. You don't necessarily need a master plan in order to shoot a masterpiece.

When I first started out in photography I would rarely plan a shot thoroughly. I would begin with a spark of inspiration that could be anything from a beam of light, to a scene in a film—or a prop from the loft, to a fleeting mental visual from a dream. The visual aspect, however, would lead the way into a shoot, and I would be guided by what looked best superficially. Over the years, I have felt an increasing need to let concepts steer the direction of a shoot, to counteract the frustration I feel with images that are pretty, but to me, meaningless. In doing so, I have found I sometimes produce images that have wholeheartedly attacked a concept or idea, but are esthetically uninteresting, which prevents me from feeling passionate about that piece. This seesaw-like conflict is one I constantly try to balance and is a battle I imagine many other art photographers face. How do we make our images relevant to our own thoughts and conceptually interesting to our audiences, and yet also eye-catching enough to validate our choice of visual form? The answer to that question does depend on what you intend for your photography and your reasons for producing self-portraiture, which may not even be clear to you at first.

In this chapter I look at clothing, makeup, and props—crucial to the visual language of your images. I explore how different locations make an impact—how using your own home can result in countless possibilities, but also how quirky new places can reinvigorate an ailing uninspired outlook. I look at how low lighting can transform a location, providing a unique atmosphere to your images. I also discuss shooting nudes and talk about my own inspiration taken from paintings.

SOUTH BY SOUTHEAST *2007*

The filmic quality that I saw in this largely SOOC self-portrait after converting it to black and white, inspired me to title the image as a reference to Hitchcock's *North by Northwest*—but with a reference to the South Downs on which it was shot.

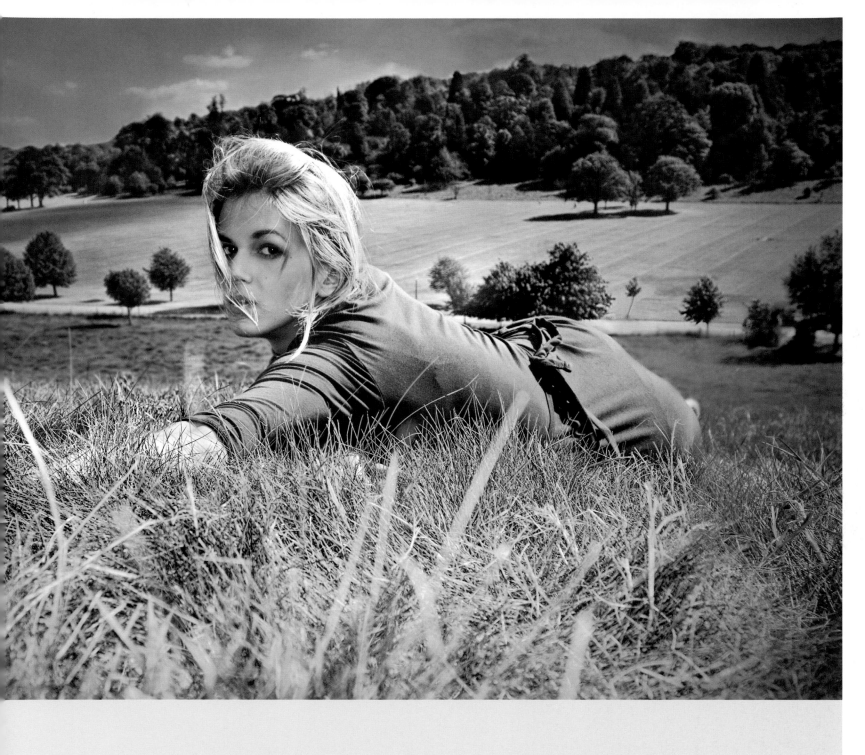

CLOTHING

Your choice of clothing is one of the key artistic decisions you will make for your self-portrait shoot. There is no end to the possibilities in your images once you experiment with different clothing. Clothing can suggest a particular era; a plain white dress or shirt can evoke a nostalgic mood, while wearing a pair of jeans with a sequined top would give the image a distinct contemporary tone. Because self-portraiture is a form of acting for many artists, the choice of clothing becomes an important "character" decision. Cindy Sherman is known for her series of film stills where her outfits were contributive to the creation of recognizable movie-like scenarios.

Synergy between outfit and location

When I first started shooting self-portraits, I shot a lot outdoors and to make each image distinct from the last, I found it imperative that I wore a different colored outfit each time. I would then choose a scene that worked well with my choice of garments, as in *Up The Wall* (right).

Sometimes the texture or color of an outfit can offer character to an image in a way that other garments do not. The dress I wore for *Crosswinds* (below) worked perfectly

for this image. Although the dress is relatively nondescript and therefore does not overtly dominate the scene, the way it billowed in the strong wind gave the image its title theme, and the deep-set creases down the skirt draw the eye through the frame. The color of the dress was easy to manipulate from pale blue into turquoise in Photoshop (using Curves and Color Balance adjustments), which gives the dress a leading visual role in the image.

Experiment with your own clothes, but also look in thrift stores. Shopping this way will also save you money, and it is an excellent ethical and environmental choice in terms of re-using and recycling people's discarded goods. You may even find a piece of clothing that comes to be a staple item in your images. I have managed to use the same silk gown that I bought very cheaply in a number of shoots, and even pose models in it. Being white, it works well in low-key lit photo shoots and is often complemented by a soft, diffused processing adjustment in Photoshop.

For *Party Pieces*, I dressed up in an outfit I had bought quite inexpensively for a Bollywood party. The jewelry and accessories instantly gave the image a distinctive exotic feel, very different to anything I'd created before. However, sometimes the simplest, plainest outfits can be the most effective as they work as part of the shot, but don't dominate the composition. Generally you will want the focus of an image not to be on the styling, but to be centered on you as the model, and the concept at hand. I used a relatively mundane, everyday outfit in *On the Terrain* (page 27) and *The Adjustment* (page 47) which were appropriate for the mood and concept of the compositions.

Clockwise from above

UP THE WALL *2006*

This cloned self-portrait is a good example of where the clothing has given notable form to the composition of the picture. The bell shape of the skirt in the foreground draws the eye in and around it. Its strong blue is complemented by the red of the flowers, and the yellow of the shoes and road markings.

PARTY PIECES *2008*

Making the effort to dress up for a photo shoot can prove fruitful from the outset. This was only a quick shot I took of myself by holding the camera at arm's length, and worked well as a square-cropped self-portrait leaving only one eye visible.

CROSSWINDS *2009*

This dress was bought very cheaply from a charity shop, and I have used it several times in subsequent photo shoots. The style of the dress means it can fit a range of sizes, allowing me to use it on other models.

HAIR & MAKEUP

Like clothing, the manner in which you choose to style your hair and face will affect the artistic outcome of a shoot. While some self-portrait photographers might not pay much attention to styling, your appearance will undoubtedly play a role in the final images, so it's useful to understand how you can adapt your appearance through the use of makeup. The amount of time you invest in styling can steer the look of an image in interesting directions and also save time in post-production if you know from the outset what you intend to get from a shoot.

Generally in this industry, particularly in beauty and fashion, hair and makeup are a significant part of a photography shoot. In self-portraiture, however, it is completely up to you how you approach it, if at all. The self-sufficient nature of most self-portraitists' practice means that it is usually done independently, and often quite simplistically. There is nothing to stop you getting your makeup and hair done professionally, by consulting a stylist. However, I have shown with all other aspects of preparation for your shoot, from the type of camera to your choice of clothing, that you should always consider what you need and try not to spend too much time, money or energy on over-preparation. The key is in taking action.

Hair

My hair has always been quite a strong feature in my work, mainly because it has always been quite long, but also because I have increasingly enjoyed using movement in my images. Having long hair is an instant ticket to dynamism—for both men and women. Hair movement also allows you to choose whether to hide or reveal your face. Because the face is conventionally the central part of an image, the part to which the viewers' eyes naturally lead, choosing whether to show or obscure your face (and what expression to have there) will steer the narrative direction in your image. This is why I think women often have more flexibility than men when posing for self-portraits, because of the higher likelihood that they will experiment not only with hairstyles, but with makeup and clothing. An artist like Jon Jacobsen (pages 138–145), however, shows how this general notion can be challenged. Also, the work of

Rossina Bossio (pages 106–113) and Federico Erra (pages 146–153) challenge the stereotypes of gender roles. Hair can benefit from preparation, such as curling, crimping or straightening. It might be easier to ask someone else to help you, but I have always worked independently on styling, as do a lot of other self-portrait photographers.

Makeup

In my own work, I have found makeup to be generally unnecessary. This may well be to do with the advantage of my youth, though I often remove blemishes in post-processing. However, in my earlier work, my lower-resolution camera and amateur approach to lighting meant I spent a lot of time using the clone tool to attempt to "scrub out" the noise that had been created on my face, especially under my eyes. Learning some lighting techniques, even just using a reflector, is the best thing you can do for the quality of skin tones in your images.

Most of my images are wide shots that exhibit substantial context, so there is not a great deal of opportunity to scrutinize the look of my face and makeup. There have been some occasions on which I have shot a close-up image and makeup has certainly helped dramatize the features of my face—for example, in *Party Pieces* on the previous page, my eyes were heavily made up and the viewer is automatically drawn to the eye that is visible in the shot as a result of this. I may have applied the makeup quite thickly, but in the manner of theatre makeup, it has allowed the face to stand out flatteringly in the final image. Another example of this is *Portrait with a Cup of Light*. I applied black kohl eyeliner around my eyes, together with black mascara and a dark eyeshadow. I used a foundation/concealer to cover blemishes and a significant amount of blusher on my cheeks. You are also able to enhance makeup quite easily in Photoshop—adding further saturation to blusher and lipstick if needed. This would not be so easy if there were not makeup in the original image to build on in Photoshop. The main areas I tend to accentuate is the red of the lips and cheeks, so applying a dash of lipstick or colored lipgloss in preparation for a self-portrait shoot can reduce or even eliminate the need for

Clockwise from above right

THE FINAL GIRL *2009*

I stepped into the role of a horror movie "last girl standing" character in a ghost town scrap yard in Arizona. Spontaneously applying mud to my arms, legs and chest helped the character come alive and would have been difficult to recreate in post-processing.

PORTRAIT WITH A CUP OF LIGHT *2007*

This self-portrait benefited from the application of makeup as part of the preparation, as the composition focuses intimately on my face. The image was shot in the corner of a low-key lit room, with candlelight incorporated as an additional ambient lighting source.

THE FIXATION *2009*

The shape created by my hair in this self-portrait, shot on a windy day, was created by flicking my hair while remote-clicking the shutter.

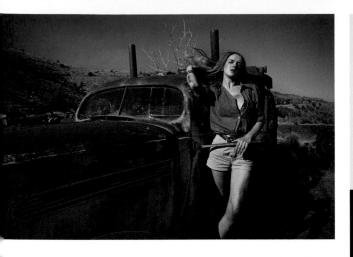

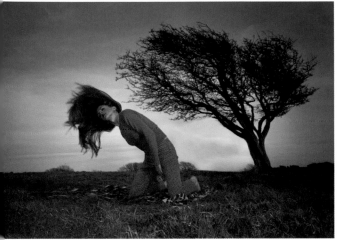

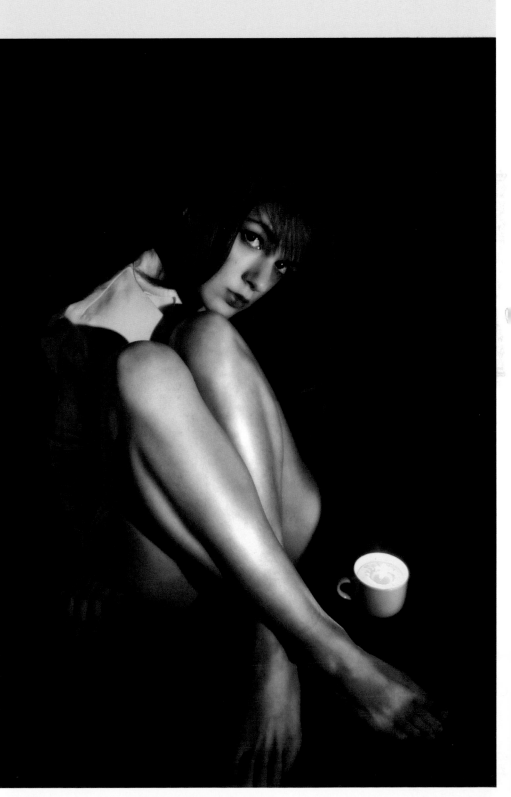

retouching in post-processing. Generally, however, I tend to go for simple, natural looks, and concentrate on using all the other elements of a picture, in combination, to give impact to the self-portrait.

Other "makeup"

These pages are only a starting point, after all, why should your makeup be conventional? You might also think about the ways you can use "makeup" beyond your face: in *The Final Girl* (above, top) I smeared mud on my legs during an impromptu moment in a scrap yard, which served as a great way to get into character as a runaway horror film victim. It was also something that could not be added in post-processing, as it would have been a very difficult effect to obtain, or would have not looked very realistic. Thinking about your hair and makeup is a productive way to get into the habit of planning your images properly and achieving the results you want.

LOCATIONS

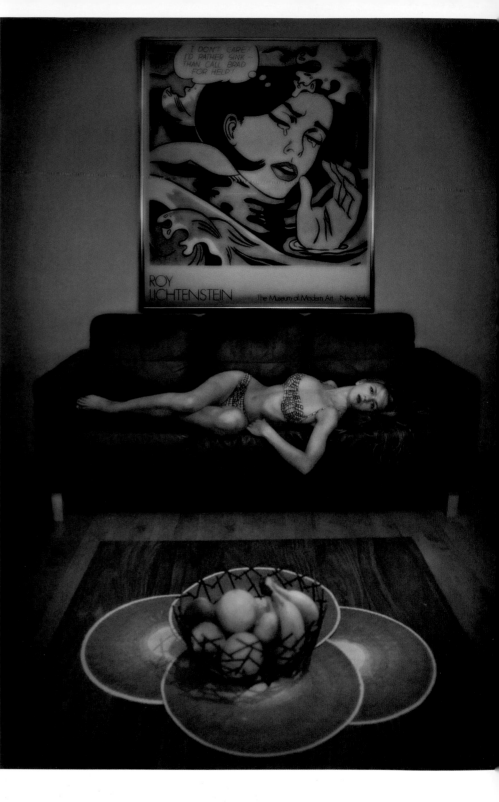

The locations you choose to use will always play an important role in the concept and final look of your self-portraits. A lot of self-portraitists start out using their own home environments to experiment in, and even the most basic and seemingly banal room can be the location where you shoot many diverse images. It is important to consider, then, that it is what you do with a location that is important, not the location itself. Nevertheless, finding interesting and quirky new places to shoot can be one of the most exciting aspects of photography.

We think of a typical portrait photographer as someone who conventionally uses a studio, but so far I have not really used one in my work. It is quite possible to go about taking portraits and self-portraits without having to hire or purchase professional set-ups. What is more important, as I have similarly expressed regarding equipment, lighting and styling, is to effectively use what you have to hand. Amazing images can be created in a studio, as much as they can be created in normal, everyday locations. In my experience, I have found locations to be much more inspiring, because I have always enjoyed having props and scenarios readily available, rather than having to construct them from scratch. A studio is a blank canvas that can be somewhat sterile unless you have a preconceived idea of what you want to create.

I have found much artistic pleasure in utilizing the surroundings of my home, other people's homes, natural environments, and other quirky locations as I find them. The following pages will explore the different types of location you might use to create your self-portraiture.

Making the most of your environment

It may be hard to believe, glancing around at your own home, that many different images can potentially be made in the same place. While my earliest self-portraits were shot outdoors during the spring and summer, I found it difficult to use the outdoors so much when it became darker and colder outside. Turning to interior settings, the most obvious place was my own home.

In some of my self-portraits, elements of my home have become features of the image, such as *Portrait with*

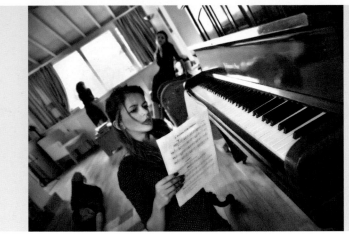

Lichtenstein & a Thorned Basket of Fruit (left) where the large framed image on the wall, along with the sofa, table and bowl of fruit are as important in the image as my own reclining figure. This is an example of using ready-made settings. They also bear conceptual relevance to your images because you are shooting with your own belongings, rather than borrowed or hired items. Additionally any white wall in your home can be used as a studio backdrop, or simply hanging a bed sheet or large sheet of paper over a wall can provide the same blank canvas as a studio, especially if you have the necessary lighting equipment.

Other people's houses

The next step you might try in diversifying your approach to locations, is simply asking your friends and neighbors if you can use their homes. For example, in *A Quartet* (right) I made use of the most memorable "prop" I saw in the living room of a friend—the piano. In *Sea View* (pages 48–49) I am looking out to sea through the unusually-shaped window in the room my sister was renting at the time.

Beyond the indoors

Creating self-portraits outdoors can be beneficial in terms of lighting and being able to experiment, without having the stress of working with artificial lighting. Whether or not you choose to start within your home environment, you should certainly consider the esthetic advantages of getting out and about. Regardless of whether you live in the city, in a rural area, by the sea, or by mountains, take advantage of whatever is on your doorstep. Don't be fooled into thinking that great locations are all beyond you. Good photography is about using what you have to hand; little use comes from bemoaning things you do not have.

I lived for five years in East Sussex, in the UK, where I had the good fortune of being near the coast, as well as expansive countryside, and the city too. I have used all three, particularly the last two, in my outdoor shoots. I shot *The Adjustment* (page 47) on a particularly windy day on Devils' Dyke, a location on the South Downs I have often used. *On the Rocks* (right) was shot on the beach at Shoreham, on an

even colder January day. This image also demonstrates the possibilities of combining an interesting location with your outfit—in this case, the two elements starkly contrast one another, giving the image its esthetic appeal.

Live near a swamp? A dumping ground? A derelict playground? Sometimes the most unlikely places will be the most interesting. A pleasing, sunset vista from the top of a hill, or a beautiful beach may be obvious choices, but it's not always easy to know how to use them uniquely, and to make them come alive in your images, especially when you are using yourself as the human element. Look for urban decay, for scenes that subvert the idea of beauty, and you may find yourself with some great juxtapositions at your disposal. See the work of Yulia Gorodinski (pages 130–137), who has used the limited locations near her home in Israel to full artistic advantage. Also, see my images taken in abandoned locations, such as *Her Possession* on the following pages.

Clockwise from far left

PORTRAIT WITH LICHTENSTEIN & A THORNED BASKET OF FRUIT *2007*

This self-portrait, shot in my flat, was featured on the cover of *American Photo* magazine in the spring of 2009

A QUARTET *2007*

Shot in a friend's house, I chose an unconventional angle that would make the piano a prominent part of the image, bigger than myself. I chose some piano notes as a second prop and then decorated the rest of the frame with a multiplicity of "selves."

ON THE ROCKS *2007*

I hid in and around the rocks for this multiplicity image, shot with help from my partner Matthew on Shoreham beach in Sussex, UK.

Further afield

Going away on holiday is a perfect time to explore new scenery. When I visited the Palm Springs Photo Festival in 2009, I had the opportunity to drive to locations like the Grand Canyon and the Hoover Dam, and shoot self-portraits in Death Valley, as you can see on pages 44–45. Locations like these are a world away from the kind of places I have access to in the UK, so take advantage of what you find when you are abroad, and do some research beforehand in order to plan your trip and shoot in the kind of locations that interest you.

The Escape (page 79) was shot at Lake Crescent near the Olympic Peninsula in Washington, USA. My boyfriend and I hired a boat for an hour and rowed out to a bank where we collaboratively shot a series of multiple images of myself going to and from the boat. The result was one of my most popular limited edition prints. People comment on the use of stark red against the beautiful backdrop.

While you are on holiday, try shooting in your hotel (or wherever you are staying). Depending on the quirkiness of your accommodation, you have the instant advantage of a new, private environment. My image *Breakfast on Bed* (page 32) was shot in a country hotel in Pembrokeshire, Wales; and *Washed Up* (page 83) was shot in the Hotel 1000 in Seattle, USA.

In the next chapter I look at how post-production compositing can be used to enhance your locations and bring together shots taken in different contexts into one final image. This is how you can make use of images of beautiful scenes that you might have taken on holiday, which you later incorporate with a self-portrait to make it look as if you shot yourself in that environment. It can be tricky, but it is an option to consider.

Seeking locations

As you start to become more confident and intent on your concepts, you will likely want to actively pursue new locations. Photographers naturally find themselves on a perpetual location scout and you will at some stage need permission to photograph in a chosen location.

It must be said that there are certain legal issues, some rather gray, with regard to shooting in public places. There are numerous news stories about photographers being stopped, questioned and even searched, when doing something as simple as taking pictures on the beach or on the street. It is important to check what the legalities are in your country and to be aware of potential situations where you might be viewed with suspicion, even if the notion seems absurd. You should certainly be careful when taking pictures on private grounds (most stately homes, for example, either ban or inhibit pictures being taken inside the building), so don't shoot unless you know the rules. Depending on the place, security will often be happy with

your actions provided they are not distractive to other people, or that the results of the shoot are not directly commercial. If photography is prohibited, however, and you go ahead and shoot, you may find yourself asked to delete the images—so avoid a sticky situation and check beforehand.

However, I want to encourage you to be confident enough to gain access to locations at least in cases where it is clear whose permission you need to seek. You might spy someone's shop or cafe, for example, as a photogenic scene. A simple request will likely be worthwhile. I shot my self-portrait *Pink & Read* in a book store after asking the owner. Don't feel embarrassed or reluctant, just because you are shooting pictures of yourself!

Advertise the fact that you are looking for new and interesting locations. The general manager of a hotel in Eastbourne in the UK contacted me through flickr offering me the use of the hotel for my self-portraits. The hotel became the location for *Their Evening Banter* (pages 80–81), as well as *The Balcony Breeze* (page 21) and *The Dance* (page 59).

For my image *Joyride* (above right), I asked the owner of a carousel on Brighton's seafront if I could pose on the fairground ride while it was static, which resulted in one of my most colorful self-portraits to date. *Her Possession* (far right) is a collaborative self-portrait I shot in an abandoned mental asylum in Hellingly, East Sussex, UK. There is a whole scene of devoted "urban exploration" photographers (or UrbEx for short) who explore derelict buildings as photo locations, and there are many sources on the web for finding them, wherever you live. Make sure you get permission if you can and take care in potentially dangerous structures.

The Final Girl (page 39) and *The Bus* (opposite) were shot in a ghost town that my partner and I stumbled across by accident, near Jerome, Arizona, while we were traveling. We found that the place had a paying entrance, and was in fact a real tourist attraction, though it was very obscure. There were so many "props" available that we didn't have time to use them all. I used the clothes I had in my car and rubbed mud on my legs to create a horror-victim look.

Clockwise from above

JOYRIDE *2009*

This self-portrait was shot on a carousel in Brighton, UK, with a Phase One 645DF medium-format camera with a P40+ digital back. Part of the post-production involved changing the name of the horse from *Gemma* to *Fear*, as a twist on the idea of a pleasant funfair ride.

THE BUS *2009*

Shot in a derelict scrap yard in Arizona, I used the large vehicles prominently in the frame to menacingly dwarf the figure of the victim-like "character" I was playing.

HER POSSESSION *2009*

This was shot in an old laundry basket in an abandoned mental hospital. I wore gowns that I bought from a thrift shop and held a teddy bear as a prop for the narrative of the image.

PINK & READ *2008*

I had planned to shoot in a messy book store cellar, with books strewn over the floor, but the owner had tidied it up before I got there. I decided to use different body "shapes" on the floor in front of the towering shelves of titles.

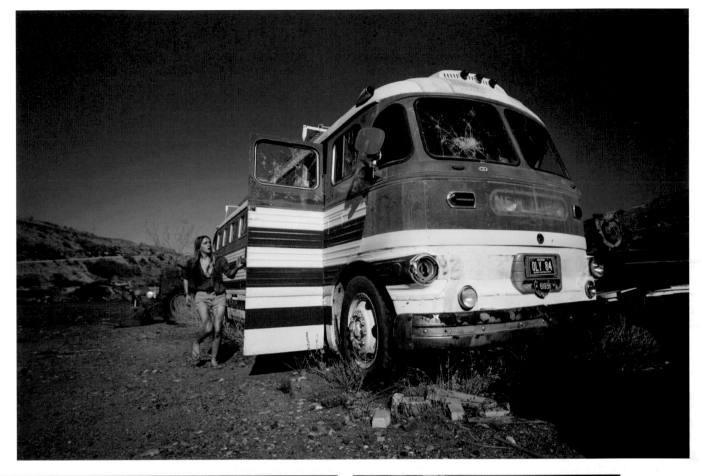

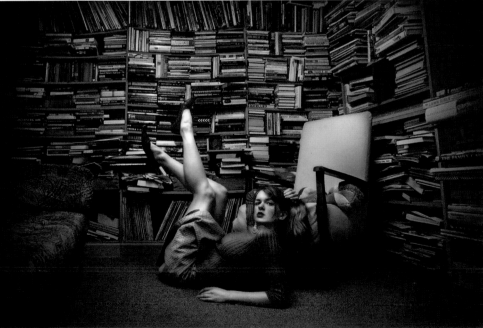

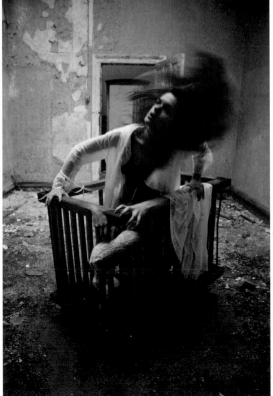

SHOOTING IN DEATH VALLEY

I shot this series of images in Death Valley, one of the most famously hot locations in the world. My partner Matthew and I were traveling around the US West coast after attending a photo festival. We headed out from our hotel in Las Vegas early one morning with the intention of shooting collaborative self-portraits.

It is always difficult, even if you are in an amazing location, to know exactly what to do with the scenery unless you have a specific plan, commission or brief. With my self-portraiture, I seldom have a fixed plan, which leaves me open to experimentation, but also occasional frustration over the number of possibilities. When traveling, this tendency can become even more problematic because of time constraints in any one particular area you visit, unless you make a repeat trip to a certain place to pursue a concept. Fortunately in this situation, I had the preconceived notion of shooting images that were themed on the spine, or at least that used the spine in a visually arresting way. The sweltering, deserted location of Death Valley was a perfect scene, both pragmatically and artistically, to stage this series of nudes.

I posed in various ways against the landscape, curling myself around a rock for some of the images, and sitting upright on top of the rock in others. At the time, I wasn't fully certain about the concept: how I would title the images, how each specific one would be processed, and so on. We took as many images as we could before moving on.

On my computer back home, I was able to work through the images and determine which images had the most impact. The images did not need a great deal of post-production because of the strength of the location. I added vignetting, and adjusted Curves to boost both color and contrast in the images.

For *A Part* (right), I clone-stamped out a section where you could see my hair on top of my shoulders. I decided that I wanted the figure to be pure flesh and bone, with no hair visible, as if it were a sculpted formation. I also noticed that I had a couple of scratches on my back, but instead of clone-stamping them out, I decided to accentuate them and add more. This is where I started to create a narrative for the image, and I gave it context by juxtaposing it with a poem themed on the loss of "parts of me"—the loss of three family members when I was a child.

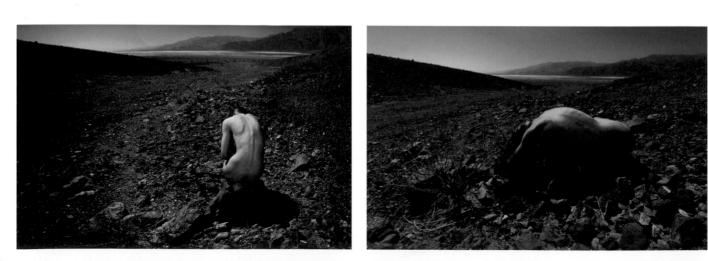

Clockwise from far right

A PEACE (ii) 2009

I kept my hair visible in this image so it became more of a literal study of a figure in a landscape, compared to *A Part*. By breaking a rule and centering the figure in the image, I feel that the sense of scale of the desert is emphasized.

A PART 2009

These images were shot with a Canon 1DS Mark III and a 16–35mm *f*2.8 L II USM zoom lens. I slightly rotated this image to make the landscape straight, and boosted the saturation.

THE ARCHES 2009

For this image I was actually sitting on my jumper, to protect myself from caterpillars and sharp rocks. I edited out the jumper in Photoshop using the Clone-stamp tool, taking care to keep each cloned rock looking unique against the others.

A PEACE 2009

I liked the twist in the body of this shot. I processed this image a little differently from the others, with tonal adjustments in Curves to make the scene look colder. I also slightly distorted the landscape using the Warp transform tool, to subtly curve the path leading out to the mountains.

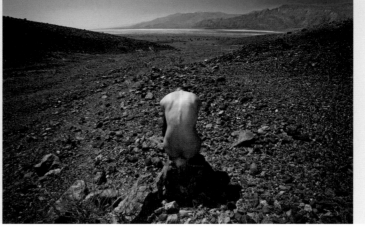

PLANNING A SHOT

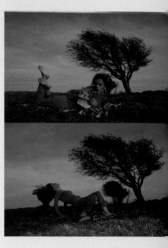

This is where we think holistically about our equipment, styling and location. The equipment we use will influence how the shooting is done: if we have a remote, for example, we will be able to shoot more images quicker, and further away from the camera (within limits). Our styling, from clothes to makeup, will dictate the artistic direction of the shot, while the location will have both esthetic and practical considerations.

It is interesting to look at the way different artists work and to observe the way their habits change over time. Each contributor in Chapter Five recounts his or her own journey and how they have approached self-portraiture; some are more methodical with their planning than others, and some have tried to tighten up their attention to forethought over time. All of them have learned to embrace a little spontaneity.

Your shooting will always be driven by a desire: what has inspired you to pick up the camera? Self-portraiture is often very personal and you may find that you are motivated to address an issue that is happening in your own life at the moment, even if the outcome is somewhat more "universal" and relevant to anyone. Is there a theme or topic you want to address that may not be so confined to your own life in terms of relevance? For example, you may want to draw people's attention to topical issues that you are passionate about. Making notes about what is on your mind can be helpful, especially if there are a lot of things buzzing about your brain that you can make clearer on paper before you start shooting.

Many photographers find sketching useful—even those who can't draw very well! Sketching out an idea, be it a simple stickman diagram or an elaborate storyboard (depending on your skills and patience) is a good way to get thinking visually as soon as possible. It does, however, require you to envisage something about your composition before you have got into the shooting, and therefore, to know something ahead of the shoot. Even if you don't follow your sketches, it can be a good way to get your ideas moving.

Once you are in your location, with your equipment, and your necessary styling all ready, how do you go about shooting yourself? I start by reviewing the scene and looking through the viewfinder of the camera to really establish what I want to shoot before mounting the camera on a tripod (assuming I am not in a situation where I have propped my camera on the floor or against an object). Thinking about your distance from the camera is important in self-portraiture, otherwise you might end up with headless shots or images that are out of focus. With digital cameras, it is easy to fire off some test shots to guide you into an appropriate position within the frame, without wasting resources as with film. If you are working with film, you will need to think ahead about your position, as you won't be able to check the result until after the shot has been taken. I also use these initial test shots to get a feel for the mood, the light, the color, and decide whether there is something of interest that will keep the shoot going.

Using the ten-second timer, the process can be slow walking back and forth from the camera, so a remote is recommended for keeping the pace. However, you still need to return to the camera to check the results that will inform the next shot, and you may well find that even if you have an intended direction, you can't just tweak it slightly for the subsequent shot—the next photo might be completely different. If you want accuracy, you have to work hard on being able to replicate exactly where you were positioned in one shot, to be able to tweak one aspect for the next. This is where tethered shooting can come in extremely handy.

If you want to manually focus your images, you will most likely need someone to assist you, so you can position yourself in the shot first. I recommend auto-focusing, so that you can do the job of focusing the lens on yourself while you stand in the shot. That is, of course, if you want to be in focus. If not, then you can manually focus the lens to whatever focal point you desire, provided that the object is already in the frame, and then step into the composition. Not everyone likes to use auto-focusing, but I have found it absolutely necessary for independent and accurate self-portraiture.

Due to the trial-and-error nature of shooting self-portraiture, how do you know when to stop? I would

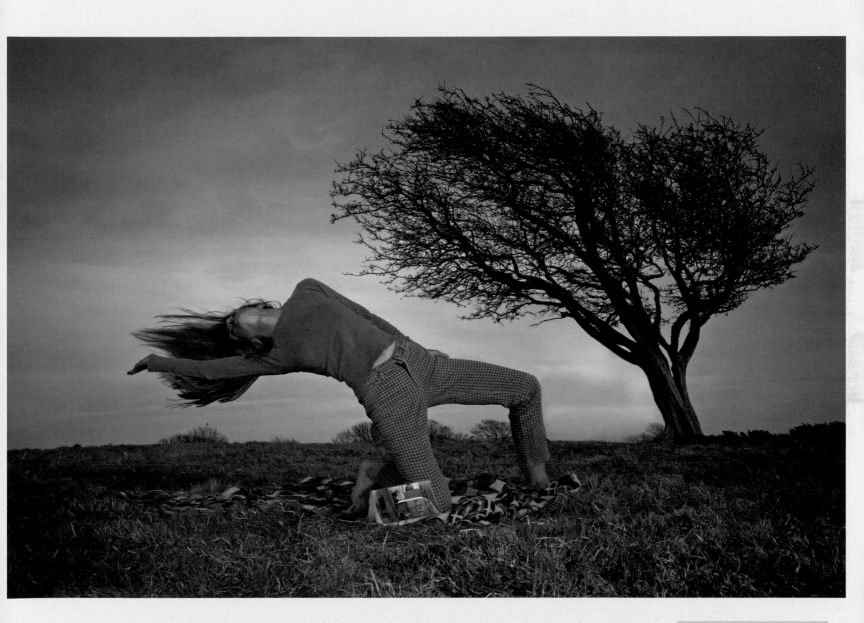

recommend that you keep going until you have at least a few shots that interest you, but it entirely depends on the context. If you're in a faraway or obscure location or have spent a great deal of time on preparation, you will naturally want to get as much as possible from the shoot. However, I always find it easier to work with fewer shots, as you are clearer on the options and possibilities when it comes to the selecting and editing stage. Fewer could mean ten rather than 80, or 50 rather than 200. I either stop when I'm fed up or tired, or when I know I have a shot complete in-camera that excites me beyond belief (a rare

occasion—examples include *Life on the Downs* on page 65 and *The Dance* on page 59). The selecting and editing stage for me, however, is most often the time when I can decide whether a shoot has been a success or not. Even the obvious difference between the way images look on your camera's LCD screen compared to the computer screen can drastically alter your impression of a shoot.

THE ADJUSTMENT *2009 (above)*

This is an example of a self-portrait that I feel is more concept led than the vast majority of my images, and yet the shooting process was somewhat unexpected, and led predominantly by my eye. I chose my outfit, props and location, and had the themes of the spine and chiropractic in mind, but did not know what I would eventually produce. I allowed the spirit of the shoot to guide me into creating an array of poses *(right)* until I started to observe a synergy between the tree and myself.

POSING

AN IMPROMPTU PERFORMANCE *2008*
(left)

In this image I performed a series of
jumps under low light in my corridor
at home. Combined with the outfit I
had chosen, it suggested dancers caught
in a frame, like a Degas painting. The
streaked motion effect of the dress was
achieved in-camera, but the composite
of three characters was put together in
Photoshop during post-processing.

Self-portraiture is a way for you to practice photography skills, and try out ideas without anyone else's intervention or help, but it will also be a modeling experience—voluntarily or not—and require you to think about the presentation of your body and face. For many people it is a great way to begin to understand how various poses and expressions work in a photograph. It is also a significant time to learn more about ourselves as individuals—not merely how we might look from a certain angle, but understand how our whole outer "self," most always arcane to us, actually appears to others.

Your reaction to the experience of continually seeing yourself in images may well determine how long you pursue self-portraiture for, but don't make the mistake of thinking that enjoying self-portraiture makes you vain. I take hundreds of images of myself that I dislike. I don't discard most of them, I simply file them away and later I might look through them again and think differently (I do recommend hanging onto all your images).

When it comes down to it, for me posing is one of the most difficult aspects of shooting an image. I may have a superb location, a quirky outfit, luscious natural lighting and even a particular concept in mind—but a bad or clichéd pose can kill the whole set-up. I have a problematic relationship with posing as I always want to strike a balance between a position that is dramatic enough to be interesting, but not so contrived to the point where the image crosses the line into a kind of gimmick, or dressing-up game where meaningful concept is lost, and the viewer is made all too aware of the mechanics behind a scene. I want to act, but not travel too far from the real "me."

Aspects of posing: Male and female

Speaking generally, we are conditioned to take on either masculine or feminine traits. It is fair to say that in the nature of gender roles, there are some limitations for men insofar as how creative they can be with their appearance while also keeping their masculine identity intact, and also, that women face a problem in trying to challenge their conditioned role as object of desire in a photograph, to overcome the feeling of posing for the "male gaze" of the camera. As a woman myself, I regularly feel frustrated at how to perform in front of the camera in a manner that is not clichéd and superficial. I try to avoid overusing hackneyed poses, and instead, to appear dynamic and active. For example, in *Sea View* I wanted to add an edge to an otherwise feminine pose. I wanted to look out of the window, but in a confident and expressive manner, rather than one of passivity and melancholy. By raising my arms I felt I added a certain empowerment to the shot, and the movement also tensed the muscles in my body to appear a lot more interesting visually. In Photoshop I added reflections of myself in the glass of the window.

Dynamism

By introducing action into my poses I also feel I can steer away from the usual gender-related clichés. However, I also recommend the use of movement whether you are a man or a woman—it's a fantastic way to make your images instantly more animated. Whether you are slightly tossing your hair, moving your dress or jumping straight into the air as in *Hurricane Ridge* (above far right), movement at its most subtle can transform a stiff pose into an interesting one, and at its most dramatic, can make your shooting experience an experimental lucky dip of otherworldly captures. You will need to pay attention to the lighting and choose an appropriate shutter speed to be able to capture as much detail as you need, but don't overlook the stunning effects you can get when you shoot in low light, achieving motion blur. In my image *An Impromptu Performance* (above), I jumped up and down in my hallway, in low-key ambient light, to achieve ghostly, dancer-like action within the camera. Images like *The Dance* (page 59) show where I have used movement combined with nudity to achieve a pose that is dynamic, but static enough to appear more like a frozen, "sculpted" movement suspended in time. Action can give you something to do in an image. In most of my self-portraits I am preoccupied with doing something, and the more extreme you can make the action the more convincing the performance will be.

HURRICANE RIDGE *2008* *(right)*

Jumping up into the air at Hurricane Ridge, Washington. I caught myself frozen mid-air by setting the appropriate shutter speed, which here was 1/320 of a second. My partner Matthew triggered the camera for this image.

SEA VIEW *2007* *(below right)*

For this self-portrait, taken in my sister's room, I did not have a tripod so I had my sister hold the camera in position where I wanted it. I set off the ten-second timer and posed for the shot, having to later crop the image as the framing was slightly askew. The image turned out to be my best-selling limited edition print.

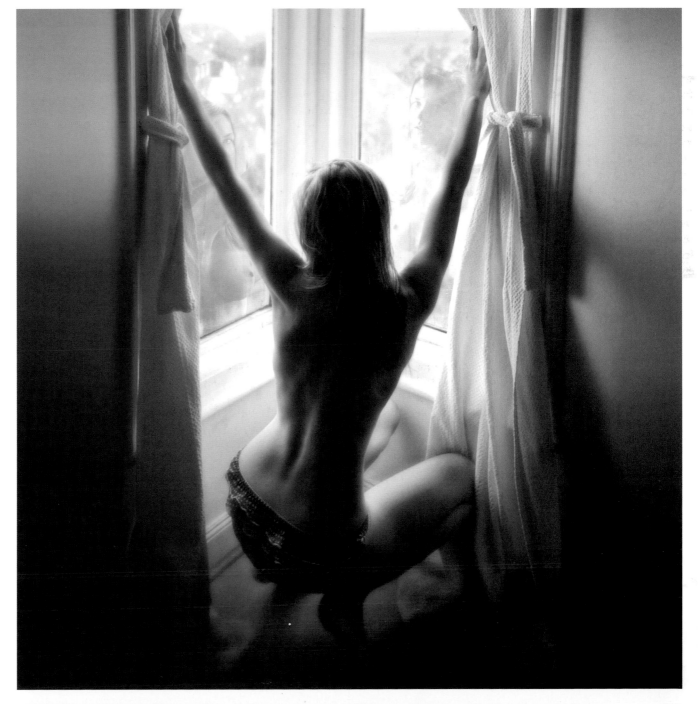

Clockwise from top right

THE DARK CONTINENT *2009*

Posing for a series of horror film-inspired images with help from my partner while traveling in Arizona—these collaborative self-portraits were taken in a ghost town scrap yard near the town of Jerome.

SOJOURN *2009*

Sometimes the most dramatic poses are the most convincing and therefore the most powerful in terms of visual impact. Throwing one's head back can result in arresting shapes. Using a remote shutter, as seen in this image, can also help.

CORAL SUNFISH SORTS *2008*

In a hotel bedroom, I angled myself so that the light from the window illuminated my face and body without creating a silhouette. By pushing the curtain towards the window, rather than just to one side, it shielded me from receiving harsh direct light.

IN ALL THE COLORS OF THE FLUSHING YEAR *2008*

Out of the various poses I did in this shoot, which included sitting on the ground and walking into the distance, this pose worked the best as a "shape" in the composition. The triangular shape of the pose of my arms and my legs gives the image depth, leading the viewer's eye along the winding path and curves of the trees.

Making shapes

In All the Colors of the Flushing Year (opposite, below left) proves that a good location is not enough. This spring scene in the south of Wales was absolutely breathtaking, and I naturally wanted to add a human element in the form of myself. However, what would I do? I wanted to complement the scene, not distract from it. By turning my head away from the camera, I let the viewer take in the beauty without being engaged by my gaze—the shape of my arms and crossed legs gave a tilt to the composition. I posed intentionally under the dappled light in order to obscure my face slightly. In *Sojourn* (opposite, below right) I have thrown my head back, which helps create balance in relation to the position of my legs. This action, more suited to women, can create a sensual feel to images that works in certain contexts, but can look melodramatic in others. The only way to know whether it works or not is to try it out.

To smile or not to smile?

In most of my self-portraiture I am not smiling, and while this is personal taste, it is a common decision across the work of many artists, and not just self-portraitists. If I were to try and pinpoint reasons, I would suggest that the image of a smile is most associated with images in advertising or in stock photography, where the mood is simplistically conveying the notion of everything being ok. I find that my motives for producing self-portraits often come from negative feelings or desires to change or challenge something; hence, the possibilities for different narratives are opened up. *For Tatuś* (page 73) is one of the rare occasions where I found it appropriate to smile and to act almost elated, as I felt that it suited the message of the photo, which was in commemoration of my late father, and almost a message to him. There is no right or wrong and it really depends on your intentions, narrative and your own emotions.

Where to look?

Gazing into the camera lens can give a certain mood or message, and often a powerful and confrontational edge will be created, for example, in my image *Dear Gourd* (page 74). However, sometimes it can disrupt the fictional setup in an image and give the sense that you are engaging directly with the viewer and thus making their presence overt. Looking away from the camera can suggest a more complex and voyeuristic narrative on the part of the viewer. Choosing to obscure your face can work on a different level altogether and be a powerful way to disrupt the viewer's conventional instinct to search for eye contact, which is exemplified in my image *Don't Look Now* (page 71). Incorporating props, as well as action into your images, can often solve the problem of "what to do" in an image. On the following pages this is discussed in more detail.

"Multiplicity" is a term used to refer to photographs that feature more than one of the same subject within the same frame. It allows you to adopt different poses within one setting, thus creating a variety of poses within one image. Technically this can be simple to achieve, but it can also be a complex exercise in formulating a composition that works effectively. On pages 76–81 you can read about the technique and the ways in which I have employed it in my own photography.

How I posed for *The Dark Continent*

Putting yourself into an acting role can transform your images. Along with a superb location, a hint of makeup in the form of some mud on my legs brought the styling edge to this shot, as well as to *The Final Girl* (page 39) and *The Bus* (page 43) from the same shoot. There were lots of broken-down vehicles in this ghost town, which I imagined this fictional character would hide behind, in a chase scene typical of a horror movie (this location is in reality being used as a set for horror films). The main difficulty I faced was in trying to make the scene, which was brightly lit with afternoon sun, look menacing and gloomy. Some shots looked too blue-skied to elicit the kind of mood I wanted to convey, however, the strong light did mean that we were able to shoot the images without having to use a slower shutter speed or larger aperture than normal, and the sense of "action" could keep its pace. The lens flare in this image was achieved naturally by positioning the camera at an angle to create the flare with the sun's glare over the top of the car. These images, which to me are slightly reminiscent of Cindy Sherman's film stills, are some of my most histrionic self-portraits.

I did feel at the time as though my images were merely replicating clichés of the girl victim from a horror film, but the images are much more powerful to me in retrospect. This is probably because I no longer take the location for granted as I might have done when I was there: the photos have taken on more impact through time. This is a point worth remembering—although you might be at a great location and be wondering what you can do with it, sometimes it's possible to have too much expectation, and put too much pressure on yourself, to perfectly combine location and human element. Certainly, your audience will not take the location for granted; its impact will be greatly increased just by the sense of surprise the image has for them. My images taken in derelict mental asylums (see page 43) and a school are also good examples of this situation where I may have been stuck for an idea at the time, but later realized I was undermining the impact of my efforts.

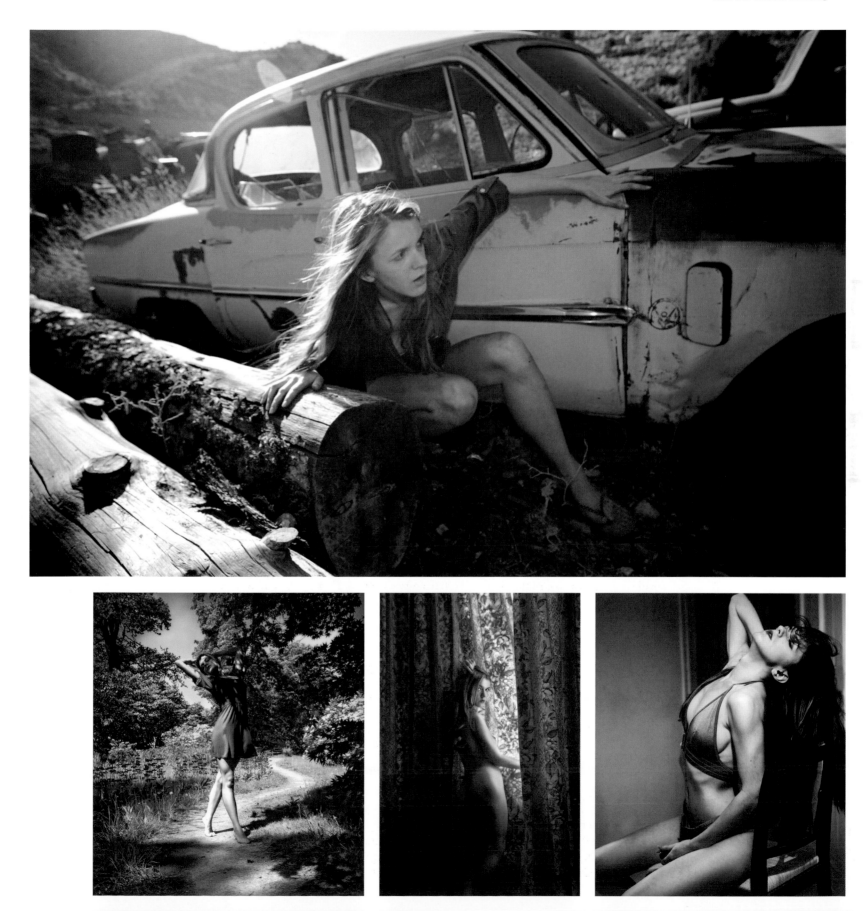

SHOOTING WITH PROPS

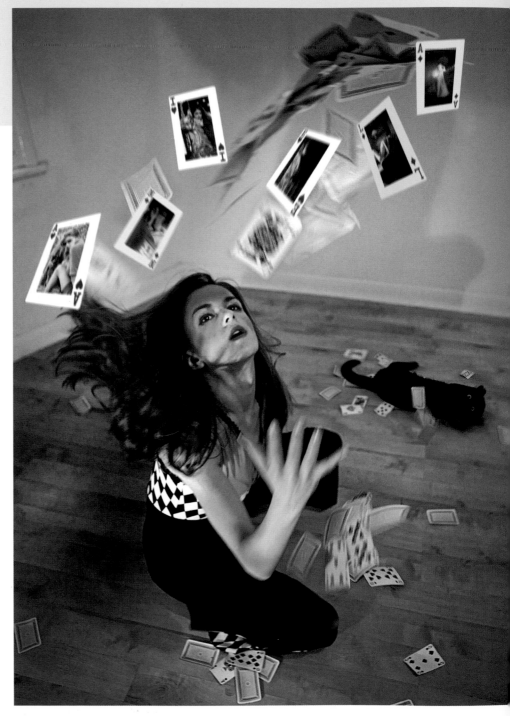

IT'S UP *2010*

In this image, the playing cards were a prop with which to occupy myself, as well as esthetic decoration. The theme behind this self-portrait was the launch of my new website, hence the title.

Using props in your self-portraits can significantly strengthen your ideas: for the posing, styling, and indeed the entire content of your self-portraits. Often if you are stuck for ideas a prop can spark the imagination.

Props can be part of the styling, as with jewelry and accessories (see *Party Pieces* on page 37); they can be a feature of a particular location (such as the broken down vehicles in *The Dark Continent*, page 51, or the carousel in *Joyride*, page 42), or they can simply be everyday items in your own home (see *Portrait with Lichtenstein & a Thorned Basket of Fruit*, page 40). If you are in a hotel room or a friend's house, take advantage of the things you see around you—such as the piano and music notes I used in *A Quartet* (page 41), the tray of breakfast items I put together in the hotel room for *Breakfast on Bed* (page 32), and the telephone and lamp you see in *Dial M For* (opposite).

For *The Adjustment* (pages 46–47), I began planning my shoot by selecting an outfit and two props: a blanket and a book. Not entirely sure of what I would do with them, the only thing tying them together initially was the color scheme. The title of the book, *The Way of all Flesh* by Samuel Butler, turned out to have a profound link to the final theme—the spine, life and mortality. For my image *For Tatuś* (page 73), mushrooms were the prop I chose for an image that would be dedicated to my Dad.

Post-processing enhancements

For *It's Up* (right), I incorporated a pack of playing cards, catching them in motion by flinging them into the air with one hand, while I pressed the remote shutter with the other, hidden hand. It was a challenge to achieve the final composition I wanted, but I exaggerated the effect in Photoshop, by taking cards from one image into another, and then layering a series of six strategically-placed cards across the top half of the frame. I transformed, motion-blurred and color-balanced them, to make them blend in with the rest of the image. This image is also an example of featuring animals in your self-portraits: my cat BB appears in the background. I talk more in depth about making moderate compositing changes like these in Chapter Four. *The Manifestation* (opposite) is a self-portrait I shot with

DIAL M FOR *2008* (left)

Here I posed in low-key lighting in a hotel room, inspired by the films of Hitchcock. The telephone and lamp became the central props.

'NOTHER DOG! *2006* (below left)

Animals, though animate, can be thought of as props. I held the camera at arm's length for this shot with my dog Nyoop. It can be very difficult to shoot with animals in self-portraits, and even the most obedient animal can be erratic in their behavior in front of the camera—however, *It's Up* shows how compositing can be used to achieve the final shot with both you and the animal in it.

THE MANIFESTATION *2008* (below)

The props here were simply trinkets and oddments selected from around my home. I put them together as a set, giving me a context within which to pose, and also something to physically focus on, giving purpose and intrigue to a fantastical self-portrait.

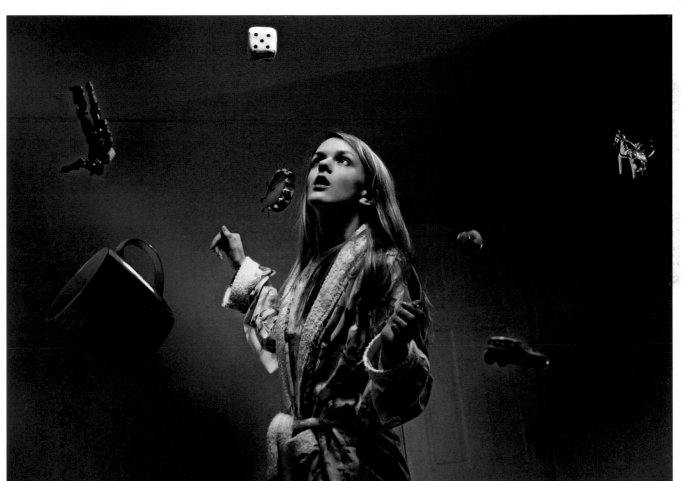

assistance from my partner. In this image a variety of household props are floating surreally in mid-air around me. These props, which included a mug, toy figures, and a furry car dice, were actually suspended from the ceiling by fishing wire. This was the same shoot that produced *The Adrenalin* (page 84). The props formed a basis from which to start, in that we actually created a "set" that subsequently framed the portraits. Starting with the props or the set in this way, rather than advancing straight into spontaneous shooting, can be an excellent way to solve frustration or lack of ideas for poses. It does require more forethought and planning, but this shoot, which took at least two hours of preparation, was well worth it.

Preparation for a shoot could include investing some time into constructing your own props from discarded objects or material from craft shops. It is excellent practice for thinking strategically before embarking on a shoot, however you will still be able to improvise and allow for spontaneity when working on-shoot with your creations.

SHOOTING
IN LOW LIGHT

Using low light can be a fascinating way to transform your shooting experience and the resulting images. My earliest low-key lit work was inspired by Italian artist Caravaggio, whose work was influential during the Baroque period of art, and epitomized the technique of *chiaroscuro*, a style of bold contrast between light and dark. The suggested light sources in his paintings would often be candles, torches, or shafts of light coming through cracks and windows. Using similar improvised lighting methods can be a great way to shoot haunting images especially if you don't have much access to professional lighting equipment. Additionally, if you're limited with locations, using dramatic low-key lighting can be the answer to differentiating one image from the next.

We Three and *They Gathered to See* (opposite) are two examples of (multiplicity) self-portraits shot in my flat, but which have no specific reference to their environment other than to use the dark space as their setting. *They Gathered to See* was simply shot with the illumination from my bedroom light fixture, while *We Three* was shot with candlelight in the dark hallway. Both were shot on a Sony R1 with ISO 400. Inspired by the short stories of Edgar Allan Poe, I shot *Disturbed* with a candle alone, in a room that was almost completely dark, which resulted in dramatic shadows on the ceiling and wall.

The Aura was shot on a beach with my partner's help. This was a particularly memorable shoot for me because I brought along a torch to use as an experimental lighting aid, with the light from my car headlights as a secondary source. Ideally I would have arrived earlier to capture a little more light from the setting sun. The slow shutter speed captured the ghostly movement of my hair and gown in a manner that was not technically conventional, but very arresting. I shone the torch straight at the camera, which produced a flurry of natural lens flares around me. In post-production, I edited together parts of my body and the lens flares to get the ideal final image.

The Shape of Light was lit simply with a small bed lamp tilted on one side. This image was made up of two shots which I "mirrored" side to side in post-production, merging the two walls into each other to become a central pillar. This was as a result of shooting unplanned "clone" images—read all about the multiplicity technique on pages 76–81. I also dodged and burned this image to achieve the glow and shine on the limbs.

Technical issues

If you are shooting in very low light, you may have trouble auto-focusing your camera. It will need sufficient light to be able to focus on you, otherwise you will be forced to use manual focus, which may require an assisting hand to keep the focal point on you.

One of the biggest issues with low-light images is digital noise. This may not be apparent until you print an image. To avoid disappointment, make sure first of all that you do not stretch the limits of a picture to an unfeasible level, and if you do, sufficiently de-noise the image in Photoshop. You can also darken the image with Levels, or use the Blur tool. It may be best to mark out an area as a new layer and work on it independently to the rest of the image. To avoid noise to start with, you need to shoot at a lower ISO, which means opening the aperture, slowing the shutter speed or introducing a stronger or second light source.

Another problem I constantly battle against in low-light images is banding, which is a color compression problem giving an unflattering array of boxy pixels in areas of an image. This can be reduced in Photoshop. First, add a moderate Gaussian Blur on a new layer. Make another new layer, and in the Layer options, choose Overlay, and tick *Fill with Overlay-neutral color (50% gray)*. Add noise to this layer (Filter > Add Noise, selecting *Uniform*) and choose a level that is appropriate to obscure the banding without introducing too much noise into the image as a whole. Of course, it is not desirable to have noise in your image either, but meticulous tweaking with the minimum addition of noise to cover the banding will achieve the right balance. You can then use a soft eraser to reduce the blur and noise in parts, sufficient to cure the banding.

Clockwise from right

WE THREE *2007*

This Christmas-themed self-portrait is made up of three separate shots, which were composited together in Photoshop. Lit only by the candle, it was surprising that there was barely any noise on the faces. Noise elsewhere in the image was reduced in Photoshop.

THE AURA *2009*

A haunting spectre shot at night on the beach with only a cheap battery-powered torch, and the headlights from my car. This was shot with my Canon 40D.

THEY GATHERED TO SEE *2008* (top)

This is one of my most Caravaggio-inspired self-portraits, where I wanted to use low light dramatically on the surface of my skin. The degree of darkness made it easier to merge the seams of the individual images afterwards during post-production.

DISTURBED *2008* (bottom)

This was shot with a candle to my lower left, which resulted in harsh shadows over my body, face and the wall behind me. I wanted to create an unnerving atmosphere, as if I were a character in a thriller story.

THE SHAPE OF LIGHT *2008*

In this image I wore a skirt as a "dress." The outfit here was instrumental to the glow achieved in the final image, demonstrating how white clothing can significantly complement a low-lit image.

Clockwise from below

WHAT THE MIRROR TOLD *2007*

This was shot in my bedroom, with the camera angled into a mirror to create a different vantage point than that which I am used to shooting in this room. I added both the mirror frame and the red lamp from stock imagery.

NIE JESTEM SAMA *2007*

This self-portrait was shot into my bathroom mirror. I was able to press the shutter while posing, by angling the camera at my hip and shooting upwards into the mirror.

ABOUT TIME TOO! *2006*

I shot this timer-controlled self-portrait into a mirror, but decided to keep the shadow of the camera as part of the scene, to throw up questions about the gaze of the viewer. The notes on the wall show how to tell the time in Polish, which ties in with the image's theme: celebrating happiness after a period of sadness.

SHE WATCHED FROM THE CORNER *2008*

Here I used a hand mirror as a prop and also to reflect my gaze back toward the viewer. I posed in the corner of a room and later applied the vignetting in post-processing.

USING MIRRORS

The mirror has always been an invaluable tool for self-portraitist painters in order to recreate their own likeness. For the photographer, while the camera acts as its own highly-technical form of "mirror" to physically record the artist's image, a mirror as a prop can be useful to help the process or to make it more creative.

Preparing for a self-portrait, a mirror can be used to style appearance and practice poses and expressions you plan to use. It can also be used to facilitate the shot itself. At its most simple you might shoot directly into the glass. By positioning the camera at a point where it cannot be seen directly reflected in the mirror, at an angle, you can capture the scene within the mirror, either close or from further away, with a perspective that may not be achieved had the camera been positioned to shoot the scene conventionally. This is how I shot the two photographs in the clone composite *What the Mirror Told* (right). This technique managed to give a depth to the scene that wasn't possible in the restricted size of my bedroom. The slightly smudged surface of the mirror created texture, while the gold frame was added in Photoshop. *The Jitters* (page 85) was also shot into a mirror in a similar fashion.

In *Nie Jestem Sama* (Polish for "I am not alone," taken after the death of my grandfather), I shot into the mirror from bottom left, and allowed the flowers to come close into the shot on one side. I felt that this method worked well as it gave a sense of voyeurism, as if someone was peering in on my own private introspection. It also worked well as a practical method, because I was able to watch my expression closely as it was shot. The picture has a secondary mirror element if you view a larger version of the image: there is a mirror in the background, in which appears a faint image of my grandfather and a gravestone with the name "Aniela" on it (from a photograph taken of the grave of an aunt, whose first name was Aniela).

She Watched From the Corner incorporates the use of a small, antique hand mirror to reflect my eyes back towards the viewer. For other examples of the creative use of mirrors in the work of self-portraitists, see Joanne Ratkowski on pages 122–129.

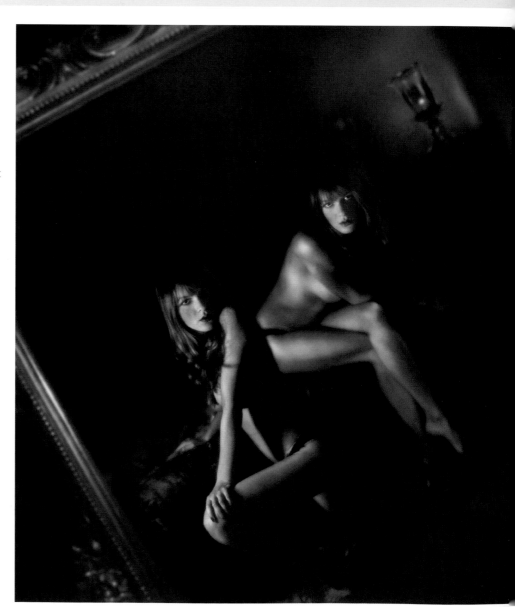

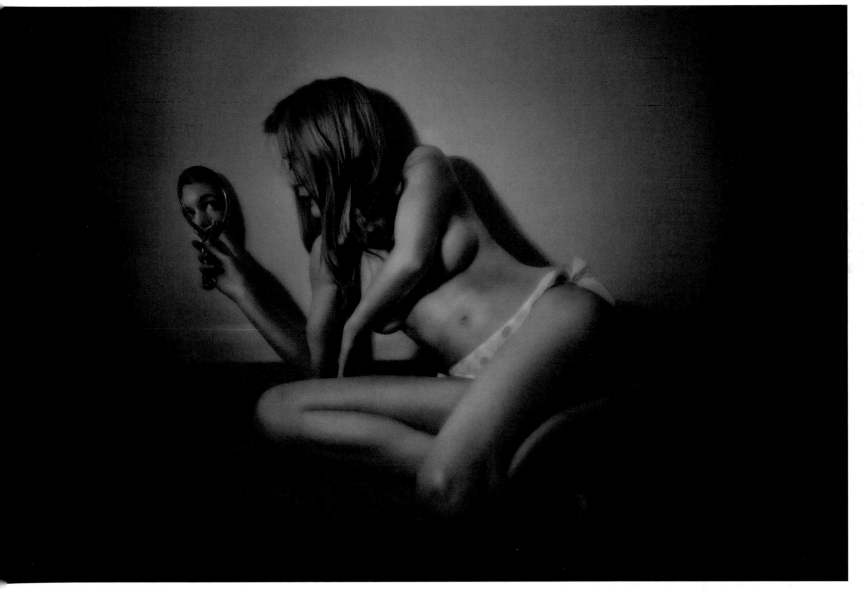

SHOOTING NUDES

The naked human body is a beautiful form, and whether you are a man or a woman, bearing all for your self-portraiture can be a liberating step. It is not always easy to feel comfortable posing nude, even for your own, private self-portraiture—but these pages will encourage you to think about how the esthetics of the nude form can be complementary to your art.

Because our society normalizes the notion that nudity is something adult and open to censorship, it is difficult to extricate the sexual connotations from nudity. This is often because nudity, when it appears in art and the media, is most often accompanied by sexual narratives. If nudity is at once sexual, then posing nude for a portrait becomes a taboo act. First and foremost, I encourage you to try and think beyond this, and recognize your naked body as a beautiful form for photographic study. Secondly, sexual desire is an area of expression in itself and does not have to be a taboo or unsavory topic. Some of my own nude self-portraits have an undercurrent of sexual playfulness that I do not feel jeopardizes the seriousness of my work. What is important is that you express yourself in the way that you choose to—personally I embrace myself as a viable subject whether clothed or unclothed.

Nudity is just another outfit that is appropriate in some situations and not others. There have been many times where I have tried a nude pose and it hasn't worked for whatever reason, and that is when I know the context isn't right. A series of nudes that did work was shot in a hotel room, using just the light from lamp shades—*The Dance*, *The Recline* and *The Passion* (opposite). This series was very much inspired by the paintings of Balthus, whose work also influenced *Girl Dreaming* and *Girl Awoken* (pages 60–61).

I shoot nudes because of my fascination for the human form. The contours of curves and bones; the texture of skin; the suggestion of intimacy which does not have to be overtly sexual, but rather an expression of passion; and the way in which the image becomes timeless without the adornment of clothing, are all motivators to use nudity in my own work. I feel in control of representing my own body as a desirable object, and therefore challenging the other contexts in which imagery of women and naked women exist (most prominently in the media), and I also like to surprise and shock the audience with whom I share my work online.

I have always felt as if the best images from a shoot, the images I choose to take further and make into final pieces, are those where my body has taken on a particular look—different from my own everyday perception of my body. My personal preference for nude images is for those that show the subject as a dynamic and powerful form. With my own self-portraits, I have tried to represent a woman who is not self-conscious of her body. However, I also feel that subtlety is desirable. I seldom pose nude face on to the camera, instead I prefer a position that obscures my complete nakedness, where I am seemingly occupied with something else, unaware of the camera. A good example of this is *The Dance* (opposite).

There are obviously some practical considerations to make before you shoot yourself nude, primarily, the implications of location. Shooting in the privacy of your own room or home seems like the best bet, or if you have access to a hotel room or a room belonging to someone else. However, you may even seize the opportunity to shoot nude images outdoors, obviously where there is no one else around. I posed nude for my images taken in Death Valley (pages 44–45), which was a suitably deserted area.

Think about your *mise en scène* as with any other self-portrait: the location, your posing, your styling, your artistic message. A word of caution, however, about sharing your work: it is unfortunate that even the most innocent and artistic intentions for nude portraits can be misunderstood by the audience with whom you show your work, such as on photo-sharing sites (see pages 164–165). Particularly in art, there is endless debate over the use of nudity and what should and should not be censored, and if you aim to share your work online, you should be aware that most websites have strict rules on nudity. Some necessitate content filters to appropriately flag your work (such as flickr), while others do not allow it at all. Many self-portraitists prefer not to share nude photography. It's up to you though whether or not you choose to pose nude, and you don't have to necessarily share the results.

THE DANCE *2008 (below far right)*

Shot in a hotel, my decision to employ movement in this image is what I feel makes this nude a success. The shape created by my moving nude form, along with the textures and lighting on my skin, makes the image a graceful study of an active female body. I only moderately adjusted the image with Color Balance and added vignetting.

BLESS THIS MESS *2007 (above)*

This is a good example of how shapes and context "frame" a nude form in a way necessary for any successful photograph. The correlation in this image between the curve of the banana and the curve of my pose, made this image interesting to me. I thought that without the film poster on the right, the image would not have felt so complete.

THE RECLINE *(opposite)* and **THE PASSION** *2008 (opposite bottom left)*

From the same series as *The Dance* here each image was interpreted slightly differently during post-processing. For *The Recline* I cooled the image with a distinct blue in Color Balance, whereas I warmed the tones of the *The Passion*.

SHE HELD THE LIGHT *2007 (below)*

Shot at home with only the light from a candle, I was surprised to be drawn to this overtly-nude image after reviewing the results of a spontaneous shoot in my dressing gown. I liked the way the breast, face, candle, curl of hair and folds of the gown were arranged: they came off the screen with a certain depth. I adjusted Levels and added a subtle white Diffuse Glow to accentuate the image.

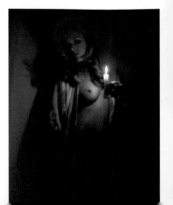

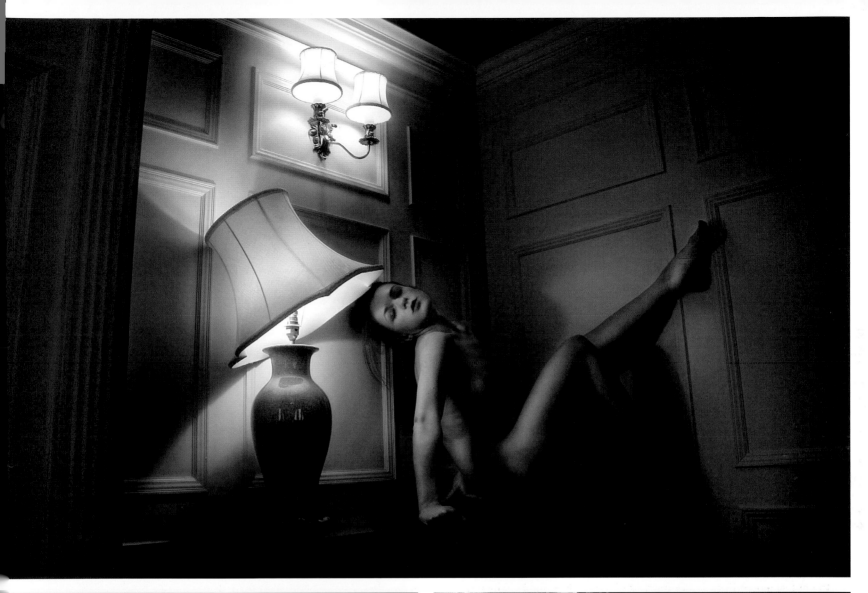

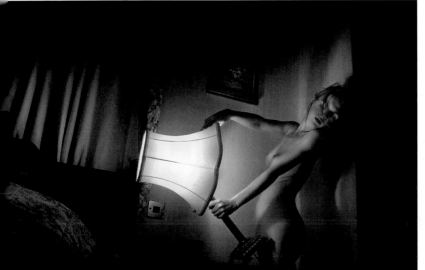

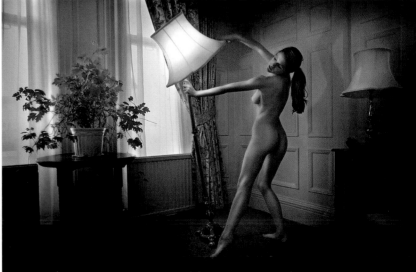

HOW I MADE *GIRL DREAMING* AND *GIRL AWOKEN*

This shoot was both an act of whimsy and also of prepared intent. I had been looking at the work of the painter Balthus, a 20th-century Polish-French artist whose work often featured nubile, female bodies splayed before beams of natural light. I wanted to produce images that were directly inspired by his pieces such as *The Room* and *Nude with a Cat*. However, I did not have any appropriate furniture in my own home to use. For my planned self-portrait to look effectively "Balthussian," I needed to find some props, or preferably a complete location, that had more of a classical look than the black leather sofas and modern accoutrements in my flat.

One day, going into my friend's empty house to take his dog out for a walk, I entered the study to come across a tempting scene: a window with its blind partially drawn, with light entering through the crack, spilling deliciously onto a plump, red wingback chair. I saw that the setting was highly appropriate for an image inspired by Balthus, so I decided to take advantage of my good fortune there and then. Not knowing when someone might come into the house, I made sure I worked quickly, so the shooting procedure itself was fairly spontaneous. I propped my camera up on a side cabinet and performed various poses with the ten-second timer. The images were impressive in-camera; the light rippled across my body delicately outlining the contours, as if I were sunbathing in one spot of sunshine in an otherwise cold and darkened room. In reality, the blind on the window was half down. I did not see until the post-processing stage that the blind looked distracting, so to remove it, I simply superimposed a sample of the bottom part of the window over the top, stretching it using the Transform tool. Because the blind was partially drawn in the original shoot it meant that the light entering the room was not harsh enough to blow out the highlights of my skin, particularly round the middle of my body. If you look at the front most leg, you will see the beginnings of overexposure, but further up my body, the shielded window saved the detail. Though this was unintentional at the time of taking the picture, I believe this is what gave the image its subtle, beautiful light.

In post-processing, I also enhanced the saturation slightly, and composited a Balthus painting (the one that directly inspired this image, *Nude with a Cat*) into the small frame at the top of the image. I also added a picture of my face into the small photograph-holder on the windowsill. I like to add these unexpected features for my viewers—especially when they buy a large print and are rewarded with surprises in the detail.

I interpreted *Girl Awoken* with slightly different processing. I cropped off the window to isolate the scene as one dark corner of a room. I forged a ray of light from the lamp, using the Paint tool, to almost look as if the image had been painted. The lighting had a stronger quality of contrast on my pose here, so I made the image bolder overall, with boosted saturation.

GIRL AWOKEN *2007 (right)*

Both of these images were shot with my Sony R1. I liked the way that my body appeared different in this particular image: voluptuous almost, a change from my slim form, because of the lighting and pose.

GIRL DREAMING *2007 (below)*

This image was shot in a friend's house, inspired by the paintings of Balthus. I covered my breast here because of the overt exposure of the rest of my body, however, I felt that it passed as a gesture rather than an intentional obscuring of my nudity.

CHAPTER FOUR
PROCESSING

There are many views on digital processing and its validity as a part of modern photography. We each have different views on what "photography" is that depend on our experiences and tastes. While some photographers believe that an image should exist as shot, and that any retouching or manipulation is against the ethic of what should be "truth" in photography, other artists recognize that an image is mediated from the outset: from the very clicking of the shutter itself.

To believe that programs like Photoshop have invented a kind of photographic subterfuge would be misinformed, as long before computer-editing programs came along manipulation of images was always possible in the darkroom. We all have our own preferences as to how far to distort an image once out of camera: one photographer might seldom use any processing at all; another may use the darkroom to develop their images; while others—this applies to most photographers nowadays—take advantage of the ease, lower cost and increased sophistication of using digital equipment and processing programs. What you will most likely find is that the best or most successful photographers are those who keep an open mind: they don't assume that all their images can come out of the camera looking like the finished product, but neither do they rely on post-production to achieve an effect. What won't work for one image will work for another. There is no simple answer that any tool or solution, whether in shooting or processing, can instantly improve an image. I believe the best artists and photographers are those who take advantage of all the tools available to them, and don't make a big thing of trying to be "for" or "against" any particular mode of production.

What you do with an image is ultimately about taste. Your own taste is the main barometer you should use to approve the direction in which you take an image. It may be easy enough to make that statement if you produce images only for your own artistic satisfaction, but that is primarily what this book is about: creating images that are first and foremost about you. In building your new skills your end goal might be to work in commercial or fashion photography, an area where you must accede to other people's demands—but to get there, I encourage you to develop your own style through experimentation.

CATATONIC *2009*

I used a fast shutter speed to freeze my movement as I tossed my hair into the air. I converted the image to black and white in post-processing by using the Channel Mixer and then adding slight vignetting.

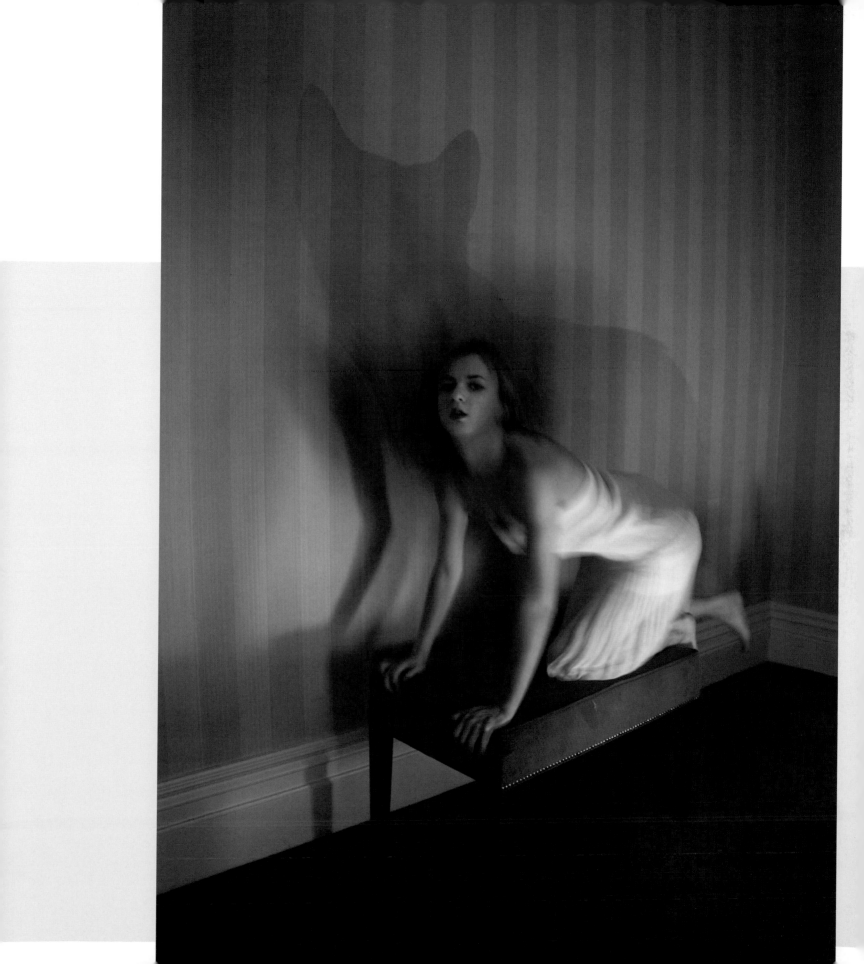

INTRODUCTION TO DIGITAL PROCESSING

I got into photography by working through digital and have never used film. The fact that I haven't yet tried film (even though I am open to the idea) exemplifies how much digital photography has allowed me to "get up and go"—to do things immediately without having to plan ahead to invest in special materials or organize access to a darkroom. As well as the magic of the digital camera itself, the appeal of digital post-processing was a key part of my initiation into fine-art photography.

However, it would be wrong to say that my work is all about Photoshop. My work uses post-processing to a degree that is appropriate for each image. Some shots will take a long time to process, whereas others are barely touched. Sometimes the "shape" within an image, the shape I look for, is there in the in-camera shot. At other times it will emerge through compositing, which is why I might

take a long time processing an image. Sometimes I might get it wrong, and after hours playing with an image I don't think the result "feels" right. That is when I know that I am trying to use post-processing impossibly, to "fix" an image that, for me, has no potential.

Though I recommend you take full advantage of digital post-processing, I also think it is wise to keep your vision balanced by appreciating the images that come straight out of your camera, and regularly looking at the photography of others, particularly work that is subtler than your own. By doing that, you are less likely to over-process your images and feel frustrated by the process. You will also be less inclined to rely on post-production in a way that can develop into a bad habit. Ultimately, you'll spend less unnecessary time on the computer, which is always a good thing—even if just for your eyesight!

Clockwise from right

LIFE ON THE DOWNS

This image is almost SOOC (straight-out-of-camera) so I consider it to be in the first category of processing—images only slightly tweaked. Some adjustments were made to the Color Balance to enhance the greens and blues, and also to the Levels, to lighten the image slightly and to darken the sky. Compositionally, the final image is identical to the original. This is a commissioned self-portrait shot for a bottled water company. The hair becomes the dynamic sweeping shape dominating this image.

AT PORTLAND BILL LIGHTHOUSE

This image is not a composite, but a part of my blowing hair was taken from another shot and significant processing was done to darken the sky and to lighten the front of the image (adjusting Shadows/Highlights). I therefore consider the image to be in the middle category of "moderate" processing.

IN THE CHURCHYARD

This self-portrait is a "composite," belonging to the third category (opposite) and the highest level of processing. Here, the final image is made from three shots of myself at different points in the churchyard, which have then been combined into one image.

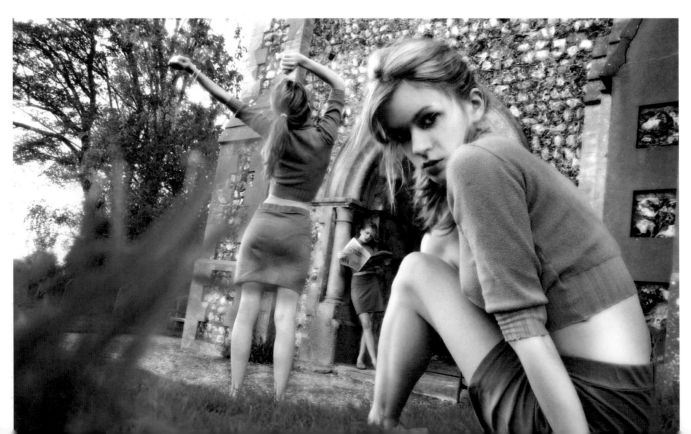

Categories

In my own work I have identified three separate categories into which my work can be placed according to how much post-processing has been done:

1 Slightly tweaked images, where the image is almost SOOC (straight-out-of-camera).

2 Moderately processed, "50/50" images where some manipulation has been done, but the original shot and final image are equally important to the artistic result.

3 "Composites"—a layering of several images where the result is drastically different from the original shots. Multiple photos are merged into one image, taking on a particular shape or form that is largely due to the positioning in post-production.

I will often be unaware of what category an image will end up in, though I try to avoid working on images which I think have little potential. It is always worth investing time into the shooting process to have the intention of using as little post-production as necessary. However, the following pages will detail the different levels of processing that you can use and will show you how you can use post-production to achieve effects and transform your images.

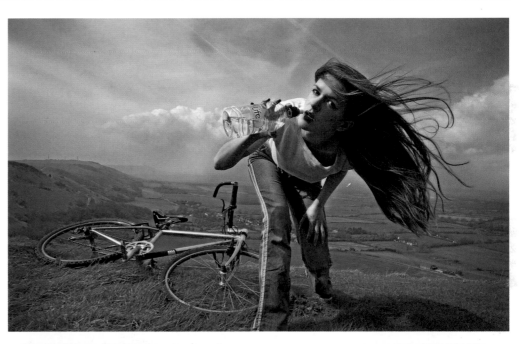

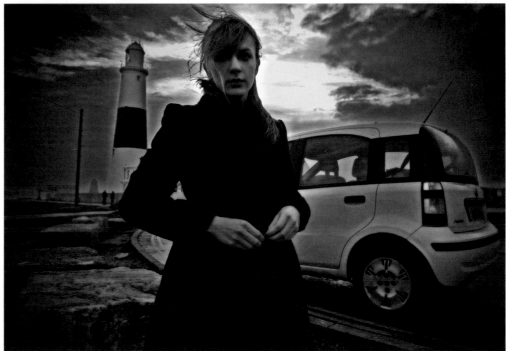

SAVING & STORING YOUR WORK

It is wise to get into good habits when it comes to the technical side of your photography. Your choice of file type in both shooting and processing, the way you organize your archives, and how you choose to save and store your work will all have implications on the overall quality and safety of your artistic creations.

JPEG

A JPEG file (named after the Joint Photographic Experts Group) is probably the most common image type you will come across, which formats an image into what is known as a "lossy" compression. This means that once the image is saved at a certain size and quality, information is discarded in order to keep the final size small. When an image is shot in JPEG, the camera makes certain decisions on the way the image looks (saturation, sharpening, etc), discards information and makes the JPEG smaller in size than other file formats. JPEGs are ready for printing and sharing, as the image is already "processed" by your camera.

My advice is not to shoot in JPEG. Instead, make spin-off JPEG "versions" of images for the appropriate purpose such as printing, or uploading to the Internet. Shoot in RAW instead. A RAW file is the "digital negative" of an image. Your DSLR should give you the option to shoot in RAW.

RAW

A RAW file is not technically a "file," but an image in its uncompressed state, ready to be processed on the computer. The image is the complete information from your camera's sensor, which means it will be softer than a JPEG, less saturated and sharp, and of a higher dynamic range. This means that you need to do work to the image to take it to esthetic completion, and also save it as a changeable file, as the original RAW file does not change. You can make many more flexible adjustments to your images than with other file types, and the changes are saved in what is known as a "sidecar" alongside the file.

RAW files are larger than JPEG, which does have implications when it comes to the size of your memory cards, but they become even larger once they are processed and saved out full-size as a TIFF. I would highly recommend investing in enough memory cards to be able to shoot freely in RAW throughout a shoot.

By shooting RAW, you ensure the best quality start for your images, especially if you end up doing a lot of post-processing work.

TIFF

A TIFF (Tagged Image File Format) is a lossless file format that means an image can be edited and re-saved without depreciating the image (unless the TIFF file format is used as a "container" for a lossy JPEG file, which is also possible through the save settings). After converting from RAW, I save all my final images out as TIFF. These are larger than JPEG, but the size can be reduced using LZW compression, an option you select in the dialog box after saving the file in Photoshop. This halves the file size without losing any information.

It has been proved by printing labs that there is no difference between printing an image from a high-res JPEG file and its TIFF equivalent, so you can print straight from JPEGs. However, I recommend you save your original images as TIFFs so that you can make amendments to the files, and you won't lose image quality in opening and closing the file in Photoshop to make any edits.

Saving your work

Another aspect of saving images that I am keen to advise new photographers about is to always keep your original files. You would go the extra mile to find more drawer space for physical negatives, so likewise make sure you invest in lots of memory space for your images. Digital storage is very affordable nowadays. I would also advise against deleting images, even if you don't intend to use them at the time. You will very likely find the shoot more interesting in a few months or years—you might even like them enough to do something artistically with them that you didn't see at the time. Remember that our tastes change. If you have enough space, try to save progressive versions of your work. You might already save your work in the form of complete PSD files (Photoshop files, with

each altered layer intact), but if you are like me and tend to flatten and re-save as new TIFFs at several stages, then keeping each one as a new file might come in handy for reverting to previous versions (in case you have a change of heart about a filter you added) or so that you can recall the process of creating an image visually through a tutorial or "making of" from a blog or book.

I also want to add how important it is to back up your work. Keeping your work on an external hard drive is paramount in case your computer fails or is stolen—but don't forget that your hard drive can fail too. It is vitally important to get into good habits regarding keeping your work safe and secure—who would want to lose months or years of their art? So, buy a couple of hard drives, back your computer up to both of them (software like Time Machine on Mac helps you keep an accurate back-up). Keep your hard drives in separate places, and back up to DVDs and CDs too. Never take the safety of any of your equipment for granted—in 2009 I was burgled and had all my laptop equipment stolen. Luckily I'd backed up my last few months of images to a hard drive, which also could have been stolen. I learnt the important lesson not to keep all of my equipment in the same place and on view. I also recommend installing recovery spyware such as Undercover (for Mac) or Laptop Cop (for PCs) especially if you own a laptop. You can also use online storage to "back up in the cloud"—sites like Dropbox, Xdrive or Wuala offer both free and paid storage. Alternatively, invest in a home server, which will keep everything on your system backed up around the clock.

Organizing your images

It can be useful to hear how other photographers set about organizing their files. The way I organize my images is thus: I create a library of images that is made up of folders for each year, with sub-folders for each month. A new shoot will constitute a new folder that is placed inside the appropriate month's folder. Using my memory card reader I import new images onto my computer, into a new folder, leaving their filenames as they were on the camera (which I keep in a continuous state, where the numbers continue on from the end of the last shoot, as they only have relevance within the folder in question, not for my system overall). I normally do this manually, directly dealing with the files, for example, straight through Finder on my Mac. I prefer to deal directly with the files rather than use a program as an interface, though others will prefer to import new images by using a program such as Adobe Lightroom, Adobe Bridge, or Capture One Pro, for example.

Before I do any RAW conversion, I like to sort through the images to get a feel for how the shoot went, and to earmark the best shots. I will want to sort through the images using the simplest and quickest program. At the moment I use Adobe Bridge as it allows me to bring up the images quickly, promptly view the thumbnails big or small by toggling the scaling bar, and add labels. Regarding labels, there are lots of programs out there purporting to making the process easier, with custom fields, labels, ratings, keywords, and so on. I find that all I want to do is use a one-labeling system, adding a label to the images I am interested in working on, and sometimes a second label to images of secondary interest. I do this in Adobe Bridge, using the colored labels of green for "best" and yellow for "second." I can then filter the folder to view only a particular label, select and move them to a sub-folder that I entitle "Best." If I have shot in both RAW and JPEG, I shift the JPEGs into a sub-folder. I then open that folder of RAW images directly in Capture One, and view only the RAW files of approved images. This makes for a much more efficient experience than if I were to wait for the entire shoot to load in a heavier program like Capture One. Alternatively, I will open a RAW file straight into Photoshop to be converted with the Adobe RAW plug-in software. At other times, I open RAW files straight into Photomatix to merge HDR images (see pages 92–95 for the section on HDR).

I will save progressive versions of images within the same folder as its original, adding an "ADJ" (for "adjusted," an old-time habit) onto the end of the filename (instead of renaming it entirely, as I keep it simple at this stage) and then the appropriate version number: 2, 3 and so on. I add metadata to the final image, by selecting File > File Info in Photoshop, to add the title and copyright. I then save a copy of the full, high-resolution final image into my portfolio of completed images, under the file name of its given title. This is a separate folder, which is an ongoing library of finished images. Having a portfolio folder becomes a requisite with time, as the more images you create, the more need you have to swiftly access all your finished images without having to delve through all your folders of different shoots.

GETTING STARTED IN PHOTOSHOP

Many photographers agree that all images can benefit from some form of processing. A valid point in favor of processing is that if you are shooting RAW you are obliged to process the image on your computer before it reaches a functional stage. These adjustments may be mild, but what you choose to do to your images takes some thought—especially if you do not yet have your own established approach to processing. This next section is an introduction to post-production for those who are using it for the first time.

In my own work, images that have emerged almost SOOC have been the most rewarding and memorable. However, I also feel that same excitement, albeit over a more gradual period of time when producing an image that has been composited in Photoshop. Here is a round-up of the various basic, everyday functions you will want to use in Adobe Photoshop. The references I make are specifically to version CS5, but are common across most of the earlier versions too. Bear in mind that all adjustments should be done on a new layer. This means that you can discard the layer easily afterwards or save the file as a layered file (to adjust or discard later). You also have the option to change the opacity or blending style of the layer. When erasing through a layer adjustment, add a layer mask so you can apply the changes non-destructively to that layer.

Levels (Image > Adjustments > Levels)
The Levels control, which opens to show a histogram, represents the distribution of tone in an image. An ideal histogram will generally show gentle peaks throughout the range, although peaks on either side are not undesirable if you are aiming for an image that is particularly high-key (values weighted to the right) or low-key (weighted to the left). Adjusting Levels will add or reduce the overall tonal kick to the image. Try not to use Brightness/Contrast, and adjust Levels instead. It takes some fiddling to understand what effect the adjustments will have on your image, but there's no harm in experimenting. I typically move the middle and end slider of the Input Levels to add a kick of brightness and contrast. Take care not to blow out highlights.

Color Balance (Image > Adjustments > Color Balance)
In Color Balance, you can work with shadows, midtones and highlights, to make relatively quick, global changes to the overall hues in your images. I typically keep it on midtones. You can also alter color using Levels: you can choose to manipulate the red, green or blue channel, with better control over brightness than with Color Balance.

Curves (Image > Adjustments > Curves)
The Curves control shows the tonal representation of an image's brightness. It is similar to Levels, but offers greater control of where tonal changes occur, which means you can adjust the color content of shadows without affecting other areas. Playing with Curves adjustments can create some very interesting results.

In Curves, as with Levels, Color Balance, and Hue and Saturation, there is an option to save settings as a preset, to load later onto other images. For example, in Curves, you can create a "cross-processing" effect (a digital recreation of a particular darkroom technique) that can work really well on boosting the contrast and blues of certain images.

Shadows & Highlights (Image > Adjustments > Shadows/Highlights)
This tool allows you to lighten or darken pixels according to the surrounding luminance, making it possible to "correct" lighting, within reason, to bring back detail lost in overexposed or underexposed areas. I was excited when I first discovered this tool, as the effects you first see when moving the top Shadow slider can be extraordinarily HDR-like. Further down, playing with Highlights and Midtone Contrast can give your image more of a surreal kick. Adjusting your images with these sliders can certainly work well, but be careful not to go too far, and also be aware that significant noise can be created when dramatically lightening shadowed areas.

Vignetting (Filter > Lens Correction, or under "Distort" in earlier versions)
Vignetting is actually a lens aberration that would normally be removed in post-production, but you can both add and remove vignetting as a creative effect. I use vignetting on many of my images that you see in this book. Examples

THE RUBBER ROOM *2009* (right)
Shot in a padded cell in an abandoned mental asylum, the stark location coupled with the dynamic nude pose gave this image its impact. In Photoshop I added a subtle cross-processing effect with Curves to deepen the blue of the walls and red of the hair.

remove vignetting as a creative effect. I use vignetting on many of my images that you see in this book. Examples include *Pink & Read* (page 43) and *She Watched From the Corner* (page 57), where exaggerating the dark corners help draw the eye toward the central focal figure in the image, in a manner suggestive of a keyhole. I find it helps especially in images where there are potentially distracting areas around the edges.

Sharpening (Filter > Sharpen > Unsharp Mask, or Smart Sharpen)
/ Blurring (Filter > Blur > Gaussian Blur, Lens Blur)

Some photographers choose not to sharpen and will only do it when they are deciding whether it is appropriate prior to printing. Blurring parts of an image will by comparison cause other parts to look sharp, so you should make a decision based on the quality of the image whether it is appropriate to blur or sharpen, bearing in mind that sharpening can induce unwanted noise in an image. Selective sharpening and blurring, however, can prove to be an artistic effect to enhance (or even to ambitiously create from scratch) a false "depth of field" lens effect. In order to selectively blur or sharpen, you will need to select part of an image with the pen tool, to create a new layer. Alternatively, create a new layer on which to do your effect, add a layer mask, and then erase accordingly the parts on which you wish to reduce the effect. You can also use the Sharpen and Blur brush-format tools from the tools palette.

De-noising (Filter > Noise > Reduce Noise)

Digital noise is one of my worst enemies in photography. Noise will appear whenever there is not enough light in a certain part of an image. Therefore, you might want to add de-noising into the primary stages of processing an image, if appropriate. However, you might well notice noise being formed the more you manipulate an image because the limits of the image are being pushed by constant adjustment, particularly when lightening the image in any way. This means you might want to do further de-noising later. The de-noising effect will increasingly soften the image, so watch for the moment when you start to lose clarity and sharpness.

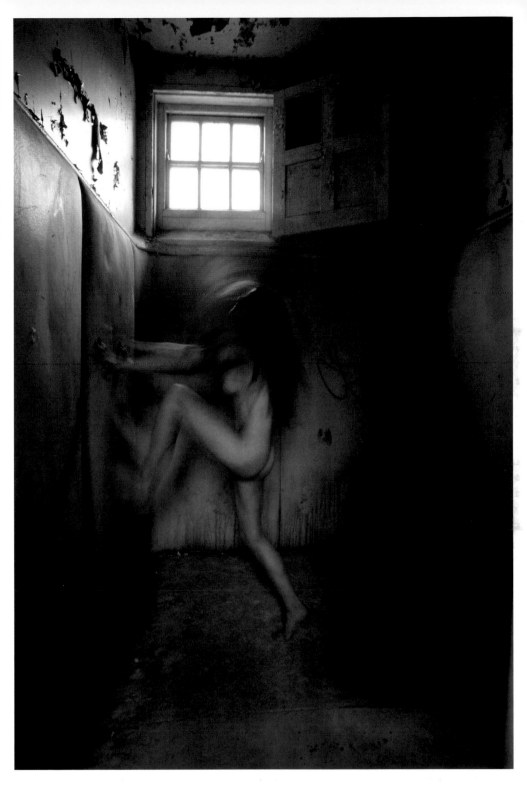

MONOCHROME CONVERSION

Turning your images into monochrome is an easy process to perform in post-production, which means it could be one of the first processing techniques you explore. Thanks to digital, you don't have to shoot an image specifically in black and white, but have the flexibility to convert afterwards. There are several ways in which you can convert your images into black and white, a range of which are outlined on these pages.

Photographers sometimes favor the simplicity of an image without color or the nostalgic, dated feel that an image can acquire when delivered in monochrome. As the first photographs were monochrome, there is a sense that like shooting with prime lenses, working in black and white allows us to go back to basics with improving our photographic eye. Shooting in monochrome encourages you to recognize a potential image in terms of light and form, and work with its tone and contrast without the distraction of color. Converting an image to black and white with the flick of the keyboard in Photoshop may be a world away from the process of consciously shooting in monochrome with film, but the decision of working in black and white is still one that has to be made carefully, whichever way you ultimately choose to produce it.

It is important to understand that not all images work in monochrome, and in my opinion, most images will look better in color. There are only a few black-and-white images in my own portfolio to date, as color often takes on a dramatic role. In my view there must be enough depth and texture in the image, created by the lighting, for it to work without color. I have shot images that I later converted into black and white, when other images from the same shoot, which may have been taken seconds before or after, do not work to the same effect.

For example, I shot my self-portrait *Carew* (right) in color, and noticed during post-production that it had a particular dynamism and depth that made a monochrome conversion ideal (left). The face seemed to pop, whereas with other images I shot at the same time, the starkness of the face seemed to pale into insignificance, as there wasn't enough shape created by the face and hair for them to stand out without color. Although the original image was acceptable in color I decided to keep it as black and white to give it a timeless feel.

Post-processing techniques

If you shoot in RAW as I recommend, you can choose to convert an image either in the RAW conversion stage or afterwards. In Capture One Pro, for example, you can make an image monochrome by selecting a black-and-white "style" from the presets, or manually bringing down the saturation slider before generating your TIFF file.

If you are looking to convert an image to black and white in Photoshop, there are several ways you can do it. You can choose Image > Mode > Grayscale, though changing the Mode will limit what you can do later.

By going to Image > Adjustments > Hue/Saturation instead, and moving the middle slider all the way back to

DON'T LOOK NOW *2007 (right)*
I feel this image works well in black and white because of the shape of the curls of my hair on the living room floor. I also felt it gave the scene a filmic atmosphere that was not evident in color. Where black and white works well, it will define the edges and lines in an image to give it an impact not so noticeable in color.

CAREW *2008 (left)*
I used a fast shutter speed to freeze my movement as I tossed my hair into the air. I converted the image to black and white in post-processing by using the Channel Mixer and then adding slight vignetting.

CAREW BEFORE MONOCHROME *(above)*
The image *Carew* as it was originally shot in color.

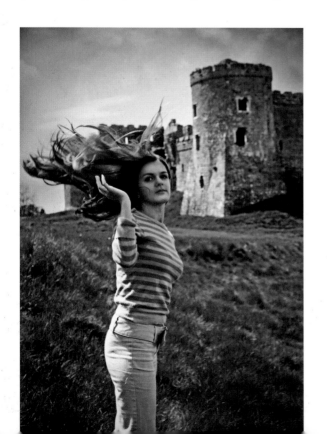

desaturate the image, you can keep the RGB information. This results in a black-and-white image, but does not give you control over the color channels, so the result can often look flat.

You can select the "Black & White" option in Image > Adjustments, and adjust the effect of each color channel to tailor the look of the your image. Another route to making an image black and white is to add a gradient map by selecting "create a new Gradient Map adjustment layer" under the Adjustments panel and choosing the appropriate black-and-white gradient.

The best way is to work with the image's channels through the Channel Mixer. As an optional preliminary step, by clicking on the image's "Channels" in the box next to the Layers and Actions palette you can view your image through each color channel (Red, Green and Blue) by simply selecting it. This gives you an idea of the distribution of color information in the image. Then, enter the Channel Mixer (Image > Adjustments > Channel Mixer), select "Monochrome" and then adjust the sliders as appropriate. A warning in the dialog box should inform you that keeping the total sum of the channels to 100 will maintain the overall tone of the image.

Extra touches

After converting your image into black and white, take some time to review what else you might do to enhance the result. The image might benefit from having the contrast deepened in Image > Adjustments > Levels, a slight vignette by going to Filter > Lens Correction, or some experimentation with midtones in Image > Adjustments > Shadows/Highlights.

You might also want to further enhance the tones by dodging and burning. These tools allow you to respectively increase and decrease the local density of an image in a selective brush-tool format. Use feathered brush tools to avoid a patchy or uneven look. Take care to do it on a new layer and in moderation, as there may be resulting smudging or noise created if you try to lighten part of an image beyond its limits.

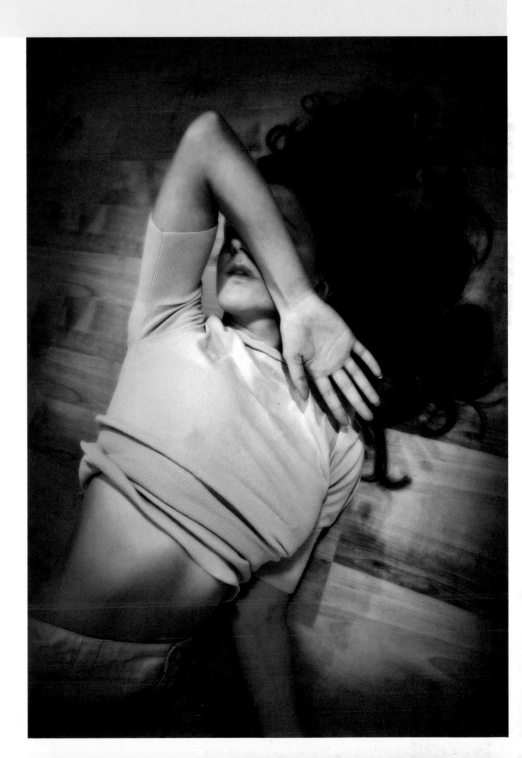

MODERATE MANIPULATION

The world of digital post-processing can make almost anything possible. Here I will be introducing you to moderately-processed "composites"—that is, where multiple photos have been blended together to form a final, complete image. Getting started using manipulation programs like Photoshop can be daunting, but it's always important to remember to start thinking in the shooting, and not to lapse into the state of mind of relying on post-production to "fix" problems.

It is always tricky to discuss post-production because I never like to encourage other photographers to focus on the post-production stage. However, what I would like to demonstrate are the possibilities available for images that might not be as good as they can be, for whatever reason. Most of the time, especially with the examples I have given on these pages, the idea for an image has come after the shooting, where I have two images that I later realize may work well together. There are also situations where I was not able to shoot in a specific location and compositing allows me to realize a vision for an image.

Tools for compositing in Photoshop

In order to do any compositing, you will need to understand the concept of layers. In Photoshop, whenever you wish to make adjustments to an image you should create a new layer. This acts like a piece of tracing paper over the top of your image, onto which you make changes. "Masks" are editable selections that work in a similar way to layers, onto which you "paint" to erase or restore parts of the layer, using the black and white paint tools respectively. A layer allows you to make non-destructive changes to an image, while a mask allows you to make non-destructive changes to a layer upon the image. You are always able to discard the layer or mask in question as long as the image has not been flattened. You are also able to change the transparency or filter style of a new layer so that the final image looks the way you want it.

When you make any kind of composite, the part of one image which you drag to another will be in the form of a new layer, which is placed "on top" of the original image. You can transform it (warp it, change its perspective, make it larger or smaller), erase through it, change anything about its color or style individually—before you then either "flatten" the file to become one final image, or save it as a layered file (PSD or TIFF) to work on later.

The tool I use to cut out part of an image is the pen tool, from the tools palette, which looks like the nib of a fountain pen. Draw a series of points around an area you wish to make into a separate layer, complete the path by clicking into the first point you made, and then, in the Paths palette (next to Layers), click onto the path you just made, holding Control (or Command, on a Mac), which will make a selection from the path you made. Then make this into a new layer by going to Layer > New > Layer Via Copy, or using the shortcut, Ctrl + J. You can also create "Layer Via Cut" if you wish to definitively "cut" that part of the image out of the original.

The inspiration for my self-portrait *For Tatuś* (right) was a desire to create an image for my late Father's birthday. As my Dad used to enjoy mushroom picking, I decided that mushrooms would be my prop for the image. I bought a box of mushrooms and placed them on the ground around me. Afterwards, I was able to manipulate the image in Photoshop and multiply the number of mushrooms. To reduce the time spent in post-production and to have a better chance that the image would look convincing, some preparatory steps were in order. I made sure that I locked the camera into position on my tripod and did not let it move between shots. I also made sure I rotated the mushrooms around in a methodical manner from one patch of ground to another in different areas of the frame. It still took time and dedication to transfer one part of an image onto the master image, and to zoom in close to each prop to make sure there were no seams, overlaps or uneven lighting. For this image, compositing was a way to get round the limitations of props and to save money.

In *The Approach* (far right) I brought together two images in order to make a landscape shot more interesting. I had shot a church and processed the image with enhanced saturation, dodging and burning, and adjustments to Color Balance and Levels to make it richer and more dramatic. However, it lacked the human element I am fond of and I

FOR TATUŚ *2009 (right)*

For this self-portrait, taken in a wood at the end of winter, I used compositing to multiply the number of mushrooms in the final image. This image has also benefited from Curves adjustments, which made the colors cooler in the shadow areas.

AT WHITE ROCK *2008 (opposite below left)*

This was shot with the ten-second timer, on a rainy day on the roof of a theater. This was one of the first times that I decided not to "fix" my smudged makeup in Photoshop, and instead left the skin largely untouched to create a sense of realism with my face in the drizzle.

THE APPROACH *2007 (opposite below right)*

This was shot in a village near Lewes, East Sussex. I composited my figure into the scene in Photoshop. Had I thought beforehand of this composition, I would most likely have shot myself *in situ*, but the luxury of compositing allowed me to experiment with options afterwards.

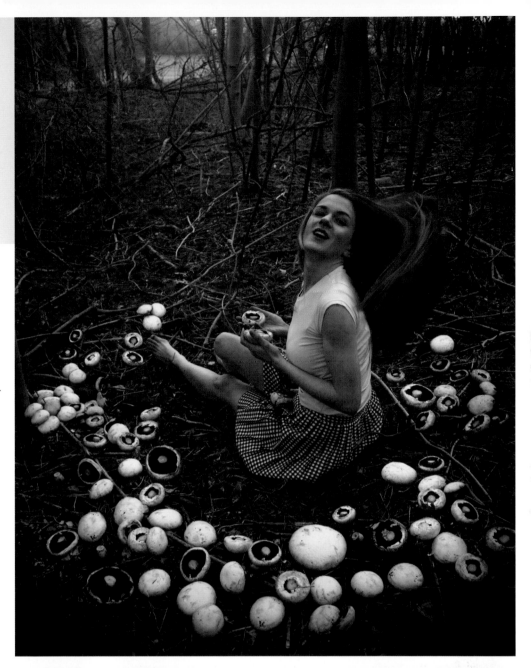

wanted to see if I could possibly use a figure of myself from another shot taken the same afternoon, to place into the image as a character looking toward the building. Because I am quite distant in the image, the composited element isn't in a prominent position and so reduces the risk of visible seams, making this kind of compositing a good place to start for a beginner.

In *At White Rock* (below), a self-portrait shot on the roof of a theater, I used compositing to bring together two shots taken in the same shoot in order to achieve sharp focus on both the subject and the background. I wanted to feature my face in the image as a dramatic close-up, but I also wanted to keep the detail of the "White Rock Gardens" in the distance along with the detail of the road on the other side. Compositing was here used as a way to get around the limitations of my camera and lens, and to essentially grab the most ideal two images from the shoot. I extended the canvas of the image (by going to Image > Canvas Size) to be able to drag the parts of the other image to either side of my face. The final image is slightly longer, to display the full vista I wanted.

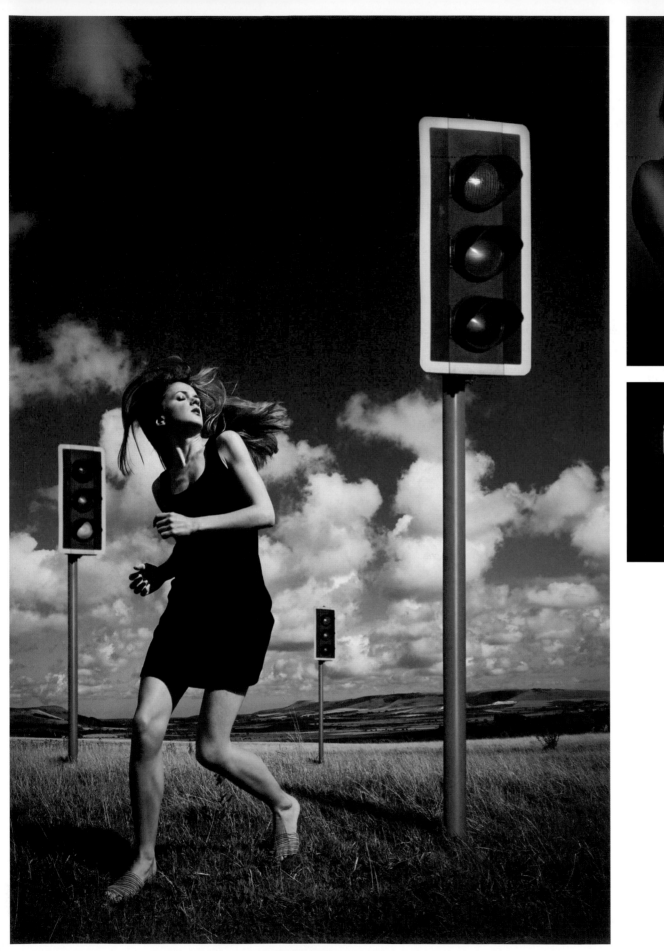

Going further with compositing techniques

Photographers use compositing in different ways. Occasionally I will take advantage of the odd prop or texture I can incorporate legitimately from other sources, but I tend to usually use my own images, since I wish to be the "photographer" in everything I produce.

Compositing in principle is not new or even radical, being a technique handed down from darkroom photography and used regularly in the press when, for example, a group of celebrities appear in the same picture seemingly standing together, but actually photographed separately. They might not have been available in the same location to be shot together, or the retoucher/photographer has wished to use the most flattering or effective image of each person for the overall image. This technique requires that you pay close attention to the lighting in your photographs so that you can match together images for a believable result, and if the images are taken at different times, you will need to make a conscious effort to replicate the same lighting, in terms of its direction, quality and strength.

You might have a landscape or street shot into which you would like to incorporate another element, and then shoot an image of a person to composite into that shot. For successful synergy, you'd need to study the lighting so that you could recreate the shot in a similar fashion. On the previous page in *The Approach*, I showed you how I brought together two images that were taken on the same day and therefore had similar lighting. *In Perpetual Light* (left), I put together two images that were taken in completely different situations: one in a church in Yorkshire, and the other an image of myself at home posing in a black veil. Playing with the images in Photoshop, I found that they had an affinity when brought together and it was easy to manipulate the colors so they matched. Thematically, I liked the idea of having my "black widow"-like self within a sacred place, something I would not have liked to do in actuality. Compositing in this case was a way to get around impracticality and achieve the kind of fictional scenario I might otherwise have only been able to visualize in a painting or drawing.

In *Dear Gourd* (top left), I started with an image of myself holding a candle close to my chest, which created the rich and spooky illumination over my face and hair. I wanted to reshoot the image with myself holding a jack o' lantern instead, but my attempts did not turn out as vibrant as the one where I was holding the open-flame candle. As an afterthought, I decided to take a separate image of the pumpkin lantern and composite it together with the image of myself that I liked. I cut out the pumpkin using the pen tool, made it into a new layer, and then moved it over the candle in the original image. With a series of transformations (Edit > Transform), adjustments to Levels and Color Balance, and blending of the edges using the eraser tool, the lantern surprisingly started to look realistic and certainly more interesting than a candle. The result is somewhat surreal, but shows how compositing can be used to circumvent lighting restrictions that arise from not having a great deal of sophisticated equipment.

The idea for my composite *The Right Way* (main image left) came as a result of being dissatisfied with an image taken one sunny afternoon in the countryside. I loved the dynamism and shape of my pose, the perfect sky and clouds, and the composition—but there was something missing, conceptually, that prevented me from seeing the image as a final piece. I decided to take inspiration from a dream I had recently had where I was running through traffic lights singing along to a song. As a result I jogged to the bottom of my street, took photos of a traffic light, then came back to superimpose several copies of the traffic lights at differently-scaled sizes into the image (going to Edit > Transform). They looked suitable within the portrait dimensions of the composition, but the challenging aspect was to make them appear "real," even within a "surreal" narrative. I worked with Levels to adjust their tone, and then created shadows for each one, by selecting an area on the grass where I wanted the shadow to appear, creating a new layer from that selection, and darkening in Levels. Compositing was here used to produce a surreal image that could not be achieved in reality.

THE RIGHT WAY *2008* (far left)

This was shot on a hot day in the countryside. By moving about in front of the camera during the ten-second timer, I captured a dynamic pose, which left space for the incorporation of a secondary element through compositing.

DEAR GOURD *2008* (left above)

I composited the pumpkin into this self-portrait. It worked well on this occasion because of the synergy between the warm, tungsten lighting of the two images both shot indoors.

PERPETUAL LIGHT *2007* (left below)

This image is composed of two separate images, taken at different places and times. I used vignetting to help the superimposed self-portrait become "absorbed" into the scene and to help obscure any suggestion of seams.

MULTIPLICITY

"Multiplicity," or "cloning," are terms that have been used to refer to the technique of duplicating a subject in an image. This could be yourself, another person, or an animal or object. In photography, it has always been acknowledged that you can create double exposures by extending the shutter speed of a camera and moving the subject around the frame. With digital photo manipulation, however, images can be composited together as layers, giving the artist much more versatility and precision when it comes to producing images of "multiples."

I was initially drawn into self-portraiture by the artistic possibilities of the multiplicity technique. I felt it stemmed from a desire to represent a split self, a "twin" that was comforting another "me," but then it led onto being more of an exercise in composition and pattern, where I found pure visual satisfaction in the final composited result. For the same reasons that make self-portraiture an advantageous way to get into practising photography, creating a multiplicity self-portrait is a way to carry the control you have in your shooting right through to the processing; to hone your compositing skills, as well as give you the opportunity to create the ultimate, and often elaborate, tapestry of self.

I find creating these cloned images is a great way to present one final, polished image from a shoot that might have involved lots of different poses and positions. Rather than picking one image from a shoot, or displaying one separately from another, you can take two or more of them, and bring them together into the same frame. This is not only for the visual delight of bringing together multiple forms, but also for the wealth of conceptual possibility. There are many reasons as to why you might want to employ the idea of a split self, but at the very least, a multiplicity image is an exercise in all the skills involved in planning, composing and using Photoshop on an image.

The images opposite—*By the Lake*, *The Oak Chest*, and *The Green Telephone Box*—are all examples of early cloning images where I went out to a different rural setting in a particular outfit, with the ostensible aim of shooting a multiplicity image. If you are trying out the technique for the first time, I highly recommend approaching it as methodically as possible.

You will need to keep the camera fixed into position, ideally locked down on a tripod, after choosing the frame that you would like to use. I started out without a tripod, which meant balancing the camera on available tree stumps and clumps of grass. I was able to keep the camera in one position, but sometimes would spend extra time in Photoshop merging the images. It is ideal if you can keep the framing accurate between shots, to make the post-processing job easier. The subject should be the only element that "moves" between the shots. Position yourself in different areas of the frame and fire off self-portraits ideally with a remote trigger. You will inevitably want to check the shots to see the results as you go along, but try and not move the camera while you do this, or shoot tethered.

We have established that self-portraiture can often be a blind process, but with multiplicity, it is even harder to foresee whether a composite will work, until you put the images together in post-processing. If you are shooting tethered, there is the facility in some software programs such as Capture One Pro where you can overlay an image over another while shooting, to gauge at the shooting stage whether the two will work together. However, even if the captures successfully "click" together in Photoshop, the resulting composition might not excite you artistically. With the compositing process, it can be demoralizing when an image doesn't work out after spending time and effort on it. I recommend a bit of patience and persistence—and I also suggest as a general rule that if the images you are intending for a clone composite don't artistically excite you on some level, don't waste time trying to put them together, unless you are just practicing working with layers. Over the page is more about processing a multiplicity image.

THE OAK CHEST *2006 (facing top right)*

I shot this one morning in the house I was lodging in at the time. The camera I used was a compact Sony S85 camera.

THE GREEN TELEPHONE BOX *2006 (facing bottom right)*

I spied this odd telephone box, which is green in real life and knew it would be an interesting feature in an image. I had a friend hold the camera at a steady, low angle for this image, as I did not yet have a tripod.

BY THE LAKE *2006 (facing bottom left)*

I used rural locations in Sussex in the UK for most of my early multiplicity images, like this one. I did not own a tripod, so would balance my camera where I could: in this case, propped inside my car window, which was parked just next to this fishing lake.

Processing the composite

Once you have shot a number of images and have transferred them to your computer, take a good look through them in order to form a shortlist of the images you will use, which is usually between two and six. You might not know exactly which images will work best, so take a few into Photoshop.

If your shots are quite consistent then you might be able to drag one image onto another using the Move tool and then erasing into the layer to reveal the clone beneath. Usually, you will have to cut out the figure from one image using the pen tool. Before you make a new layer from the path, feather the selection by going to Select > Modify > Feather (and enter anything from 5 to 30 depending on the leeway you have left within the edge of the points), which will make the edges of your new layer slightly soft and easier to work with when you blend it into the master image. Dragging the new layer, hold down the Shift key so that the layer clicks into place at the same scale and position. You can now determine how much erasing, or adjusting of Levels and Color Balance you need to make before the layer fits in seamlessly (the exposure and color should be quite consistent with the master image unless you have changed camera settings, or the shooting conditions rapidly changed).

It is paramount that you decide on the positioning of the clones before you work on overall esthetic effects. You are effectively designing the whole composition yourself, which involves looking for shape. For example, I created a triangular composition for the three clones in *On the Terrain* (page 27) and an undulating, yet balanced line of figures in *Their Evening Banter* (pages 80–81). Photography is all about playing by eye and occasionally I have not got a combination of shots "correct" first time for a composite. It can take trial and error to get the right shape within the frame. If you have a selection of different clones in the same canvas, try toggling the visibility of each layer—the eye symbol next to the layer in the Layers palette. This will turn layers on or off to enable comparison of their potential with others.

When you have the final composite in position, be sure to save it as a PSD file so that you have the layered file intact if you need to return to it. I recommend saving the file as soon as you begin working on it, and keep saving regularly especially if your computer, or copy of Photoshop, is volatile and prone to crashing. After the hard work is done, you are then free to do the exciting bit—enhancing your final composition with overall effects, primarily the adjustments such as Levels, Color Balance and Curves.

Clockwise from right

THE DEATHS *2006*

For this image, I subverted the idea of happy, playful "clones" and used a pair of black heels (partly inspired by the work of fashion photographer Guy Bourdin) to create stark visual impact.

THE ESCAPE *2008*

This multiplicity image was shot by Lake Crescent near the Olympic Peninsula in Washington. My partner and I hired a boat, rowed out to a bank and shot the self-portraits collaboratively.

When I positioned the clones as I wanted them to appear, I began processing by brightening the image; working with Shadows/Highlights, Levels, Color Balance, and adding vignetting to draw the eye toward the middle of the scene.

Process: The three shots I took for *The Escape* (above right). One image was shot from a different angle, but because I wanted to use that particular pose, I cut it out as a layer as normal and brought it down to the level of the boat, erasing the legs accordingly so that they reached the same perspective.

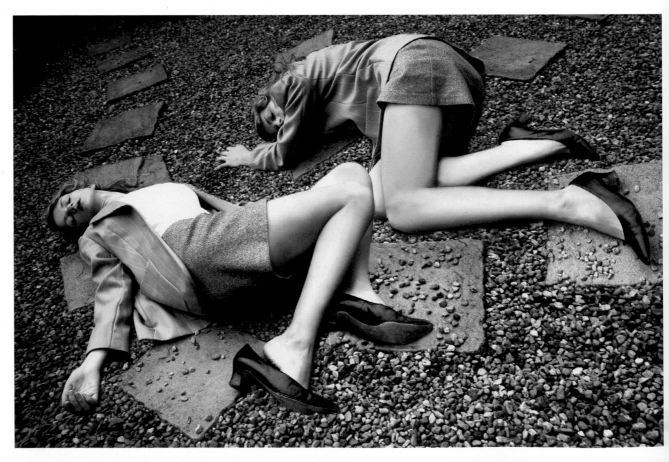

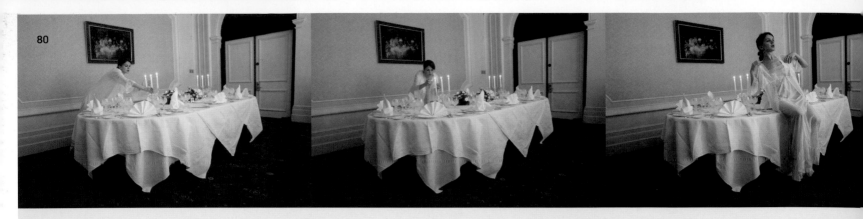

HOW I MADE
THEIR EVENING BANTER

Their Evening Banter is a composite of six clones shot in a hotel room. In planning how to use the room, I decided to remove the chairs from the table as they were rather chunky and in using them, at least half of the character's backs would be to the camera. As it would have taken time and effort to ask the manager for the table to be filled with food, I chose to have the clones standing and looking as occupied as possible around what was simply a laid table, to make an interesting scene from the viewer's point of view. Inspiration came from the painting on the wall of the room.

I had no idea of the title or artist of the painting, but the scene inspired me to try something where the figures at the table were sitting at different angles, almost engrossed in their own interaction with one another. I did later find out that the artwork is called *The Dinner Party* by Jules-Alexandre Grün. I discovered this by running a photo of the painting through a useful website called TinEye (www.TinEye.com), which showed me a list of other URLs where the image appears on the web. Those other sites revealed the title and artist.

I set the camera up as far away from the table as I could in the small room, on a tripod set to knee height. I used my Sony R1 on auto settings, in RAW. (Notably, the R1 allows you to shoot RAW while in Auto, not a feature offered by all DSLRs.) I wanted to capture the busy feeling in Grün's painting, particularly with the girl adjusting her dress at the front, almost as if caught in an unposed, candid manner. I directly emulated her pose for the front clone. To create the feeling of action in the background I tried various poses, including running round the table, and lighting the candles with matches.

I took over 20 shots in total. I made sure I shot an image in every area of the frame so that I'd have options for covering the entire scene with clones. I even dived under the table in an attempt to make maximum creative use of the space and offer more possibilities when choosing the shots later. I had made the mistake of leaving my socks on until halfway through the shoot, assuming they could not be seen under the flowing hem of the dress. These were shots I couldn't use, as a colored foot coming out from the classical gown obviously wouldn't look right. The error could have been corrected in Photoshop, but wouldn't have been easy to do—which reinforces the importance of correcting details while shooting as opposed to relying on retouching at a later date.

In processing I chose six of the pictures, and using one as the master image, cut round each of the others with the pen tool, making a new layer and dragging it across to the master. I then used the Eraser tool to blend around the edges of each one, especially where the clones overlapped, as this composite has quite a few areas of (indirect) interaction between the figures.

When the composite finally came together into what I thought was a pleasing visual synergy, I made sure all layers were roughly the same in terms of color and brightness, and then flattened the image and started on the overall creative processing: Levels, Color Balance, Curves, and Shadows/Highlights.

Because I did not use any lighting equipment for this shoot, I had only the available tungsten light in the room that gave a rather bright and bland quality to the images. A lot of the "lighting" work therefore happened to take place in Photoshop. I worked on producing directional light from the candles using Photoshop, and with vignetting to focus the eye in toward the scene, and also made selective paths around parts of the image to apply Levels changes exclusively to those areas. Afterwards I worked on dodging and burning, added a white Diffuse glow, and retouched the faces and skin.

THEIR EVENING BANTER *(right)*

I entitled this image *Their Evening Banter* in order to anchor the after-dinner mood of Grün's painting and to suggest an easy feeling of chatter between the two front characters.

When I shared the final image online, it was quite popular. I think the image set a new benchmark for multiplicity, having been so intricate and therefore difficult to produce. Comparing my finished piece to Grün's painting afterwards, I was pleased to see a similarity in the "shape" of the light and color.

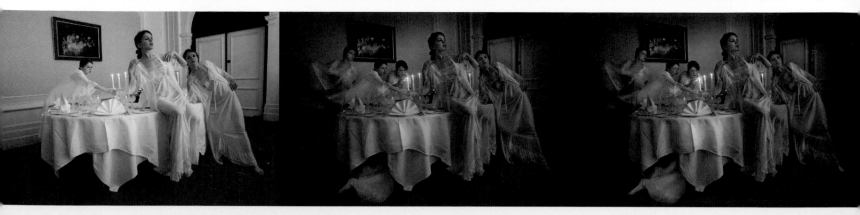

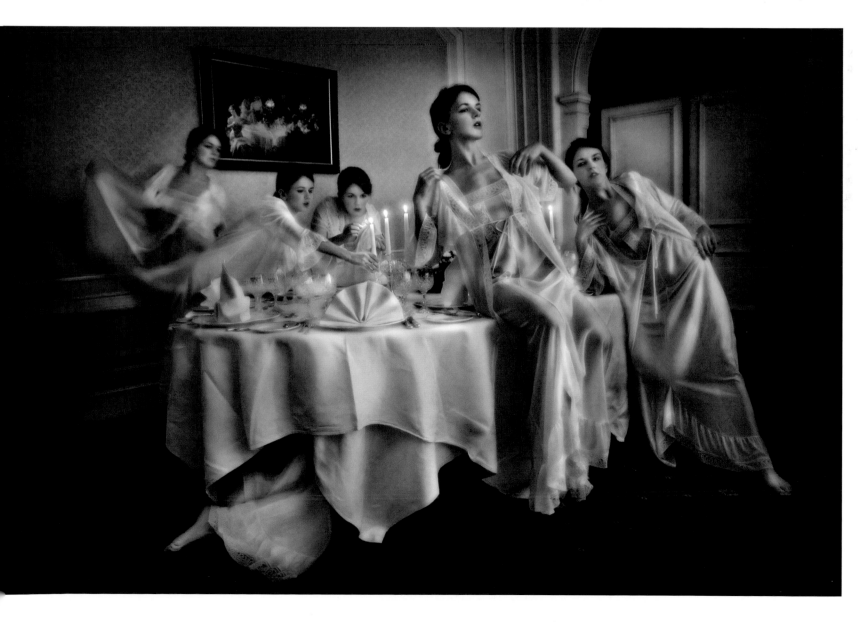

TRICK IMAGES

With multiplicity, compositing is used to multiply elements in a picture. With trick images, it is used to hide parts of one image within another, creating the illusion of an impossible feat. This is where you get a chance to explore your surrealist side! Trick images need a little more care and attention than other composites, and are often more reliant on the minute detail that makes the overall trick look "real."

For the self-portraitist, producing these images can be a challenge, as it requires you not only to achieve one single composition, but to produce a series of composed frames that can be blended together. Unlike a clone image, which adds the content of one image to another and makes what is there surreally multiplied, the success of trick images relies on what "isn't" there; that which has been taken away in order to create the visual feat. It is therefore important that the shooting process is done in a methodical manner to ensure that when the images are brought together in Photoshop, they merge with ease. On the following pages I illustrate the various different ways that you can approach trick photography, using examples from my own experience at both a basic and advanced level.

Sprung (far right) is a self-portrait that I created one afternoon in my bedroom. It was quite spontaneous—shot within ten minutes—and demonstrates the simplicity of using this basic approach. It did not involve any assistance or aids, just the wall and my own body. In a sense the final image does not necessarily "lie," but is simply a collection of all four photographs that I took. By placing one leg on the wall, then swapping to another, then taking another shot with my head turned around, then another shot of the scene without me in the frame at all—and keeping the camera completely still throughout—I was able to easily merge the images by dragging one onto another in Photoshop and erasing the necessary part. I used the Clone tool to "paint" the wall over the clutter in one corner, and then chose to tightly crop the image to make the figure dominant in the frame. I then added final retouching of my face and skin.

Washed Up (bottom right) is another self-portrait created in a similar fashion—simply photographing limbs in their relevant positions across a series of shots. I shot this completely unaided with the ten-second timer. I ran back and forth from the camera holding one leg up, then another, then an arm and so on, in a manner that wasn't as efficient as it could have been (had I used a remote, I could have stood in the same place repositioning my limbs), but through careful post-processing I managed to produce the illusion.

The next step up, so to speak, is in using a tangible prop such as a table or chair to help you achieve a position, and then using compositing methods to "mask out" the object in question. For my image *Reverie* (top right), I laid across a table taking care to also shoot an image of exactly the same frame without me, or the table in it. Though it was easy to click the two images into place in post-production, I spent a bit of time adjusting the image to reduce the shadowing effect that had occurred between my back and the dark table, which was particularly strong as my dress was white. A good tip would have been to cover the table with a white sheet so as to reflect light back up at myself, meaning I would not have had to forcefully lighten the image so much via adjustment to Levels and Shadows/ Highlights. However, with de-noising, the resulting image was still good enough to print at 70 x 70cm.

The Jitters (page 85) is another example of using a prop—this time a chair—to support my position. I shot this image with a Canon 1DS Mark III. I found it difficult to position the camera and tripod within my limited bedroom space to create the effect I wanted, so I pointed the camera into a mirror and shot the reflection. I let the chair take the weight of my body while I clasped my hands around the lamp flex and tried as hard as I could to let my body drop naturally downwards without pulling the cable. By hiding my supported leg (the leg on the chair) so that it was behind my other leg, I made for an easier job in post- production as the manipulated area is less visible. It was fairly challenging to keep still as the chair was unstable on the soft surface of the bed, so I made sure I posed the shot several times and reviewed the images carefully. Over the page I describe a more advanced method of trick compositing.

REVERIE *2008* (*facing above*)

A combination of careful preparation, nifty compositing, and further enhancement in Photoshop brought this ethereal trick image to life.

WASHED UP *2009* (*right*)

This was shot in a hotel in Seattle. I used my Canon 40D and natural indoor lighting from the hotel room.

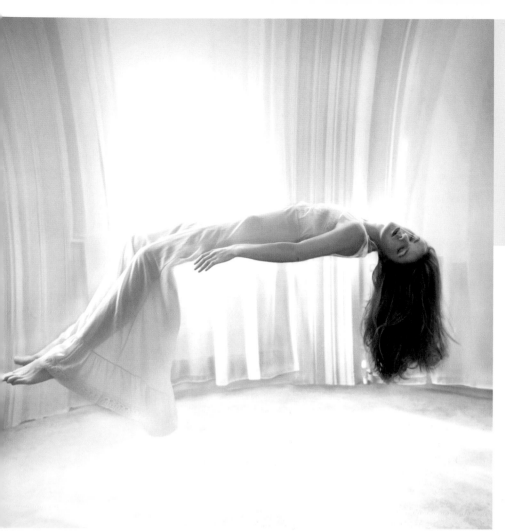

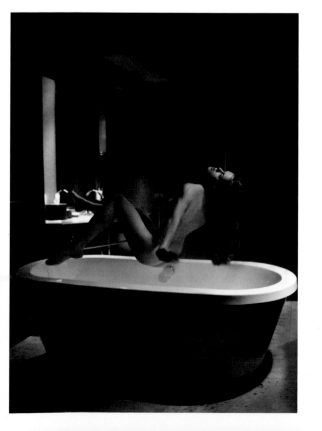

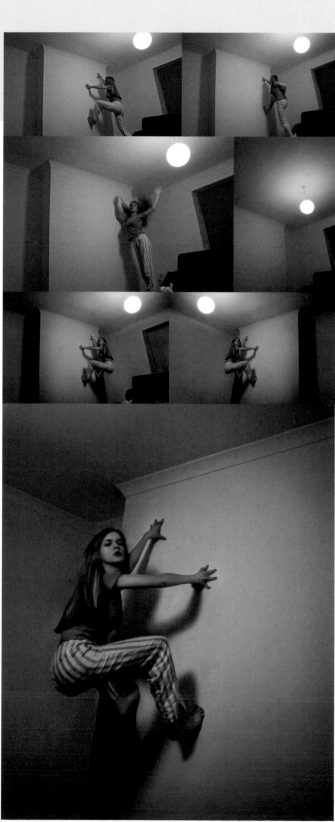

SPRUNG *2008* (right and above)

This trick self-portrait led to many "Spiderwoman" associations, but in terms of cinematic influence it was more inspired by *The Exorcist*.

Process: I took four shots: one with each of my legs on the wall, and another of my face, and a shot of the scene without anything in it. I was then able to composite one over the other, by placing the "blank" scene over the top of one of the images, erasing around the leg I wished to keep, and then bringing in the second leg.

Cleaning up: I removed the clutter by clone-stamping the wall, and then decided to tightly crop the image to omit the orb of the bedroom light. Finally, I adjusted Color Balance, and dodged and burned my skin.

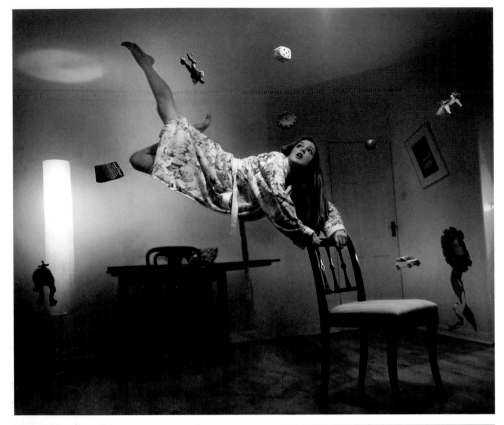

The next level of producing a trick composite requires another dimension of assistance, beyond what a prop like a table or chair can provide. For *The Adrenalin* (left) and *The Smothering* (overleaf), I had the help of my partner to propel me into the air during a ten-second timer dash. The resulting images had people believe that intricate measures such as cables were used, but actually a human assistant is masked out in Photoshop to leave the illusion of a person floating or levitating.

The beauty of these images is that they are "as shot," only with a particular element removed. Even the floating objects in *The Adrenalin* are "as shot": they were each hung from the ceiling with fishing wire so that the light would fall on them in a manner consistent with the rest of the frame. After I had composited the necessary pictures together, I then worked on Color Balance, Curves, and added a neon texture to exaggerate the pockets of colored light that were already apparent in the image. The main source of light along with the ambient light of the room was from the blue of the television screen in one corner.

A theme predominant throughout my "trick" images is anxiety. I wanted to convey the feelings associated with it, from disorientation to irrational panic as in this image and in *The Jitters*, to light-headedness and feelings of suffocation as in *The Smothering*.

Other ways

In the self-portrait *Climbing Closer* (bottom left), I acted out the appropriate pose in a place where it could be transferred to another image. I climbed and hung onto a pillar, shooting several images from slightly different angles, and photographed roofs and seagulls. In Photoshop I chose a roof that was a similar angle to that of my body in the previously posed image. It took some time to find the right combination of images and to choose the seagulls that worked in the composition in terms of angle and lighting.

Quick tips

- Lock down the camera onto your tripod to keep it absolutely static between shots.
- It is very important to take a picture of the scene without anything in it.
- Look carefully at lighting when merging pictures taken at different times and/or different places. This will make or break a composite.
- Aim for simplicity: don't over-clutter the image, and clear the space for shooting so that you don't spend hours in Photoshop removing things.
- Don't be afraid to ask for assistance: it is still your creative work if you steer the direction of the shoot, though you can always call the result a collaboration.

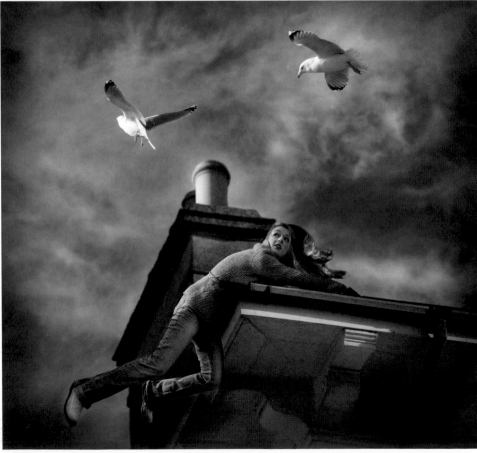

THE ADRENALIN *2008 (left top)*

This was shot at home, after clearing the space and hanging objects from the ceiling. This is an example of a self-portrait created with the assistance of another person.

THE JITTERS *2008 (right)*

I had a simple but effective idea for a self-portrait, which resulted in this dramatic image. I used a Canon LC-5 remote control together with the ten-second timer, which allowed me to toss the remote onto the bed after firing the shutter and pose in time for the image.

CLIMBING CLOSER *2009 (left below)*

This was made from several images shot with my Sony R1, all taken in my neighborhood in the same afternoon. The most difficult aspect was working out which images worked together—but with some trial and error I produced an arrangement I was pleased with.

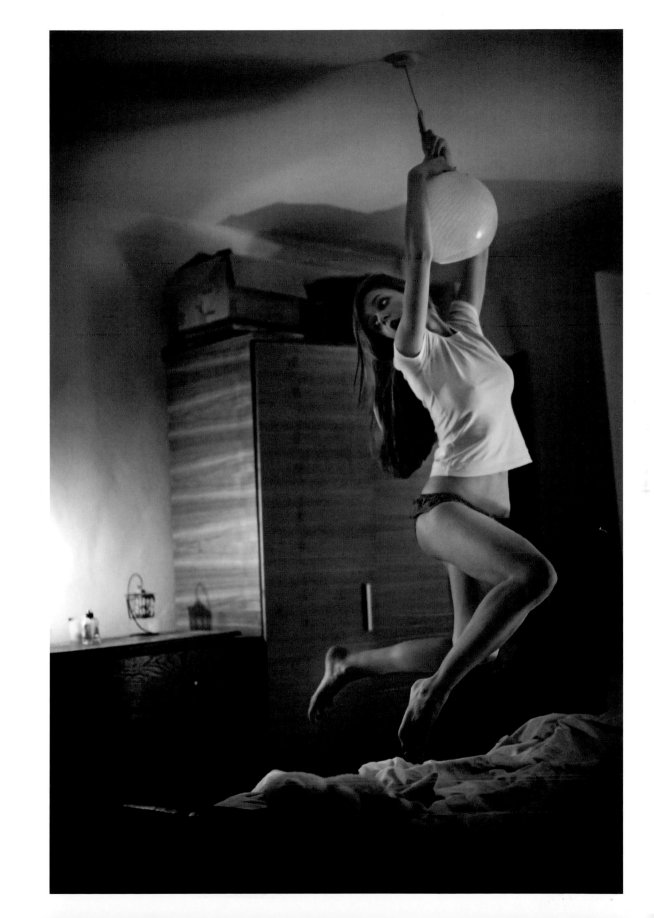

HOW I MADE *THE SMOTHERING*

*T*he *Smothering* seems to be one of my most popular and eye-catching images—this is according to the number of comments it has received, both online and in the physical world, when it has been printed and exhibited. This is most likely because it throws up the question "how did she do it?" and tends to leave people wondering about the methods of production more than the artistic intent. I created the image out of a desire to express anxiety and the feeling of suffocation. I chose a box as a prop in which to put my head, but thought that the image would be much more interesting if the rest of my body was active, rather than simply standing statically. I wanted to express the symptom of light-headedness, so the theme of levitation was appropriate. I purposefully kept my hand in motion for this image, to convey a sense of unease within the whole frame. The legs hang almost gracefully, as if floating underwater until the eye reaches the surreal and almost amusing chaos of the head in the box at the bottom of the shot. The overall theme of anxiety is anchored by the tension in the moving hand.

Surprisingly, it did not take long to shoot the images necessary for this composite. I locked the camera down onto the tripod, using the 17–85mm lens on my Canon 40D, and shot myself bending down with my head in the box. Then, for a separate shot, I asked my partner to propel my legs into the air while I balanced myself with my hands in the form of a handstand. I then shot another image without anything in the frame.

I layered the "empty" shot over the image where I had been suspended in the air and erased through the layer to keep only my body in the frame. I made sure I zoomed in close to be able to do this accurately, with a fine eraser on 100% opacity.

I then cut out the figure of me with the head in the box, from the waist up. This was the trickiest part: aligning my top half with the bottom half of my body on the other image, and using the eraser to blend in the join. I used the blank area captured in the empty image to mask over the area where you can see my hands and pillows on the floor.

I moved onto cleaning up my ankles where the hands had been masked out. Because it is such a small area, I simply reconstructed these from surrounding leg skin, using the Clone Stamp tool on 100% opacity again, and zooming in close to ensure I did this meticulously.

Because I was creating an illusion, I had to introduce fictional shadows that would be there had my body really been suspended in the air. One of the trickiest aspects of this kind of composite is getting all the physical details "correct"—the lighting is the main aspect. I drew a series of points with the pen tool, round where I thought the shadow would be, feathered the selection slightly and then darkened that area using Levels.

I added in extra hair (from another image) to make it appear as though it was falling over the box. By this stage, I was happy with the image and felt I had done enough for this particular composition. However, I then became aware that it was possible to make the image into a bold square crop, without the clutter of the doors on each side. I cropped into the image, extended the canvas to one side, and using the Transform tool, stretched the wall and floor out to the left.

This liberated the image and made it instantly more eye-catching, though it took some time and effort to clone-stamp out the distractions. A major aspect that required editing was the noticeably stretched floor on the left. I simply sampled another patch of floor from the same spot in another image (to keep the same perspective). I then made sure the shadows were all in place, reduced the blown out left leg with the Burn tool, and made final adjustments to Color Balance. Transforming the image into a square crop was the most arduous part of this process, demonstrating the limitations of shooting at home, but it shows how compositing can be used to transform the modest space in which you work.

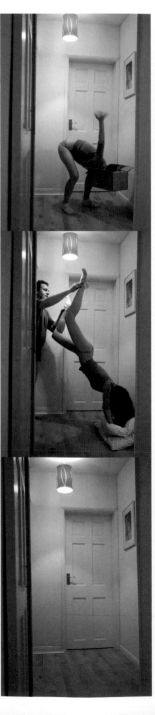

THE SMOTHERING *2008 (right)*

For this trick image in particular, I was partly inspired by the work of Julia Fullerton-Batten. Her series "In Between" features levitating women in similarly clean, bright spaces.

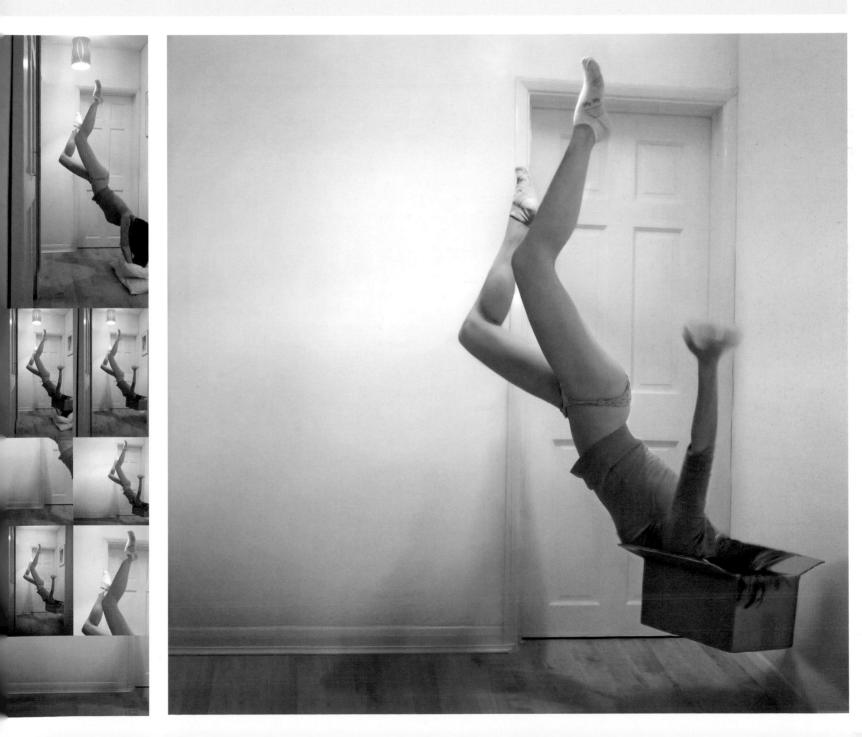

EXTREME COMPOSITES

The more expert you become with Photoshop, the less you will want to rely on it for fixing shots or performing huge compositing operations that could have been significantly reduced in terms of time and energy by better shooting preparation. However, because we don't always know what we want from a self-portrait shoot at the outset, the creativity that is possible with extreme processing can be exciting to consider.

The original shot for *The Pool of Tears* (opposite) was taken in the bathtub in my family home. Looking at the images afterwards, I found the expression on my face to be intriguing, but felt that the image was fairly boring because of the plain white of the bathtub. The way my hair dripped into the water formed the basis of my idea for the

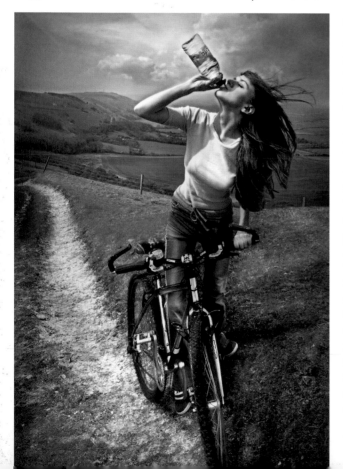

processing. I wanted to make the water look like a pool or pond, by turning it green. I started to experiment with the image in Photoshop by dragging—rather painstakingly—blades of grass cut from another image. I then built up a whole new environment around my figure, inspired by both the famous painting of Ophelia (and its many renditions and interpretations) and the imagery of *Alice in Wonderland*, from which the title of this image is derived. The bank on the right was taken from a stock image. The sunshine and my rosy cheeks were created with the paint tool. The tear on my cheek was already in the original image, but I enlarged it by selecting around it and using the Transform tool, then blending. I also added a leaf and shadow to the water.

Active Life (left) was part of a campaign for a local bottled water company in Brighton, UK. This is a close-up of me drinking the water from the bottle and a full-length shot composited together to meet the company's needs. It took some work to reconstruct my arm on the bike, and to reform the landscape around me, but the final result was seamless enough for the art director's approval.

I Dreamt of Harehills (far right) was shot in Harehills, Leeds, the area in which I grew up. On a trip back there, I took some photos of the streets at night, with the intention of using them in a composite later. Compositing was a safer approach than trying to set up shots of myself during the early hours. I wanted to convey a narrative based on a dream I had where I was running through Harehills under giant flapping seagulls, as if I had confused my inner-city home with the coastal area in which I now lived. Though the compositing job was not as involved as the other two images shown here, there was a degree of risk placing the seagull into the frame so magnified—in a larger version of the image you will notice more gulls have been placed on top of the shop sign and on the roofs of the houses beyond it. The self-portrait aspect itself might not be immediately apparent, but I am running across the junction of the street in a blue dress, barefoot. This image was actually taken one sunny day in South Wales. I also added a subtle artist signature to the graffiti on the wall.

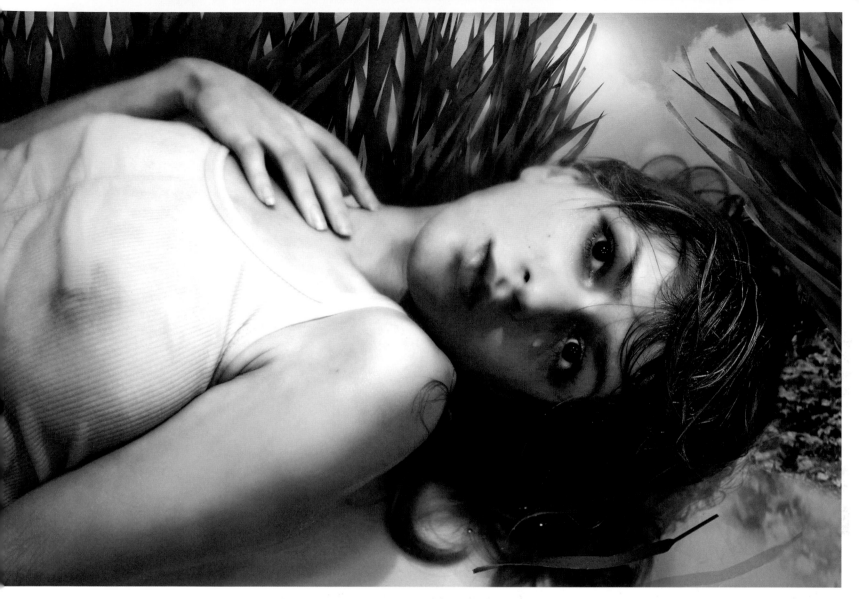

THE POOL OF TEARS *2006* *(above)*

I categorize this kind of image as a "fantasy" composite, a style I have gone on to apply to other people who have wanted to be featured in otherworldly scenarios. This image has been used on the cover of a French novel.

ACTIVE LIFE *2008* *(left)*

One of my commercial self-portraits, which allowed me artistic freedom in the interpretation of the client's requirements. The image, which was used in the bottled water company's final print campaign, was shot on Devil's Dyke in Sussex, UK.

I DREAMT OF HAREHILLS *2008* *(right)*

The "Puck Match" painted advertisement featured in this image is a memorable view of Harehills in Leeds, where I grew up. Having seen this place regularly throughout my childhood while traveling to and from school, this image explores the meeting of past and present in a dream which confused my home city with my current place of living.

HOW I PROCESSED
BENDING OVER BACKWARDS

This self-portrait, on an esthetic level, is almost purely a result of post-production. The original image is so different from the result that one might even question the relationship between the two. It is indeed an image from my third processing category: images created with significant transformation through processing. It is also the epitome of the "blind journey" that a self-portraitist—or indeed any photographer—can take not only through the shooting of an image, but through post-production too.

The original image was shot against a wall, in low lighting in a cluttered room in my flat. I wrapped a piece of fabric round my waist (actually a valance, or "bed skirt," purchased from a charity shop) in the manner of a tutu. I had a pack of playing cards to hand as a prop, though none of the original cards appear in the final image. I shot a variety of images with myself against the wall, with a vague notion that I could composite together images with one leg on the wall and then the other, with the "trick image" approach. Once on my computer, I didn't hold out much hope for any of the images as the lighting was uneven, there were distractions in the form of clutter, the baseboard and the carpet, and the implied narrative was unclear.

I came back to the image (1) with fresh eyes after having left it for a while (something I always recommend that you do when feeling jaded), and attempted to clean up the background of the image, to at least see if I could isolate my pose against a plain background. I was uncomfortable throughout this process because I knew that I was spending time on a procedure that could have been prevented by shooting against a well-lit home studio backdrop, and I was also aware that the more I dramatically manipulated the pixels, the more I degraded the image. The main leap came when I decided to import a leg from another image (2–3), crop one end off the image and clone out the remains of the original, outstretched leg (4). Now the pose was complete, but the uneven lighting was even more apparent, emphasizing the strip of darkness across the center of the image (5–6). I kept working on lightening the image by adjusting Levels and Shadows/Highlights, and de-noising the image a few times over, taking care to keep detail in the face and limbs by erasing through the de-noised layer with a soft eraser.

Once I got the image clean enough, I wondered how to "dress it up" to give the image a message or meaning. At this point the image showed me flexing with a remote shutter in one hand, which could have conceivably worked as a surreal, acrobatic triumph for the remote-wielding self-portraitist. I considered flipping the image vertically, to make it look as though I was surfing the ceiling, but this did not look right. I then reverted it to its normal position and had an idea to reintroduce the playing cards, which I had tried to use in the actual shooting, "Photoshop-style."

At the time I was about to launch my brand new website, which had playing cards as its Flash intro theme. I made screengrabs of the virtual playing cards from my web browser and took them into Photoshop (7–8). I then meticulously transformed, rotated, warped and textured them so that they appear to be falling from my hand and spilling onto the floor, obscuring the remote in the process. It took some time to format each card, and at final viewing they still looked slightly false, but it was an "unreal" look I favored, which I felt went well with the peachy "Pin-Up" style tones of the piece.

I then wanted to give the image a sense of gravity by marking out the line where the floor would meet the wall, and then changing the hue and saturation of the floor to distinguish a kind of carpet or at least a floor of some kind (9). I was then aware that a skirting board was needed to make this insinuation plausible, so I took a skirting board from a stock image and stretch-transformed it across the image, carefully erasing through a layer mask to bring myself in front of it. I added final retouching to my face, which included saturating the red of my lips and using the dodging tool to enhance the whites of my eyes.

This image took a lot of processing overall. However, times like these are proof that compositing can, with some creativity and perseverance, give some of your moribund images a bounding afterlife. These occasions also importantly illustrate how post-production is indeed an art, whether you see it as part of the art of photography, or an art all of its own.

BENDING OVER BACKWARDS *2010* (right)

This image was shot with a Canon 5D Mark II with 24–70mm EF *f*/2.8 L USM lens. Although the 5D Mark II has excellent capabilities dealing with low-key lighting environments, adequate lighting is still needed to avoid noise. This image, lit with a small bedside lamp, was shot with ISO 400. The intense post-production I applied necessitated de-noising and some clone-patch work.

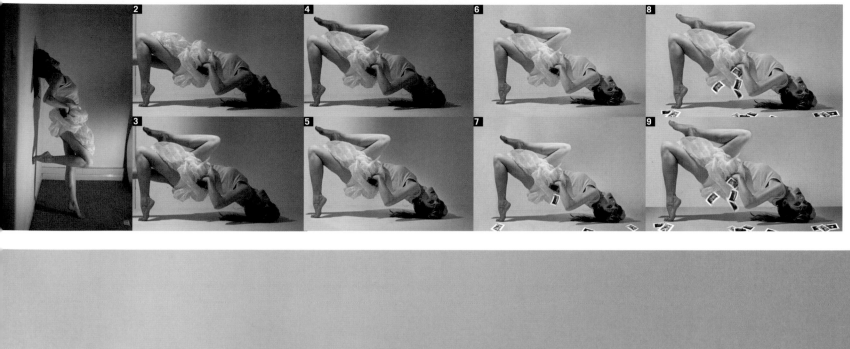

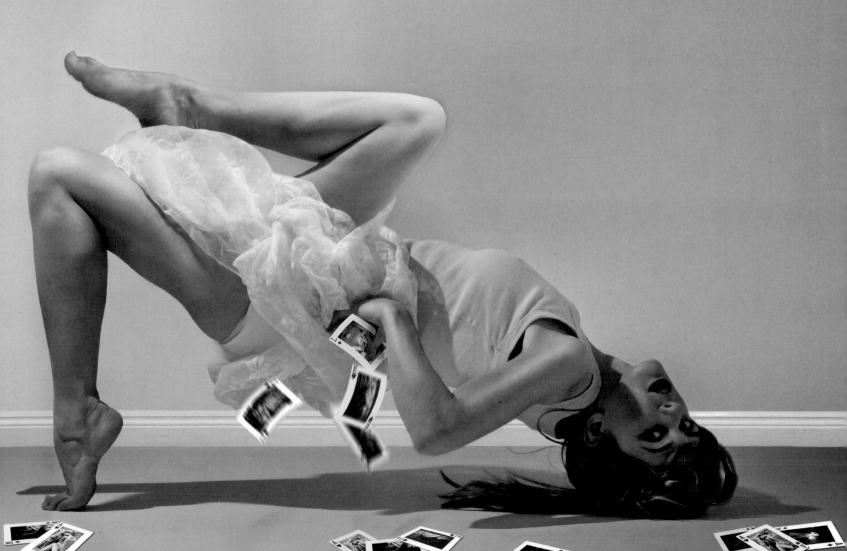

HDR

HDR, or "high dynamic range" photography, is a set of techniques that involve fusing together different exposures of the same shot to reveal more than meets the camera's eye. The notion of using multiple exposures in this way was acknowledged as far back as the 1850s with the earliest film photography. Nowadays, computer processing has widened the scope and availability for HDR techniques. Often misleadingly associated with garishly exaggerated images that reveal a bedazzling amount of unnatural color, the true aim of HDR is actually to recreate a scene as the eye sees it, in all the detail on which the camera would usually have to compromise.

Imagine the sun shining into your room. With your own eye, you'd be able to see the outdoors as clearly as you see all the detail of the room in which are you standing. Your camera, however, will need to expose either for the light of the room, or the light of the outdoors. In taking a picture, you will end up with an image of the room looking dark, but if you leave the shutter open for longer, the window will simply blow out. Either result will be uneven.

That is where the idea of "high dynamic range" photography comes in. HDR images allow a greater range of luminance between the light and dark parts of an image. It involves collecting the correct or the best exposure for all the different parts of an image, and bringing them together in a manner very similar to the idea of a composite, but not necessarily involving cutting or erasing layers (though as I will demonstrate on these pages, compositing can be used to gain complete control over the resulting image). HDR photography lends itself well to high-contrast situations, most typically when you are shooting by or near a window where there is strong, awkward light obscuring a vast spectrum of detail you wish to capture.

Dynamic range is measured in "EV" differences or "stops" between the lightest and darkest areas of an image. Higher-spec cameras will have a greater dynamic range than others. The best way to create a HDR image is in the camera, by choosing "auto bracketing" or AEB in your menu settings, but be aware that this setting might reset after you turn off your camera. AEB sets the camera to take more exposures on either side of your current settings, to

a variable degree. You should then set your camera to fire off multiple shots, which will enable the multiple exposures to be taken as rapidly as possible, which is important for a clean result. For example, most entry-level and mid-range DSLRs will offer an auto-bracketed setup to take three photos simultaneously with a single press of the shutter. The three exposures are called "+2," "0," and "-2"; "0" is the normal exposure, while the "+2" is the shutter staying open for the longest time and the "-2" is the fastest shutter speed, letting in the least light. It is also important, as with any other kind of composite, to keep the camera as still as possible, so lock down your camera on your tripod. The other way you can create HDR images is to take advantage of the flexibility of RAW editing and convert three differently exposed images from one original RAW file.

You have the most versatility in using stand-alone software for HDR images. Photomatix Pro is a popular choice, and is available for both Mac and PC. Versions of Photoshop have their own HDR function (File > Automate > Merge to HDR) and Photoshop CS5 has a more sophisticated "Merge to HDR Pro" feature offering a wider range of tools, but Photoshop has limited creative control with HDR compared to Photomatix. Over the next pages I look at how I have used myself, as an inanimate subject, in HDR images.

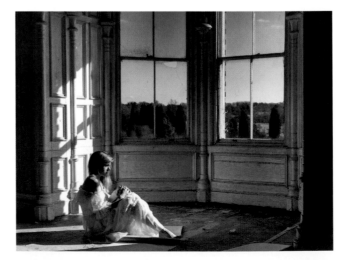

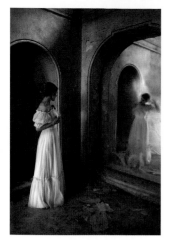

SHAFT 2010 (below)

Shot with my Canon 5D Mark II in an abandoned school. The light from the window beautifully illuminated this room, but just one single shot did not do it justice. I fused the exposures using Photomatix, and did very little extra Photoshop work to the final image.

WAITING ROOM 2010 (below left)

The blue sky outside the window and the ethereal rays coming through the partly broken glass, gave a great contrast to the peeling and dilapidated interior. I posed with a dress bought from a vintage thrift shop, and for this shot, seated myself in a pool of light on the floor.

A VOICE INSIDE 2010 (left)

The huge mirrors at this girls' school, still intact, provided great artistic scope for self-portraits. This HDR image was fused with Photomatix, and then further adjusted in Photoshop. I took my reflection from another image, merged it with another reflection to give it a sense of warped movement, and then placed it into the master image. Adjustments to Curves complemented the textures in the image.

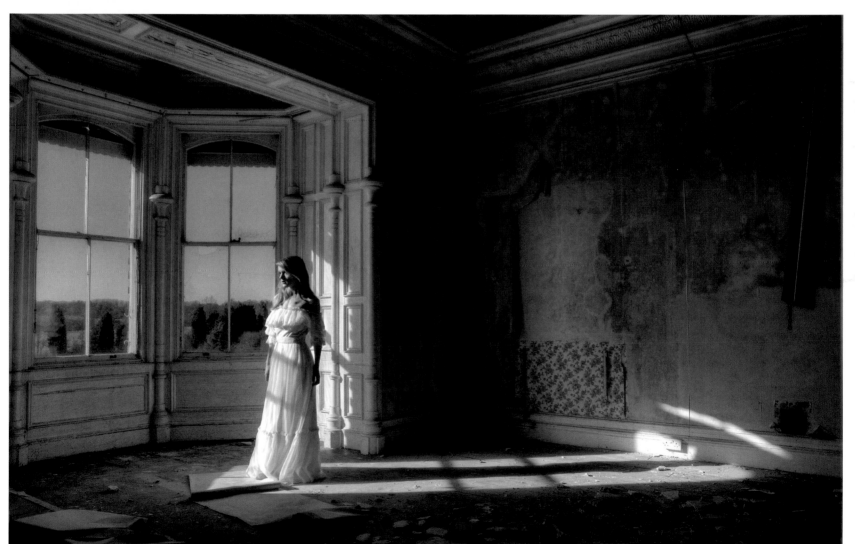

Clockwise from right

STAGE LEFT *2009*

I combined the shots for this image through Photoshop's "Merge to HDR" function. I made the figure "levitate" by simply clone-stamping out my feet from under the gown, and extending the shadow. I also introduced a slight "mist" to the scene by adding a new layer on a low opacity with a lens flare, and selectively erasing it.

HOLES IN YOUR HEAD TODAY *2009*

This was shot with natural lighting in an abandoned hospital. For this image I not only fused together different exposures, but also two different photographs: the top half and the bottom half, which I "built" into a square-format image.

AND THE MIRROR CRACKED *2009*

After I merged the exposures for this HDR image in Photomatix, I added an extra composited element in the form of my distressed face in the wing mirror.

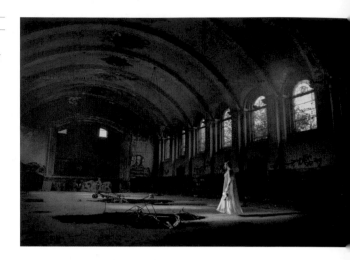

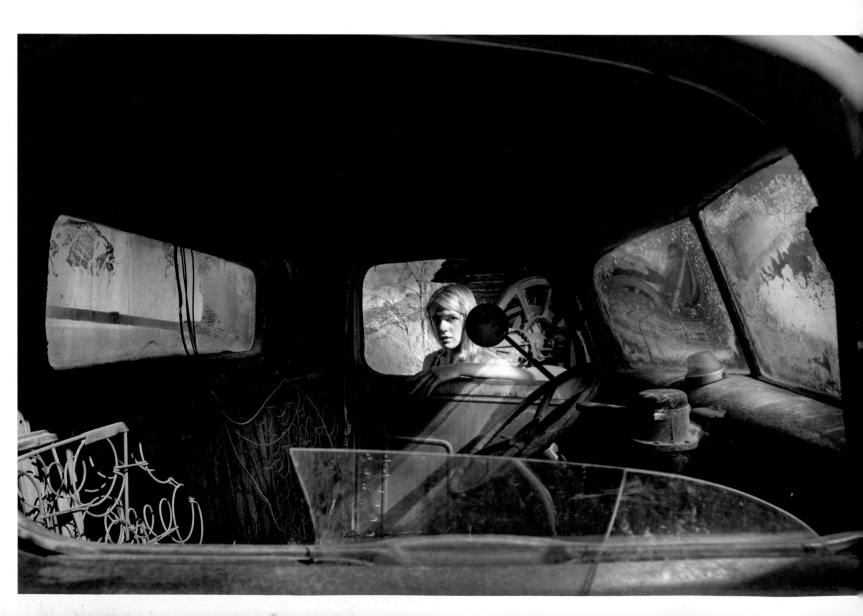

Shooting yourself in a HDR image

How does one go about using HDR techniques with self-portraiture? There are a few important considerations to make. It is not necessary to auto-bracket shots in all circumstances, as it depends on the lighting of each unique situation you encounter. Remember that shooting three frames of the same image results in three files, the total size of which could be up to 70mb when shooting RAW on a 21.1mb camera. So make sure you have enough memory space!

I particularly recommend auto-bracketing a shot when you come across high-contrast lighting: by a window, or in a situation where you have light beams and rays. The self-portraits I have shot in HDR are all set in abandoned locations, and this is because of the way light typically behaves in these environments where there are shafts of light coming through broken doors and windows.

You will need a remote shutter (or an assistant to help) so you can position yourself exactly in place before firing the shot and keeping still for all three exposures. HDR is generally not suitable for self-portraits with movement, though it is not impossible to incorporate its use. After all, shooting in HDR essentially gives you three sets of information from the same scene. You can choose to put the three together with complete manual control by using standard compositing techniques, that is, cutting out your figure from one of the three exposures (the mid-exposed one, most likely), placing it on the HDR-processed scene, and, if needed, compensating for the difference with some adjustments to the figure using Levels or Shadows/Highlights in Photoshop. This way, you can be sure to mask any signs of chromatic aberration or movement that the figure may have had in the full HDR-processed scene. Shooting an animate object with HDR techniques will always have its challenges, as the slightest movement can compromise the result. You may not be aware of slight movements between each shot until you merge the images and notice fine blurring around the outline of your body, which is where compositing can rescue the shot.

And the Mirror Cracked (left) was shot in a ghost town with the help of my partner Matthew. Auto-bracketing the shot was perfect for this situation in view of the harsh sun of the early afternoon. The inside of the truck would have been completely dark, or the detail in the windows and outdoors would have been lost otherwise. In this case, the three exposures were blended together using Photomatix, and then brought into Photoshop as layers. Using masks, I picked parts of other exposures to improve the image and further enhanced it by adjusting Shadows/Highlights. Because of the harsh light, my face was very blown out on the lightest exposure. I carefully controlled that area by importing a version of my face from the middle exposure, into the master image, on a new layer, then flattening.

Holes in Your Head Today (below) and *Stage Left* (far left) were shot in an abandoned hospital. The lighting in the location was particularly dramatic, in the way it peered through the gaping ceiling and played through cracks and crevices. By auto-bracketing the shots, I ensured that I captured this rich and diverse texture. For me, in no other environment has HDR photography been so crucial.

In making both of these images in the abandoned asylum, I found that there was movement between the bracketed shots, owing to the rushed nature of the shoots. I chose to tick the "Align layers" box in Photomatix, which helped match up the exposures. When taking the finished TIFF into Photoshop and working more with the exposures as layers, I went to Edit > Align Layers which helped synchronize the shots. Taking a manual compositing approach helped me to fine-tune the image, and make it look specifically as I desired. Through compositing parts from the other exposures, I could breathe life into areas of the image that were too dark, for example, the lower portion of *Holes in Your Head Today*, where the bits of metal jut out from the hole in the floor; and the detail all around the blue ceiling and windows in *Stage Left*. What is important to understand, therefore, about HDR photography, is that you don't necessarily have to follow rules or conventions. It is more of a concept, an age-old one, than a trick or defined type. In digital photography it can be used to wild, surreal extremes as favored by some photographers, or experimentally by those just starting out; but its subtlest—and in my opinion most proper use—is in simply delivering a scene as effectively as it appears to the human eye.

CHAPTER FIVE
SELF-PORTRAIT ARTIST SHOWCASE

ANNETTE PEHRSSON

On being asked to present a range of self-portrait photographers for this chapter, I was overwhelmed by choice. In my time spent sharing my work online I have met so many fellow self-portraitists, and witnessed their art and abilities grow. I hope that the eight people I have cherry-picked will collectively offer a broad range of inspiration for your own pursuit of self-portraiture.

These artists have years of experience photographing themselves. Each of their styles is resoundingly more idiosyncratic than that which is common in the general "photography" sphere, and yet their bold, self-centric impact and use of digital technology is revolutionary when their work is set among the contemporary "art" scene.

JOANNE RATKOWSKI

It is intriguing to observe both the differences and similarities between these photographers' experiences. Their backgrounds, cultures and artistic tendencies all differ, yet they are bound by the commonality of the simple, but powerful act of self-portraiture. I am also struck by how willingly each artist accepts the spontaneity of shooting "the self": the nature of the haphazard that flirts throughout Yulia Gorodinski's frames and lands with aplomb into Federico Erra's ten-second timer dashes; even becoming a welcome guest for the most technically-equipped photographer like Lucia Holm. The artists' approach to post-production differs from one to the next; from the delicacy of the world seen through Annette Pehrsson's Zenit-B, to Jon Jacobsen's exhilarating journey of manipulated color in Adobe Camera Raw. Every contributor here can be noted for the way they seek to challenge a norm: from the overt androgynous nature of the work of Federico and also of Rossina Bossio, to the stolid satire of Noah Kalina; from the enigmatic disquiet of Joanne Ratkowski, to Yulia's hand-tinted wonderland where she is the pin-up of her own vicarious gaze.

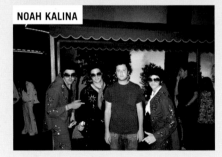

NOAH KALINA

LUCIA HOLM

These people come to self-portraiture with their own inspirations—from comics to classical paintings —with many of them interestingly mentioning the influence of cinema on their thought processes. The result is photography that springs to life with narratives, and a competence in storytelling that can only hint at these artists' wider artistic potential.

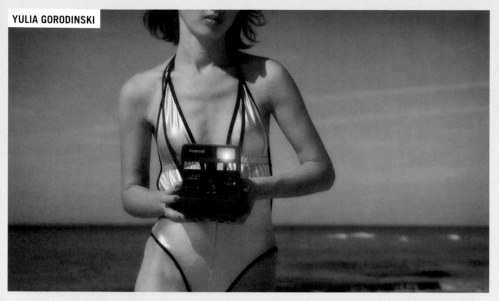

YULIA GORODINSKI

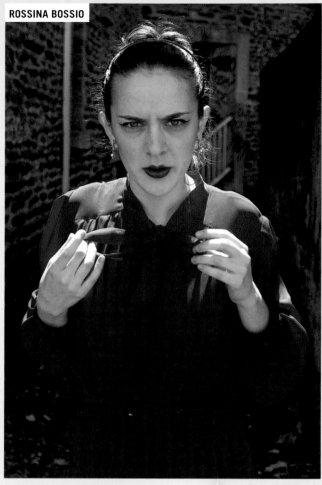

ROSSINA BOSSIO

FEDERICO ERRA

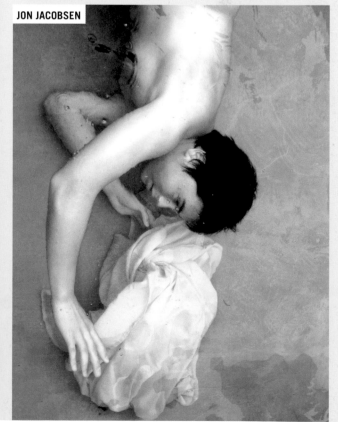

JON JACOBSEN

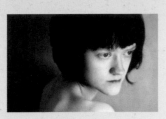

INTRODUCING
Annette Pehrsson

In order to look at anyone's work and appreciate it, we must briefly immerse ourselves into the world of that artist to understand his or her perspective. Intimacy is what Annette Pehrsson of Sweden captures best in her self-portraits, and it is not difficult to be instantly touched by the tenderness in her images. It is almost like accessing that nostalgic, carefree place that one dreams of entering: a world of warm, serene Sunday afternoons.

Largely shooting with film, the desaturated, pastel tones Pehrsson favors give her work the kind of neutral tranquillity commonly accepted by the contemporary art scene, but without any of the potential banality. There is nothing pretentious or arbitrary in these images. The person Pehrsson presents appears to be her real, raw self; but contrived before the lens in the seemingly effortless manner of a poem.

Pehrsson's photographs are minimalist and simple, and yet rich to the core with mood and emotion. The visual context in her images is usually an interior, characterized by wallpaper, curtains and ambient light. She will pose in a bathtub, on her bed or on the floor, or often, within the arms of her boyfriend. Indeed, the collaborative posing Pehrsson co-ordinates in images of herself with her partner Leo leads to some of her most touching and intimate portraits. There is an impressive, curious paradox of delicacy and powerful energy in her work. There is something emotionally moving that emanates from her images, of a world that on the other hand can be so hauntingly static. There is a filmic quality, suggestive of a past era. There are few or no smiles in Pehrsson's self-portraits, but the feelings of happiness, peace and love are all the more genuinely elicited.

THIS ROOM

This was shot in the smallest room of Annette's house, a tiny bathroom with blue wallpaper.

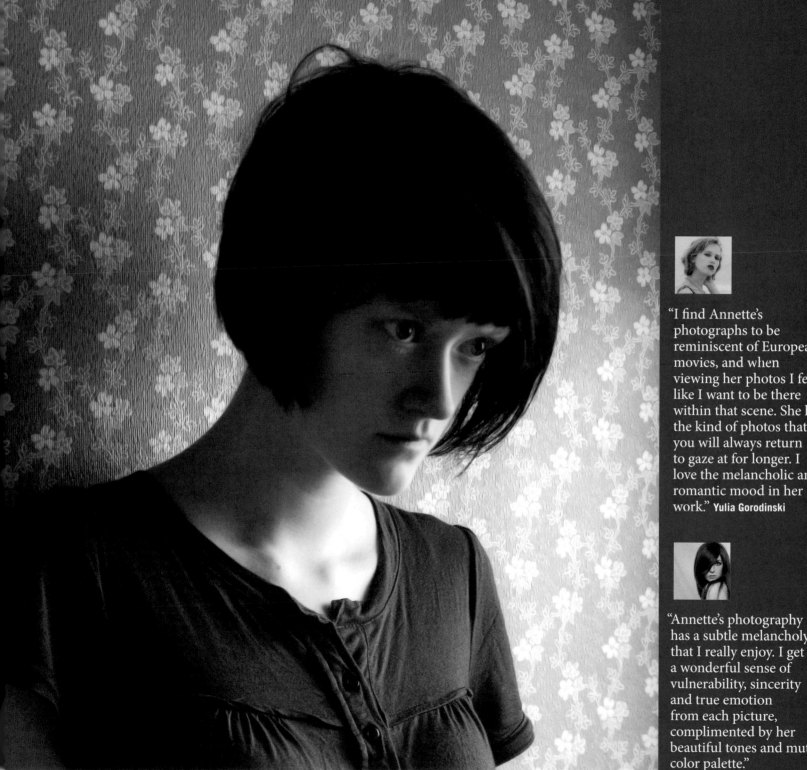

"I find Annette's photographs to be reminiscent of European movies, and when viewing her photos I feel like I want to be there within that scene. She has the kind of photos that you will always return to gaze at for longer. I love the melancholic and romantic mood in her work." **Yulia Gorodinski**

"Annette's photography has a subtle melancholy that I really enjoy. I get a wonderful sense of vulnerability, sincerity and true emotion from each picture, complimented by her beautiful tones and muted color palette."
Lucia Holm

CAUGHT ON FILM

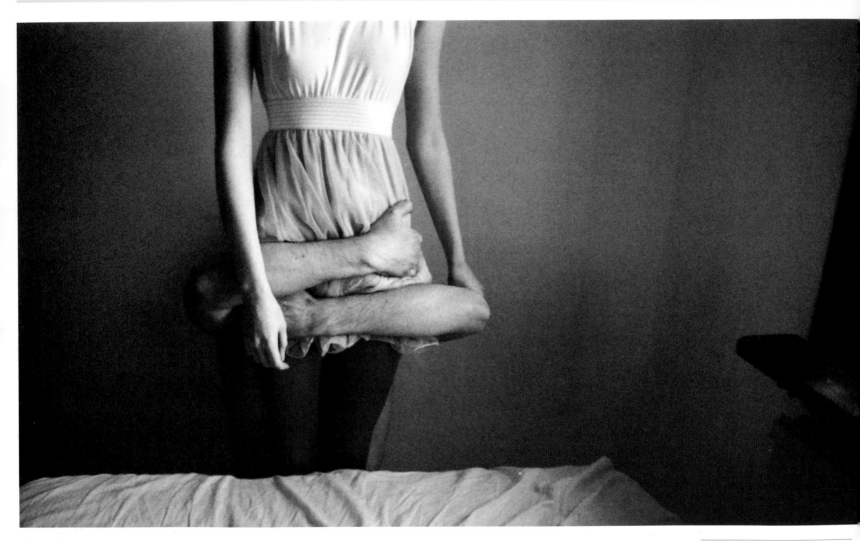

Every now and then I try to include my partner in my self-portraits, and these are some of the moments that I cherish the most.

When I was seven, my father gave me a point-and-shoot camera for Christmas. Ever since then photography has been something I treasure deeply in my daily life and for the last six years it has become increasingly important to me. When I started studying on a media-based program in upper secondary school in 2004, choosing photography as my main subject was an obvious choice. It was around this time I started experimenting with self-portraits, as our assignments often allowed us to do different series of photographs with themes we could decide ourselves, or we simply were given a pre-decided theme by our teacher, in which self-portraits easily could be incorporated. On each assignment though, I ended up showing something other than the self-portraits I made, because for some reason I felt slightly awkward about people viewing and judging these portraits of me.

During my time at school I worked with both analog and digital, however, I prefer the analog process. Developing

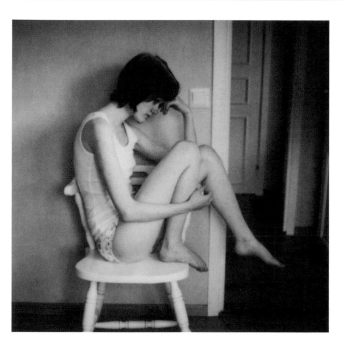

my own film and being in the darkroom making my own photographic copies on paper from the negatives was a thrilling experience. I could spend several hours each day in that dark red light, among all the chemicals of which I loved the scent. The experience of studying photography allowed me to grow a lot, both in the way I worked with images and how they finally looked in the end. I learned how to look at my work in a more objective way and take constructive criticism, something I think is highly important when it comes to working with self-portraits.

At the age of 18 I got my first digital SLR, so analog was put aside for a little while. The only thing I shot on film was some medium-format lomography with a Holga. A while after graduating in 2007 I went back to film because I felt I couldn't get what I wanted out of digital photography. The images I produced gave me the feeling of being too flat, there was no depth and I felt that even the self-portraits were too "easy." With analog, I feel completely different. In the past year I've been able to find the tools that suit my needs perfectly, a regular 35mm SLR with self-timer, a medium-format twin-lens camera and a Polaroid SX-70.

With these cameras I feel that I can finally shoot the photos I never could before, and I have at last started being more comfortable and satisfied with my self-portraits.

There is no doubt that it is slightly more difficult to make self-portraits on film, as the options are more limited when shooting analog, but the results are often exciting to see since it is easy to forget what kind of photos were shot on each roll of film. Most of the time you have no idea how the images will turn out once they've been developed.

Looking at my self-portraits, I get a strange feeling when I see myself in these pictures, and I often feel like the person in my photographs is someone else, or maybe an alter ego of some kind. I make self-portraits simply because I want to capture moments and different states of mind in my life. For the past three years or so, I have started to include my partner in my photography, both in the process of making and in the photographs themselves. His name is Leo, and seeing as he is a huge part of my life, it makes sense to portray the two of us together. I think it is important to be able to find some depth and intimacy in this, and I feel that portraying myself, and us together in this way, helps me achieve this level of closeness that I'm searching for.

Clockwise from left

UNTITLED

A Polaroid shot on slightly expired film.

UNTITLED 6843

This was shot with a slow shutter speed while I was creating movement with the bottom part of my dress. I have enjoyed experimenting with movement more in my images.

UNTITLED 8959

White wall, white sheets, bright light and our pale skin tones.

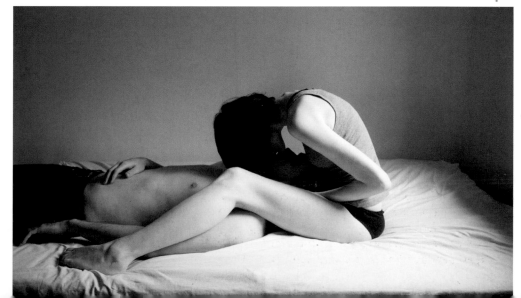

INTIMATELY HIDDEN

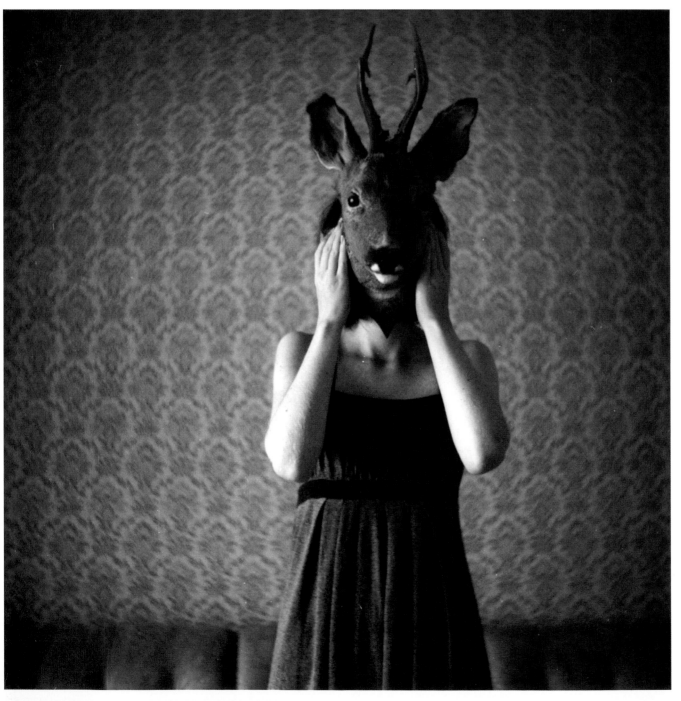

Clockwise from left

UNTITLED

My father is a fan of stuffed animals. I prefer to see them alive, but I think this makes an interesting image. This is taken with one of my first medium-format films. I love the look of photos shot on medium-format film. They always look so sharp and clear without having to go through any post processing.

UNTITLED

The cat, Kasper, sat on my lap with his eyes concentrated on the camera.

UNTITLED

This portrait of the two of us was shot with a 30-inch long shutter-release cable.

UNTITLED

I've always thought it is interesting to leave the head hidden, and also work with natural lighting from the window.

For me, self-portraits have always been a way of experimenting, exploring possibilities and learning about what I am actually capable of. Being able to use yourself as a model in photography has many advantages, and of course, some disadvantages as well. First of all, to portray yourself in front of the camera on a regular basis gives you the benefit of always having a model around, which is one of the reasons why I often make self-portraits—I'm always there and when I feel the urge to pick up a camera I never have to worry about finding a model. Since I live out in the country, quite far away from most of my friends, it is quite difficult to ask someone else to come by quickly simply because I want to shoot a picture or two.

Another advantage of shooting self-portraits is that it is easy to be comfortable in front of the camera when there's nothing else, except yourself that you need to focus on. On the contrary, this is something I have had issues with in the past, and still have at times. Do I want the photos to really show who I am, and can I be comfortable with this, or do I want them to be more anonymous so that people might not assume it is me in the photographs?

In my work, I have developed a habit of hiding myself. I usually do this by holding an object in front of my face, standing with my back to the camera, or just leaving my head outside of the frame. It is also because I have always found anonymous portraits a little bit more intriguing and interesting. Not seeing a face leaves something for the imagination. It creates a hint of mystery instead of giving away all the details. There's room for interpretation by the viewer. I honestly think the people who view my work are better at visualizing a story behind an image than I can. I always try to capture some level of my own personality in my photos, a sensation or a moment with my loved one that I want to remember in the future, which makes it difficult for me to think further about what kind of story these pictures could actually tell in other people's eyes.

One obvious obstacle of being both in front of the camera and behind it at the same time is that you cannot see yourself in the viewfinder. You have to guess how the end result will look with you included in the shot. When shooting digital, this process isn't too difficult since you have many frames to take test shots, and to determine if you need to stand four inches to the left or to the right is fairly easy. On film, the procedure becomes slightly more problematic since you can't see the result immediately after clicking the shutter.

I always try to make a composition in my head when shooting with film. I look through the viewfinder more than once to try to analyze and remember all elements in the frame, along with where I want to place myself among the scenery I'm shooting in. In this process my boyfriend offers me a lot of help as I keep asking questions, while he's looking in the viewfinder, about where in the frame I'm situated, how much space there is above my head, for example. This way I know what I need to change in order to achieve what I originally planned.

I am often more satisfied with the end results when I've gone through this slightly more complicated process of shooting self-portraits on film, knowing that I've thought out each shot thoroughly before deciding if it is worth wasting a frame on it or not.

HOW I MADE *UNTITLED*

One of the things I love most in life is my cats, and I sometimes try to incorporate them in my photographs. This is not the easiest thing to do, but on this occasion my cat Sputnik was surprisingly calm, as though he knew exactly what I wanted from him.

This photo was shot on 35mm film (Fuji Superia, ISO 800) with a Zenit-B, a Russian SLR camera, along with the built-in timer and a tripod to assist me. Most of my images go through minor post-processing in Photoshop, and I usually do this to achieve a little more softness in the tones. However, this one is completely unedited, except for a little dust removal. I always feel pleased with a photograph if I don't have to take it through this process of editing the tones. It really feels like I've done something right directly in-camera. As with most of my photos, I tried to make this as simple as possible. I had a good feeling about this session before I even started to set up the camera. To this day it is still one of my favorite images.

What I find most striking about this photo is the way the cat is the one who is focusing on the camera, while I am in a more anonymous position with my back to the viewer. As a self-portrait I think this is showing me in quite a vulnerable state, as my spine is fairly prominent and "exposed." I often get remarks about my body being too thin. However, I want to show how skin can be a beautiful detail, how it creates a certain mood in a photograph, and most of all, how personal it really is.

HOW I MADE *THE VEIL*

I was staying in a summerhouse when I photographed this. I originally planned to do this outdoors, preferably on the beach, among the sand dunes and the tall grass with the wind gently blowing through it, but since this was October, the weather was rather cold so I decided to stay inside. I shot this digitally on a Canon EOS 350D, with a shutter speed of about a second or even longer if I remember it correctly. The light was starting to fade away and it got darker and darker with every minute. I was beginning to think that I wouldn't have enough time to finish what I had started and as I browsed through the different shots in-camera I didn't feel entirely happy—it wasn't how I originally wanted it to look.

It was only when I tried to edit these pictures a second time that I actually began to see something more. I decided to play around with a new editing technique that I hadn't used much previously. I used Curves to adjust tones and contrasts, and I found a whole new world of possibilities. Looking at my screen, I immediately found a way to create a more powerful dream-like quality within the image using the soft layers of pink tones that appear to fade out into a yielding blur of yellow.

I've come to refer to this image as *The Veil*. I used a sheer curtain that I usually have in my bedroom as the veil. I wanted it to resemble a spider's web, or a sort of cocoon to give the impression that this girl has been standing in the same room for a long time and has become almost ghost-like.

UNTITLED 8925/THE VEIL *(left)*
This image was inspired by the idea of being caught or captured in "one space."

UNTITLED *(far left)*
A self-portrait I took with my cat Sputnik.

INTRODUCING
Rossina Bossio

Rossina Bossio is one of those self-portraitists who does not come at photography as a "photographer," conventionally hinged on the pursuit of the technically beautiful, but as an "artist," with probing concepts at the forefront of her mind. Bossio, originally from Colombia, now lives in Rennes, France. With an art school background, a significant part of her artistic occupation has always been painting and drawing. However, the immediacy and artistic possibilities offered by modern digital technology allows this artist to seize and perform upon her own, more immediate, stage.

Like other artists, Bossio seems driven to self-portraiture as a means of both finding her own identity, and in turn causing her audience to ask questions about each other. Bossio's persistence with portraying her own likeness is comparable to the drive of such artists as Vincent van Gogh or Picasso, where producing self-portraiture is an ongoing need, regardless of the artist's wellbeing, and it is the troughs rather than peaks of emotion that conceive and nourish the artist's most profound work.

Gender and religion play the lead role in much of Bossio's self-portraiture to date. Her most striking images attempt to de-polarize femininity and masculinity, and scrutinize how religion intersects with, and often dictates the nature of those gender roles. Bossio's own background and experiences seep into her creations as inevitably as they would into any artist's work, but there is a desire to protect her own inner genuine motives to create self-portraits, which can often be compromised when an artist allows the bustle of an admiring online crowd to get too close. Bossio utilizes modern tools in a somewhat cautious manner, revealing only crescent-moon slits of her real self during each of her visual "performances."

SHOWER *(right)*

"Looking at this photo, taken back in 2008 in the shower of a small flat I lived in when I first arrived in France, makes me think I could have used the title 'Bain Marie' (Mary's bath). To impersonate the virginal yet highly sexual figure, I put on a lot of makeup, went dressed into the shower and let the water soak my clothes and run my makeup. In Photoshop I added textures to achieve a moody, timeless effect, and create the aura around my head."

SELF-PORTRAIT III *(below)*

"A painted self-portrait from 2007, oil on wood, 40 x 30cm."

"Rossina Bossio is not only a photographer, but a fine artist and I believe her painting skills really aid her images to become far more than just a photo. The beautiful use of light and intentionally placed bold colors really draw the viewer to focus on the content of the images. It's refreshing to see a photographer whose work has some meaning, and a solid point of view."
Lucia Holm

"Rossina's unique photographic style is dramatic and imaginary, as if taken from some old fable and brought to contemporary, day-to-day life. I find her use of light, strong contrast and color to be very skillful and intriguing."
Yulia Gorodinski

STAGING SELF-DISCOVERY

Ever since I was a child I felt the need to express myself through art. I grew up in a very conservative and religious environment, where it was expected of me to follow a specific path, without aspiring to be an independent woman with a voice and opinion. Eventually I discovered that path wasn't exactly what I wanted in life, and in the process of discovering this, art was my main tool. Being very young I clung to art almost desperately, as a means to find my voice and way in life. I've found relief and freedom through art.

Drawing was the first technique I approached to silently start shaping my feelings and vision of the world. I remember at kindergarten and later in Catholic school I used to create short illustrated stories based on my daily experiences with my family and my female classmates. I guess I continue to do practically the same thing today: translating my personal experiences into drawings, paintings and photographs, but obviously I've grown and my vision of the world has changed, therefore my creations are more complex.

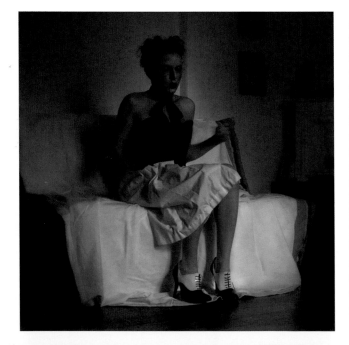

After high school I managed my way into art university in my hometown, Bogotá. I studied for three years there, following very rigorous courses in drawing, painting, sculpture, photography and video, until I decided to travel abroad. I ended up in France, where I finished my studies and started a serious career in art.

I enjoy becoming a different character, which may be a sort of elevated version of myself—an alter ego. The person behind the camera and the one in front of it are not the same. So in a sense, my self-portraits are like my own theatre. I create my own stage and I decide which role I want to play. Nevertheless, no matter how theatrical my work in self-portraiture is, the characters and scenarios I choose are never completely separate from me and are almost always linked to my most private emotions and experiences in life.

Art is for me the expression of the human mind, which is why I consider all artworks, to a certain extent and to different degrees, as self-portraits. Through a work of art we can get a deep sense of the artist's psyche, even when their physical appearance is not present in the work itself.

If I look at my body of work, I can point out every specific moment I was going through in my life at the time I created something. For instance, *White Dress* is an image about change. When a painful change takes place you sometimes get trapped in a sort of "empty space" where nothing seems to go forward or backwards… like an illusion. I remember when I was doing this photo: feeling frustrated after lots of failed attempts, I was about to take off the dress and suddenly came up with an idea for a final shot. It turned out to be something very simple, compared to the unsuccessful complicated poses I had previously tried. That day I had the theme of sexuality in mind. I have long pondered that women are "the beautiful sex" and hold the torch of sensuality and seduction. During puberty I found it hard to understand the sudden appearance of bumps and lumps on my body. Suddenly men started staring, and a very chaste me didn't know how to deal with that. Restrained by religion and biased by the media, it has taken me—and many other women—time and pain to get to love and understand my own body and sexuality.

WHITE DRESS *(right)*

For this shot I only used the soft light coming through the window. I posed with a dollish face and an ambiguous hand gesture, so that it wouldn't be obvious whether I was putting my dress on, or taking it off. I like to leave questions unanswered, but at the same time give the viewer some hints in order for them to be able to fill in the blanks. In post-processing I added the halo, which is a scanned protractor. This final touch aimed to make me look like a religious icon, holy and untouchable, representing chastity and temptation at the same time.

POWER *(far right)*

I wanted to create an image of a powerful woman—a woman who has become who she wanted to be, who has gained and mastered her power. She would be a Madonna-like figure with a halo, but still wildly sexual, filling the frame, and drawing all the attention to herself. She's a warrior, and the door handle could be her sword. She's perhaps the woman I'd like to be.

UNTITLED *(left)*

From time to time I get the need to put on some makeup and a disguise to perform in front of the camera. When I opened this photo in Photoshop to start editing, I realized it didn't need much post-processing. The only thing I did was to enhance the soft beam of light coming from the window by darkening the corners. People who know me hardly recognize me in this picture.

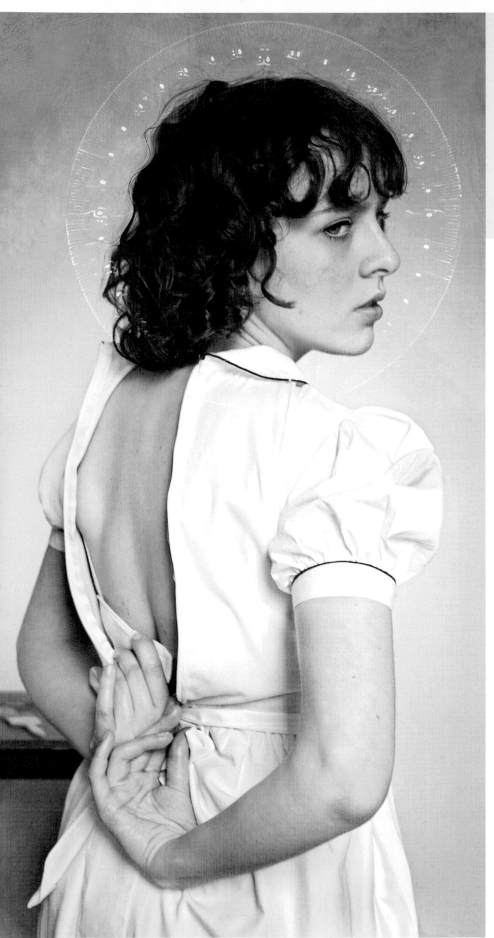

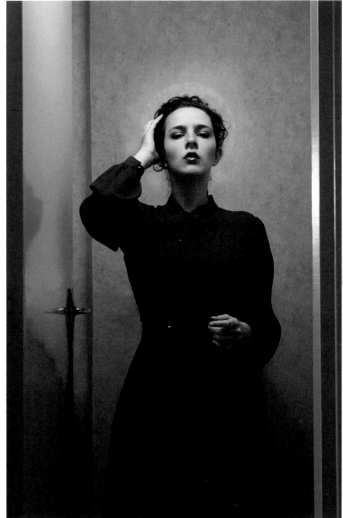

QUESTION OF IDENTITY

During the last couple of years I've been focusing a lot on female subjects. This has to do with the fact that I grew up surrounded by women: at home, with a Protestant upbringing, and at a Catholic school for girls. In both contexts the roles for each individual were strictly established: sexuality was a forbidden subject, and the world was rife with evil temptations for the good soul, from which I had to protect myself by devoting myself, mind and body to God. I was expected to be an "ideal" woman, based on the biblical paradigm: a faithful, chaste, fragile, vulnerable, virginal wife and mother. I didn't exactly fulfill these standards, and through art I strived to break the mould.

I examine other possible identities for women: I celebrate body and sexuality because, as a child and adolescent, I always had to deny them. I aim to pierce the stereotypes, because I was brought up within the boundaries of a prescriptive view of women and of humankind in general.

Undeniably, it all comes back to a personal mythology. My main inspiration comes from my own experience and memory. Aside from that, I have a large image library that enriches my artistic endeavors: religious icons, fashion editorials, illustrated encyclopedias about several subjects such as couture, sex, medicine and weapons, and also, images I find on the Internet. In general, I'm interested in images that convey different types of female identities.

Back in 2006 I had a sort of fixation with apples, which appeared in several self-portraits and paintings of mine. The apple is to me not only the symbol of sin and temptation, but of women, the second sex, created not exactly to the image and likeness of God, who apparently is a man. I could say the apple appeared many times in my images because at that moment I was figuring out my condition as a woman and as a Christian.

Despite the fact that I still introduce symbols related to religion, femininity and sexuality—for example, veils, icons, dresses, high heels, auras, lace, pink walls, baby dolls, bows, flowers, angels, strawberries, breasts—in my work nowadays, such as *Medicine and Weapons*, my concepts are more elaborate and my references are subtler.

I'm increasingly interested in conveying a sense of universality in my work. In the process of creating an image, it has become crucial for me to find the best way to translate these ideas into artworks that speak for themselves, thus being relevant for many people and not just only for me. I also aspire to break boundaries and to be questioning with my work. My view of reality is marked by contradicting feelings and incomprehension, and I'm constantly challenging my own conceptions and opinions. Inevitably, all this translates into my art.

I've come to the conclusion that creating things that I can consider as beautiful allows me to "re-build" the world on my own terms. It is this fantasy that gives sense to the absurdity I find in life. But because of my background and my vision of the world, the beauty I try to create cannot be complacent: there has to be a tragedy to it. I mean tragedy not in a melodramatic way, but as a form of art that deals with serious or sombre themes, such as human suffering, that, paradoxically, offers its audience pleasure.

LIPSTICK *(right)*

Red lipstick applied in a very untidy way, almost as if I was spilling blood from my mouth: that's what this image is mainly about. I wanted to create contrast, between the red lipstick and the blue dress, the blue dress and the white background, the rough textures and the shine in that little mirror I'm holding.

MEDICINE AND WEAPONS *(below)*

Taken from the stairs of my apartment, I wanted my nipples to be hidden behind the banister poles, as though they had been crossed out, like we see in many censored female nudes. But it was very difficult to achieve this running back and forth from the camera to the bed. This time I had to ask for assistance again, from my partner. The books lying on the bed are some old illustrated weapons and medicine encyclopedias.

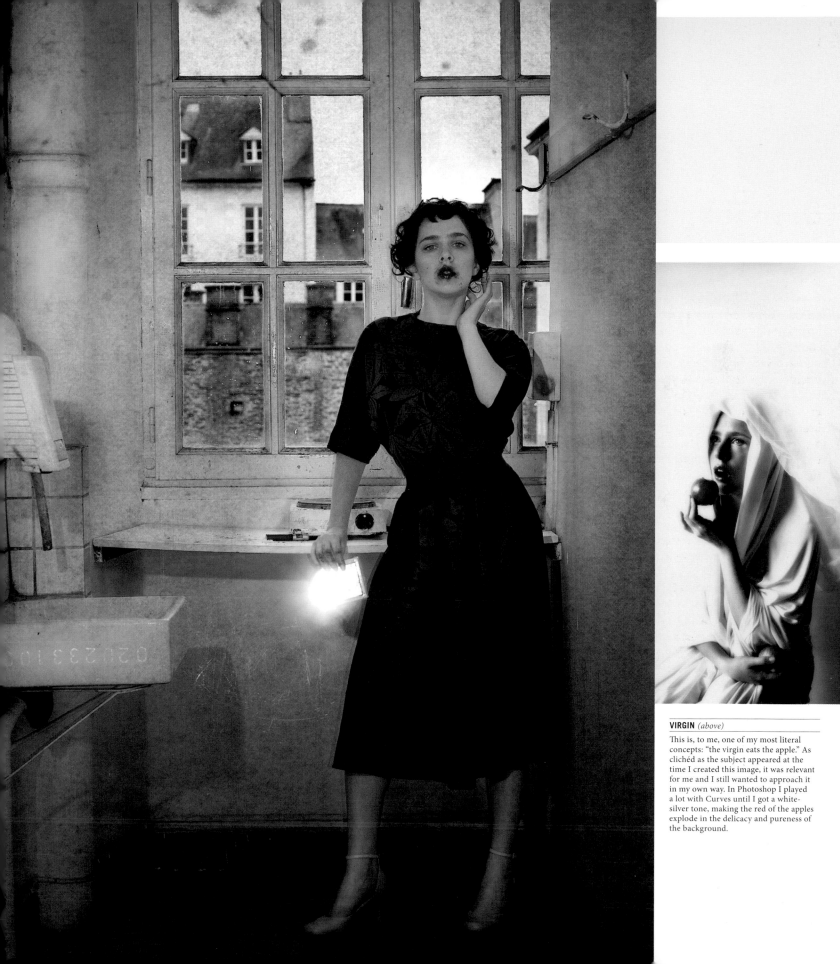

VIRGIN (*above*)

This is, to me, one of my most literal concepts: "the virgin eats the apple." As clichéd as the subject appeared at the time I created this image, it was relevant for me and I still wanted to approach it in my own way. In Photoshop I played a lot with Curves until I got a white-silver tone, making the red of the apples explode in the delicacy and pureness of the background.

HOW I MADE *SORTIE*

Sortie was taken in 2008 in one of my former art school classrooms. Often during class I dreamt of photographing those large French doors leading nowhere (there's a locked door right behind them, creating a small space where one can hide). One day, while in the same room, I watched a documentary on Rineke Dijkstra's work and finally came up with an idea for a photograph. I chose to emulate the pose of the model in *Julie, Den Haag, Netherlands, February 29*.

My image was composed of five different shots: 1) The main subject, me standing in the center of the room; 2) My face, coming from a separate shot, which I pasted on the first image and enhanced through the blue frame; 3) The location alone to get rid of the awful shadow projected by my body due to lack of lighting equipment; 4/5) Two other separate shots of me behind doors.

I wanted the image to look timeless, so in Photoshop I worked a lot with textures and brushes to achieve this. Close to the end I enlarged the exit sign at the top as it didn't read properly and I wanted that green spot to contrast with the creamy shade of the composite.

By the time I had the idea for this image I was feeling overwhelmed by the general concept of motherhood as women's major fulfillment, as though a woman who decides not to be a mother won't be a real woman. Having children has never been a goal of mine. While I acknowledge motherhood is a marvellous force of nature, I still believe it's a matter of choice.

Instead of holding a baby, as in Dijsktra's image, I embraced my own body, three times. I wanted to depict a sort of temple of the feminine, a holy trinity made only by women, praising those with no children and their power over their own bodies.

SORTIE *(right)*

On a few occasions I have revisited artworks of artists I admire, either in photography, drawing or painting. This time I emulated a pose from one of Rineke Dijkstra's photographs, part of the famous full-body portrait series of women coming out of labor. It struck me the very first time I saw it and inspired my image *Sortie*.

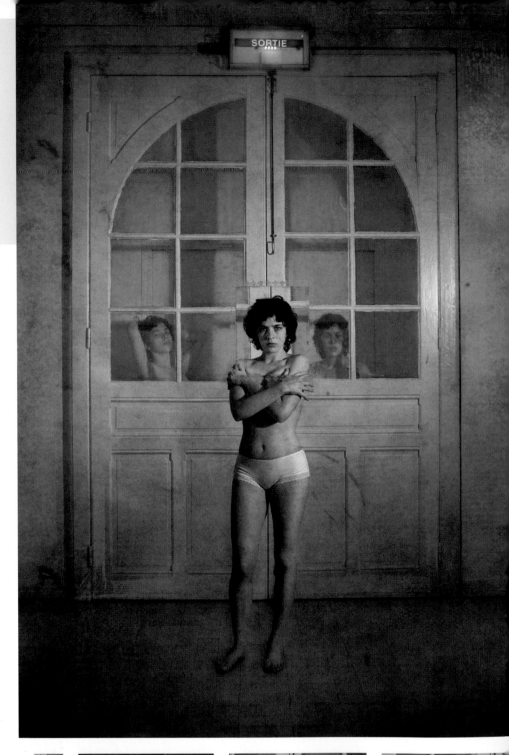

HOW I MADE *LEGS THEORY*

I'm constantly bothered by questions regarding gender roles. I try to reflect this in my imagery, which makes a lot of people think I'm a feminist. However, unlike many feminists, I embrace the specter of the femme fatale. For me, women can be fully female and sexual, and still have absolute control over their lives, mind, and body. Yet I am always questioning things like who decided women should shave their legs and underarms? Moreover, how much can we push gender-crossing in art and still achieve something esthetically appealing? It also strikes me how women have

always seemed to be the sex representing seduction. All these thoughts and questions are in *Legs Theory*.

To create the character, I put on one of my partner's shirts and a tie, brushed my hair back and put on a pair of pink high heels. With makeup I hardened my features to look more masculine. My living room is the setting and the painting hanging on the wall is mine—a semi-naked girl, somewhat "caged" by a hoopskirt. I lit myself with a single, fairly powerful light bulb. Post-processing in Photoshop was kept to a minimum.

LEGS THEORY *(below)*

This is one of the images that made me realize that even though there's no sin in post-processing—contrary to what many photography purists might think—each image sets its own rules and a lot of retouching is not always necessary.

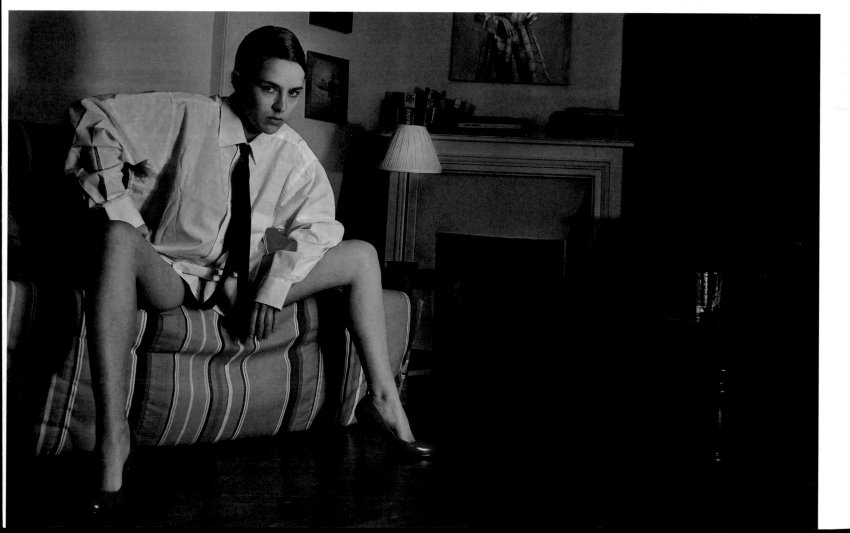

INTRODUCING
Noah Kalina

One day in 2000, Noah Kalina, a 19-year old living in New York, decided to take a picture of himself—and then repeatedly, day after day. Six years later, with over 2000 self-portraits, Kalina uploaded his images in a sequence entitled *Everyday* onto YouTube and the video became a viral hit, earning Kalina a parody in *The Simpsons*, with 14 million views online to date as of 2010. The feat prompted comments from the director of the Musée de l'Elysée who marveled at the far-reaching impact of Kalina's project through the mainstream and art scene alike.

Doubtlessly instrumental, intentionally or not, in motivating a generation of self-shooters to religiously maintain similar 365-type projects, Kalina's simple yet fascinating concept is hugely representative of the power of the Internet and viral media. Kalina can be recognized as a success story of modern technology: from avidly seizing a digital camera, keeping meticulous tabs on his everyday shooting, and then having the proactive nature to do something with it. Kalina now works as a fine art and commercial photographer, and is surprisingly nonchalant and modest about taking the world by storm. He has only a desire to keep growing, as organically and steadily as his own daily photo ritual. His sobering, yet humorous series *What happens in Vegas* tells us a little bit more about the real Noah Kalina—the artist who is game enough to exploit his self-professed "deadpan" expression for a series of conceptual tourist parodies, but who remains refreshingly realistic and modest about the process of production in creating such quietly artistic satire.

EVERYDAY *(right)*

Kalina says the idea of taking a picture of himself everyday was brought about by "the emergence of digital technology as a means to quickly and affordably take on a long-term photography project, coupled with an interest in the subtleties of the aging process."

"Noah's simple, crisp and clear images have a fantastic freshness that I haven't come across before." **Annette Pehrsson**

"Noah's photography is outstanding, but his self-portraits make me particularly curious. In the series of his self-portraits I have seen, he makes something as banal as daily routine, and the everyday world, seem incredibly interesting." **Rossina Bossio**

PERFECT PRACTICE

I started taking self-portraits when I was in my second year at the School of Visual Arts in New York City in 2000. I was a photography student and at that time I was strictly shooting landscapes using medium-format cameras. I had bought a digital camera and I was absolutely thrilled with the idea of being able to shoot as much as I wanted without having to pay lab fees. As a starving art student, this was perfect. One day, I was going through a shoebox of photographs from my early teenage years and I was amazed at how much my appearance changed over the course of only a few years. With that in mind, and new digital camera in hand, I thought, what better way to utilize this technology than to take a picture every single day for the rest of my life? So, on January 11, 2000, my *Everyday* project was born.

Another reason why I thought taking a photo of myself every day would be a good idea was because it would allow me to progress as a photographer; we all know the truism "practice makes perfect." I knew that I wouldn't shoot a portrait or a landscape every day, but I knew that I could take a photo of myself every day. So, at least I'd be taking photos.

In 2006 I saw a video by the artist Ahree Lee on YouTube, where she turned three years of self-portraits into a timelapse. I thought it was fantastic. I was six and a half years into my project and thought that I would try applying the same approach. I'd been interested in exploring video as a medium, but I wasn't really convinced it would work for my project until I saw her video. I put the video up on YouTube, and it became a huge success. Seeing it parodied on *The Simpsons* was such a thrill—I didn't expect to see my work filtered through popular culture. After the episode aired, the writers got in touch to tell me how much it had inspired them. That is one of the most wonderful feelings about making art and having it become successful, the idea that you are actually inspiring other people. Whether those people are the writers of *The Simpsons* or art students just starting out, it really means a lot to me.

I think photo-sharing is one of the greatest things that has ever happened to my career. I have got a lot of work as a result of art directors or photo editors finding my photography on flickr. I highly recommend photo-sharing: flickr is like the mall, everybody goes there, so you might as well have a shop. However, I did start to find the comments function distracting. Photography is a visual medium, and while I enjoy thinking about photography and talking about it with others, I feel that having whole conversations posted below each image takes away from that image's impact.

I've been fortunate that *Everyday* has been shown in galleries, museums and film festivals all around the world; published in textbooks, art history books and journals. In terms of my commercial photography career, I can't say it has had a direct impact; it is very rare for people to hire me just because I can take a photo of my face every day (although that has happened). Mostly, it has just given me some name recognition, a reason for them to investigate the rest of my work. I now have an agent who specializes in fine-art commercial photographers, so most of my professional work now comes through her, but I have been taking photos professionally ever since I was in school, and I have built up a steady stream of clients through simply practising. I really just like taking pictures. Nowadays, whether I am making personal work or commercial work, I am happy. They are each interesting experiences for different reasons.

SELF-PORTRAIT *(right)*
Brooklyn Bridge.

SELF-PORTRAIT *(below)*
Paris.

EVERYDAY *(bottom)*
Images taken from Noah's sequence of over 2000 self-portraits uploaded to YouTube in 2006.

AN EVERYDAY JOURNEY

SELF-PORTRAIT *(left)*

Stratosphere.

SELF-PORTRAIT *(below)*

Hot Babes.

SELF-PORTRAIT *(bottom)*

Under construction.

The technique for my *Everyday* project (seen on the previous pages) is quite simple. I use a camera that has a flip screen, so I am able to see my face when I take the photo. I hold it at arms' length, put my nose in the center of the screen and take a photo. I do it twice every day. When it comes to my personal appearance, I do not try to flatter myself. I aim to create the most accurate representation of my face. I do not smile because I like to think of that as a "control": if I am going to accurately compare my appearance on any given day over the course of a few years I thought I should try and keep my facial expression as consistent as possible. At the end of each month, I go through and pick my favorite shot from each day, add the date, and back up the files.

These days, I travel pretty frequently to shoot for a variety of magazines, mostly portraiture. Generally I take pictures of artists, architects, designers or musicians. Luckily my assignments are often fun. They send me to interesting locations and usually allow me to continue developing my personal projects. Often I'm able to get a photo from the assignment that I can consider personal work, and just being in the new location inspires me.

I like to think that all of my personal work is a sort of self-portrait. I like to infuse a certain sense of humor into my work: odd juxtapositions or weird compositions that I think of as being "hooks," like the catchy part of a song. All my pictures are extensions of my personality. I like variety, from images of nude women to landscapes. I used to look at a lot of photography, but I don't do this as much these days. Other things inspire me: mostly music, wide-open spaces, sometimes I even find art that I dislike to be inspiring in its own way.

I have a few self-portrait projects in mind. Mainly they are individual photos, not part of a larger ongoing series like *Everyday*. Lately I have been interested in self-portraits in photo booths and amusement parks. It's funny because I have never been the type to set goals. I just want to take photos. I want to make work that I think is really good, and I don't necessarily know if I am doing that yet. There is a sense of struggle: I just want to get better. I feel like I'll know it when I see it, but I also know I might never see it.

HOW I MADE
SUNBATHING

What happens in Vegas is a project I conceived in the summer of 2007. In the US there's this odd mythology about Las Vegas. It's a place you visit on the weekend, or for a bachelor party, and whatever wild thing happens "stays there." Every time I visited the place for myself, I found it to be a tremendous bore. For me it is the antithesis of fun. I decided I wanted to visit Las Vegas and take "tourist" photos of myself not having fun. I've become known for my "deadpan" look, so this was pretty simple to pull off. Technically speaking, this couldn't have been easier to do. I used a Yashica T4 point-and-shoot film camera. I had an assistant take the pictures for me. From a conceptual standpoint, the idea is what matters. I don't think it is actually necessary to physically take the photo myself. The idea is what is important, particularly in this case.

My assistant was also a photographer, so he had good knowledge of composition. I trusted him with the frame. We just did one picture at each setup. The concept was key, and the satirical nature of the concept meant that the photos didn't actually have to be "good."

I made a list of things that people tend to do when they're in Las Vegas. One of them was to sunbathe. Personally this is not something I ever do, so the idea to pose as a sunbather, fully clothed, was funny to me. With that in mind, we hit the pool area at the hotel where I was staying. It was 120 degrees outside—no exaggeration—and nobody was around. So I lay down, had my assistant stand back and get a landscape shot of the scene, and there I was. Self-portrait success.

SUNBATHING *(right)*

An image from my *What happens in Vegas* series. The idea was to parody the tourist, and here in particular, the sun-seeking tourist.

INTRODUCING
Joanne Ratkowski

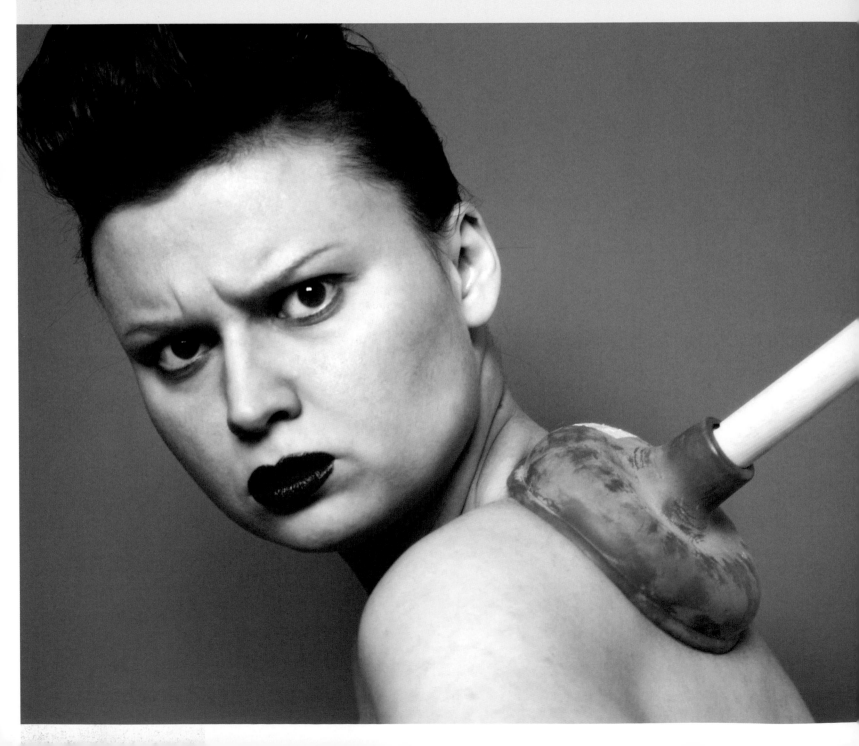

To experience the work of Joanne Ratkowski from Chicago, USA, is to go on a psychological odyssey through visual riddles. Committed to conceptual photography that is littered with literary and philosophical references, Ratkowski is also a clinical psychologist. Her work is stamped distinctively with the signs of a constantly engaged mind that thrives on repeatedly re-evaluating our existence rather than settling for commonly accepted logic.

In Ratkowski's work the concepts are key: the ideas are overflowing, rattling within their cages, sometimes unable to be contained within the esthetic frame of the image itself. There is a constant questioning, a threat to the stability of the viewer's own disposition, a certain unease, particularly in her Freudian series entitled *Sex and psychology*. There are no inhibitions in Ratkowski's self-portraits, and little desire to fulfill many people's base lust for beautiful images or something that is easy on the eye. Her use of Dali-esque surrealism through Photoshop manipulation is intentionally unsettling, serving more to strip life down than to prettify it.

To use herself as the model in so many of her images can only be an advantage to being able to explore her own inner psychology on a personal level, but Ratkowski will often become the actor within a scene, who is performing a universal role for the diverse interpretation of her viewers online. It also allows her to broach the very nature of what she calls "the moody, mercurial and mutable Self," and relate her conceptual ideas to the person at hand whom she knows best—or thinks she does.

"I really admire the fearless nature of Joanne's photography. The in-your-face attitude of her images, combined with high-contrast, saturated colors, and an overall darker palette really complement the content of each photograph in a painterly way." **Lucia Holm**

"Joanne's images are visual metaphors, filled with deep psychological meaning and great sense of humor. When I view an image of hers, I get the feeling she left a door open into her brain, giving me the chance to wander inside for a while—just long enough to leave me enchanted." **Rossina Bossio**

CUPID IS FULL OF SHIT *(left)*

"Sometimes love is not all that it's cracked up to be."

JOURNAL OF
A PSYCHOLOGIST

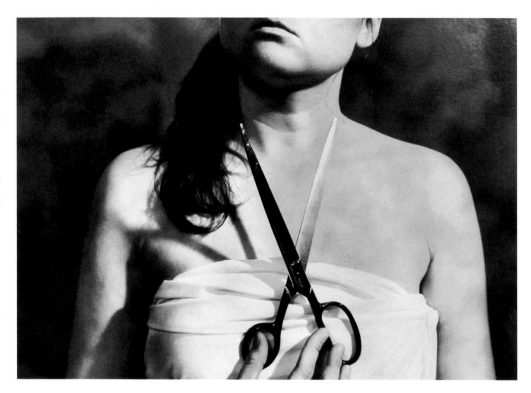

free expression) of adolescence and eventually led me to my profession of clinical psychology.

At one point in my early thirties, my father begrudgingly loaned me his very basic digital camera. Because it was much more economical than film, it afforded the opportunity for fun experimentation, a no-holds-barred way of documenting the movement and colors around me. I found myself quickly outgrowing journaling as a mode of self-analysis because photography became just so much more interesting, personally satisfying and challenging. I was often surprised how my mind's eye and the image I shot produced different results. The word "serendipity" became a salient variable in this process. I looked forward to those photographs that produced those very serendipitous results as they gave me interesting feedback about myself. In essence, photography became a natural metamorphosis of my journaling and allowed me to evolve from articulating my ideas, needs and dark desires from the intangible written word to the more palpable image.

Most importantly, however, when I began posting my work on an image-sharing site such as flickr, I now had an audience for my process and received feedback. The site also helped me to develop a kinship with fellow intrepid explorers of the "self" and learn from their process, in a way that was both interpersonal and technical. A lot of the time I chose to explore themes related to painful, personal overcoming. Seeing that other artists explored similar themes, many of them so eloquently and artfully, both comforted and validated my own process of the universality of pain and determination to understand and overcome. Overall, sharing my work has been a positive experience and a great forum for my expression. The feedback I've received has been very encouraging, challenging, and has motivated me to continue.

I always like to say that for me, the next best thing after words is images and thus I tend to think that untitled photos are like unnamed children. Photographing my process and hinting at my motives through titles eventually became the perfect marriage of my passion for self-understanding through words and images.

I was originally born in Poland and immigrated with my parents to the United States at the age of eight. I have since resided in Chicago. When I reflect on this monumental childhood event, I like to think that so very early on and at times even unbeknownst to me, I was an outsider looking in. I was an outsider trying to capture, understand and make meaningful her experiences, and to assimilate them. While the desire for deeper self-understanding may be a universal one, it can be achieved in a variety of ways.

My desire for self-exploration and self-understanding began in my late adolescence with journaling. The almost daily journal entry or mood inventory became my constant companion. I found that it helped me to better understand what motivated my reactions to other people's behaviors. This process taught me that self-awareness is quite valuable in helping to assuage the Sturm und Drang (translated as "Storm and Stress", a historical movement in German literature and music where extremes of emotion were given

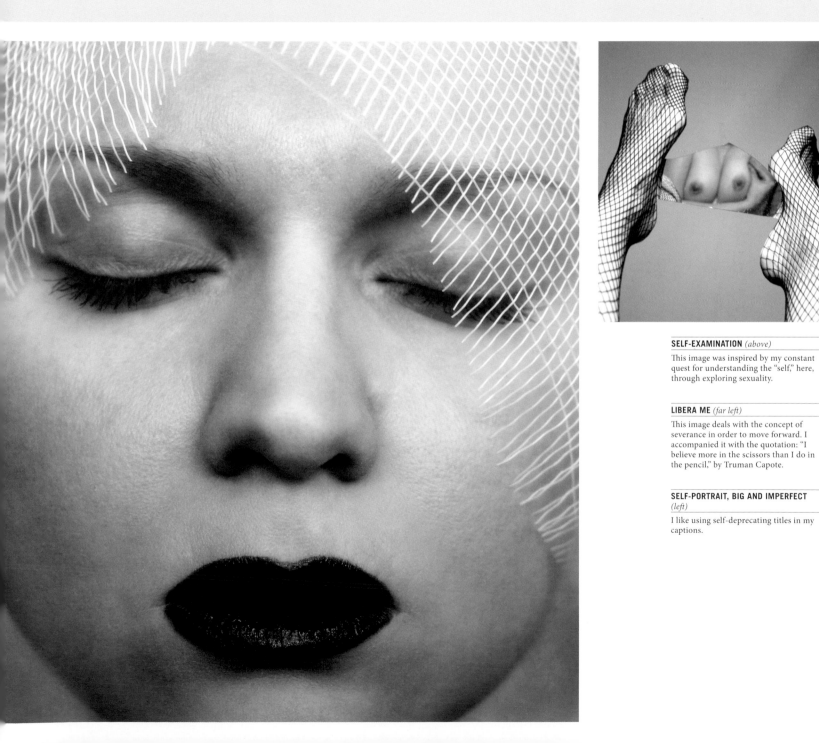

SELF-EXAMINATION (above)

This image was inspired by my constant quest for understanding the "self," here, through exploring sexuality.

LIBERA ME (far left)

This image deals with the concept of severance in order to move forward. I accompanied it with the quotation: "I believe more in the scissors than I do in the pencil," by Truman Capote.

SELF-PORTRAIT, BIG AND IMPERFECT
(left)

I like using self-deprecating titles in my captions.

FIGURATIVELY SPEAKING

Clockwise from right

PORN BY ANY OTHER NAME

I wanted to express, "what is porn anyway?"

THE SHEER TERROR OF INTIMACY

This was taken in 2007 in my bedroom and converted to black and white in post-production. In this photograph, only pure daylight was used and the camera was set to the Tv (shutter priority) mode to only illuminate the object closest to the source lighting. By focusing on a nude body laying on a stripped-down mattress and made somewhat inaccessible through dead tree branches, I wanted to create an atmosphere of sexual panic and dread, perhaps frigidity.

LOUPE SERIES

The loupe, a magnification device, is one of my favorite symbols of self-investigation.

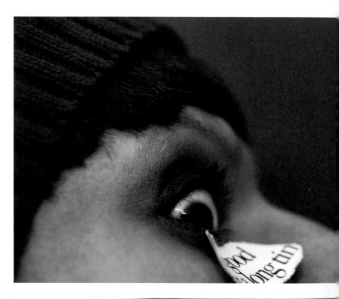

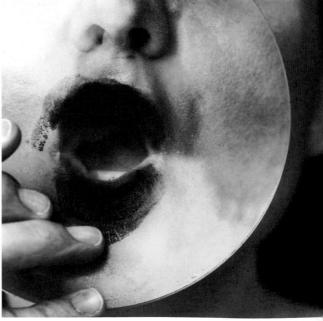

As a self-portrait photographer, my focus is on conceptual photography especially as it relates to psychology. Specifically, I like exploring the more transgressive, grotesque, unconscious and surreal aspects of the self, and the self in relation to the world. Why do I feel the way I feel? What does it mean to feel and be this way in the world? Sometimes I'm just trying to capture an emotion to simply validate its universal existence. As a psychologist, many of my impressions come from my personal experience with aberrant, even disturbing, perceptions of psychopathology. The content of my work can at times be the product of collective emotional residue or a more specific reaction to the other's process (for example, "countertransference", when a therapist projects their own conflicts onto a patient). When thinking about what frequently motivates my work, "photo-therapy" is often a word that comes to mind. But of course, I also resonate with the threads of those perceptions that I find within myself. I feel that this resonance with another's process is what gives relevance to my work. So, my photography is obviously influenced by my profession. But, in a certain sense, it is partly a documentation of my own psyche.

At the most basic level, a symbol is a conventional representation of some concept, idea or object. Psychologically or philosophically speaking, all concepts are symbolic in nature, and representations for these concepts are simply token artifacts that are allegorical to symbolism. Symbols play a significant role in my photography and other recurring symbols, such as mirrors and plungers, for example, can frequently be found in my self-portraits. Simply stated, they can represent some aspect of a relationship and be stand-ins for other "people." I feel that some of these symbols are readily understood while others bring subliminal messages that are there to help one trigger one's memory of why we are here and the truth behind the illusion of reality. In other words, symbols are a less threatening way to stay accountable for misplaced emotional reactions.

I've always considered myself a hub of underdeveloped ideas. I tend to think that it's because I understand ideas on a very intuitive level, often lacking the language to describe

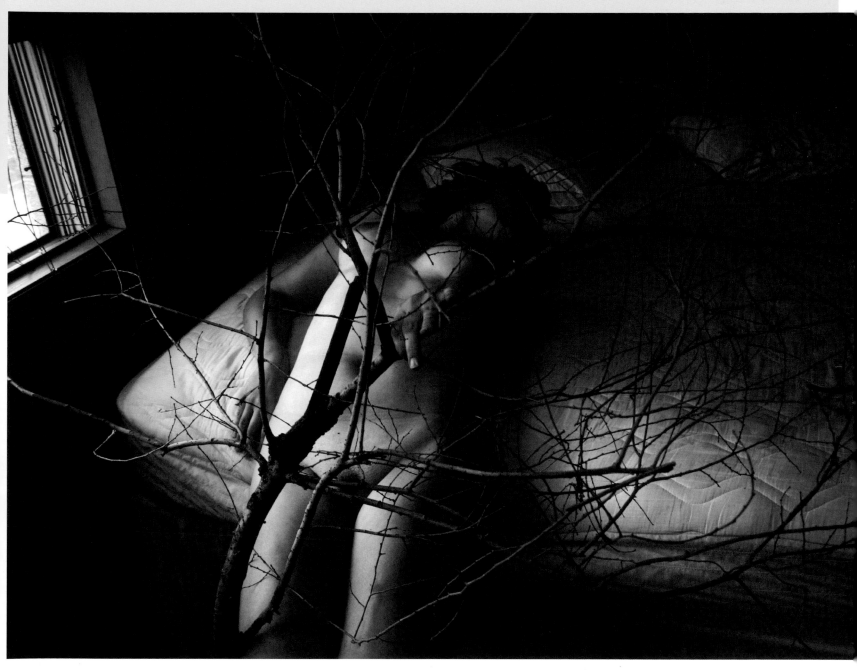

it precisely or absolutely. Reading philosophy, I felt there was always something left unsaid or perhaps "unsayable." There is evanescent meaning in symbolic objects that I see or perhaps feel at the most primitive level. I often feel that the objects I photograph allow me to symbolically express their potential relationship between the world and myself. I try to capture this naïve impression in the most raw, even literal, visual sense. I've often been asked if I worry about my photographs being misunderstood. My answer to that is that most of my images are almost "accidentally-planned-to-be-ambiguous." In other words, sometimes my

motives are precisely thought out while at other times, I act on impulse just to capture the absurdity of the moment. Like a Rorschach ink blot, there is no correct answer. So, I don't think it's possible for my images to be misunderstood. I entitle my photos very impressionistically—if others have different impressions, then so much the better.

I also employ the use of models for my concepts and ideas. Generally speaking though, I find that using a representative for my vision is not as personally gratifying and in some cases, accurate as some aspects of my vision can get "lost in translation."

HOW I MADE *SHELF OF LITTLE DEATHS*

This image is about one's relationship with loss. I've always been curious about the Jewish tradition that calls for placing a stone or pebble atop a headstone or grave during a visit. After doing some research, I found out that one of the simplest reasons for doing this is to show that someone has visited the grave. As different visitors come to pay their respects to the person buried in the grave, others can see how many people have recently stopped by.

Superstition might also play a role. Shortly after death, souls were said to linger for an unspecified time in their graves. The rocky mounds over the dead person's body kept the souls in check, preventing them from wandering away and causing trouble or confusion elsewhere. This belief seems to have stemmed from Eastern European folklore.

Keeping this tradition in mind, my thought process behind this image was that one should keep a boundary between oneself and that which was lost in the past. One way to do this is to accept that the past has its place and as such, it's best "revisited" not by recreating it or pining for its return, but through self-reflection.

I shot this image with my Canon EOS Digital Rebel XT and a tripod. It took about 20 takes to get it just right. I used a Canon Speedlite 589EX II with an ISO speed of 400. I used Photoshop to process the image.

HOW I MADE *MAD SOLITUDE*

This image is about my experience of the absurdity of loneliness, or more precisely, the absurdity of existing. This photograph was very much motivated by nihilistic philosophy, but especially Albert Camus, who asserted that individual lives and human existence in general have no rational meaning or order. As a psychologist and artist, the idea of nihilism is oftentimes a very difficult notion for me to consider, as finding and creating meaning is my lifeblood. It is a universally difficult one, as people in general constantly attempt to identify or create rational structure and meaning in their lives. Thus, the term "absurdity" describes humanity's futile attempt to find rational order where none exists.

In my photo, my hair is dishevelled to hint at a sense of madness, frustration, and detachment from prolonged isolation or simply, the meaninglessness of relationships and the act of relating to people. It shows me relating to a lemon because one is expected to react to a lemon with a "sour face." In fact, many of us are conditioned to salivate in response to seeing a lemon. My sour face in the photo is a rather absurd gesture meant to give the lemon both meaning and existence. It is as if to say, "if I can react to it, it must be real."

This photo is an example of my more experimental work that does not have a specific purpose at the outset, but can so easily be manipulated to mean something if one is so determined. This is the kind of self-portrait in which I want others to impose their own meaning or to wonder if there is a meaning at all. Ambiguity is art's most delicious provocation.

Because some of my themes were absurdity and ambiguity, I thought that converting the image to black and white would be fitting. I thought that monochrome would give a feeling of starkness, as opposed to color, which would have been too distracting. For me, a lot of the time, the final post-processed look of the photo is secondary to the interplay of its concepts. That is, the vision is completed in the mood I create with color and contrast in the post-processing.

MAD SOLITUDE *(right)*

I shot this image with my Canon EOS Digital Rebel XT and a tripod. I used a Canon Speedlite 589EX II with an ISO speed of 400. I used Photoshop for post-processing.

SHELF OF LITTLE DEATHS *(left)*

Because my subject matter was "loss," I wanted my photo to reflect a more painterly and therefore timeless quality. I feel that manipulating photographs to achieve that timeless quality nicely complements themes exploring the basic and universal conflicts that human beings have grappled with since the beginning of time.

INTRODUCING
Yulia Gorodinski

It is possible to look fleetingly at the work of Yulia Gorodinski and see her self-portraits, beautiful and sexual, as mere wanton escapades with the camera. Beheaded in many of the images, as if the camera simply arrived at her waistline or as if a voyeur were peering into her cosy cartoon-colored world as she sits on a dune or stands in a citrus grove, it is tempting to assume the model's role is simply that: a model, alluring in her semi-dressed state.

To look at any artistic images of a person, and to learn later that the images are self-portraits, can impress the viewer in any case. With Gorodinski, that surprise is heightened, because the pulsating vein of voyeurism in her work is almost too misleadingly suggestive that a boyfriend or partner of some kind is taking the pictures. Gorodinski's persistence with cut-off, unforgiving compositions that obscure parts of her body might, in one way, let us know that a tripod and remote act is in play, but the angles at which this artist shoots are akin to the genius perspectives we celebrate in the work of male photographers like Roy Stuart. Here however, it is the female model herself unashamedly naked or semi-naked, conducting a visual orchestra of post-modern "tits and ass." There is some magical spice in the recipe of the production of her images that makes the color and tones so vibrant, yet subtle, dreamlike, and yet so tangible, as if we could reach out and touch her delicate frame.

It seems Gorodinski does not really care for the attitudes of those who might deem her self-portraits vacuous, narcissistic or pornographic. Gorodinski is past that: to comprehend her work as objectifying women would be too obvious, too basic a response. The independent act of Gorodinski's images, and the way she shares them, is what gives the palette of her work its boldest color.

UNTITLED

"This image was taken at the lifeguard cabin at the beach. I asked the lifeguard if I could use his cabin for photographs. I also borrowed his binoculars."

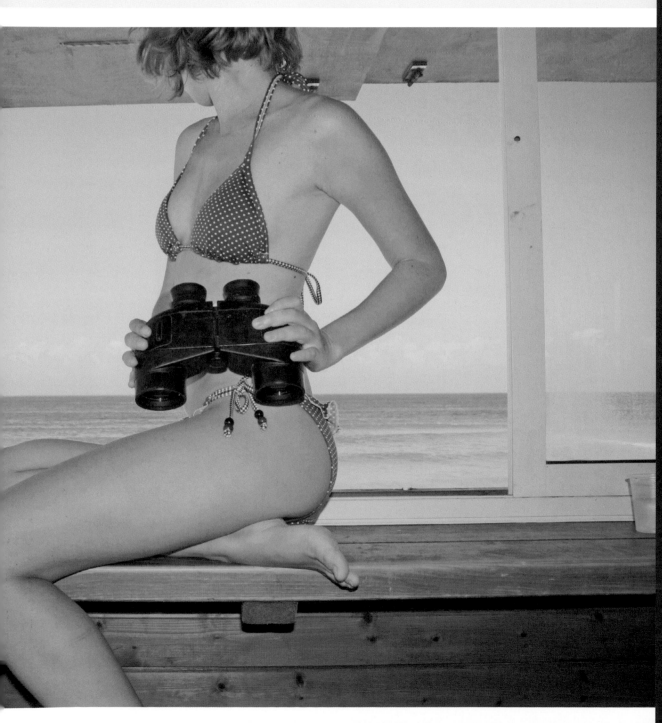

"I have become a big fan of Yulia's unusual and bold cropping, and the beautiful treatment she gives her photographs. Looking at her images makes me feel as though I'm looking at summertime family portraits from before I was born." Lucia Holm

"Yulia's work is creative, versatile and utterly dazzling." Annette Pehrsson

"Yulia's photographs embody both the joy of self-portraiture and of simply creating a beautiful image. She masters the art of having complete control over your own image and being free to manipulate it, without having to explain yourself." Rossina Bossio

WATER SPLASH (below)

This photo was inspired by photographer Aneta Bartos—in one of her images, a girl is walking and holding a bucket in her hand. I didn't have a beautiful bucket, so I used this vase. I shot it at the beach because I had easy access to water; we have a shortage of water in Israel and can't waste it.

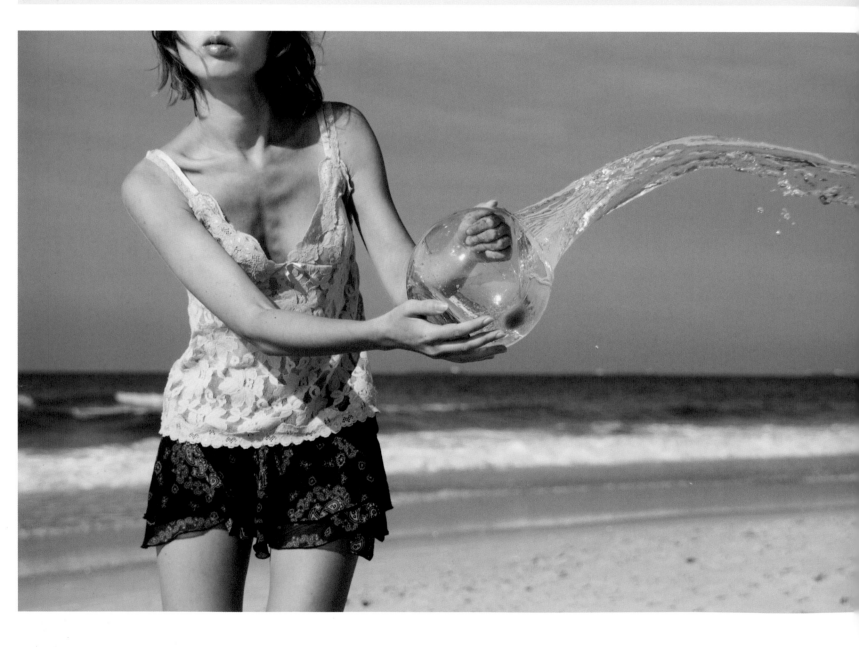

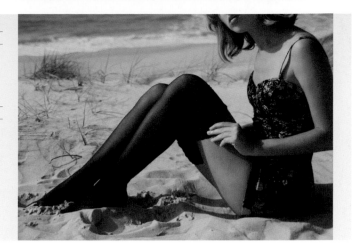

UNTITLED (right)

This image was taken using natural lighting one afternoon. I cut off the face and left only the lips to add a sense of allure and mystery.

UNTITLED (below right)

This self-portrait was taken on a dune, located close to my house. I had to take this four times before I was finally satisfied with the result.

MODEL BEHAVIOR

I was born in Belarus (former USSR), Gomel in 1984. I went to school there for six years. I also attended a music school, and played the piano for six years. At the age of 12 my family and I immigrated to Israel. I live in a small town, Ashdod, by the sea. In Israel I went to the 7th grade and in my first school year I attended Ulpan to learn Hebrew. My mother tongue is Russian, but I speak Hebrew and English.

After finishing high school, I was recruited into the army in 2002. It is obligatory for girls in Israel to attend army service. I was a secretary in a signal corps to a major for two years. In 2004 I went to the University of Haifa to do a Bachelor's degree in History and English Literature, and then in 2007 I went to the University of Jerusalem to do a Master's degree in English Literature.

I got into photography in the winter of 2007. I was chatting online to an Italian friend and he linked me to his photographs on flickr, which were just snapshots of him and his friends. Then I started browsing the site and I stumbled upon some artistic images and also self-portraits of girls that I liked very much. The more I browsed, the more fascinated I became with the photographs I saw. I felt that I wanted to create photographs of myself as well, but I only had a point-and-shoot camera. The following spring I bought a DSLR, and since then I have not stopped taking photographs. I am completely self-taught in photography and Photoshop. With practice and experimentation over the years, my photographic skills have improved. As a result of getting into photography I have completely lost interest in English Literature, and if I compare it to photography, I realize that I have never had the same degree of passion for my English Literature studies at university as I have for photography. It is the best thing that has ever happened to me.

I do take photographs of other subjects, but I mainly take self-portraits. I find the challenge of both shooting and modeling very interesting, and I love performing both roles. I like comparing modeling in a photograph to acting in a movie. When I started taking photographs I quickly realized that it is not so simple to portray a certain emotion, to take a conceptual photograph and

to make it look genuine. I therefore find it challenging to be both in front of the lens and behind it. Being both photographer and model gives me complete control over the photograph I want to take. I want the composition to belong entirely to me. I also take photographs of myself to document my life, to keep a visual diary and to record what I am going through. Another reason is that I want to have artistic photographs of myself, which is the initial reason I started. If I can take my own photograph I do not need to pay another photographer to do it for me. I would like to diversify into shooting other models as soon as I have the opportunity, and I aim to work professionally as a photographer.

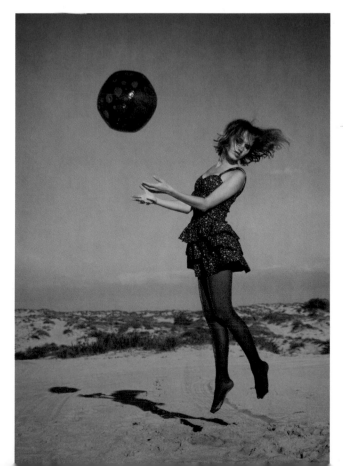

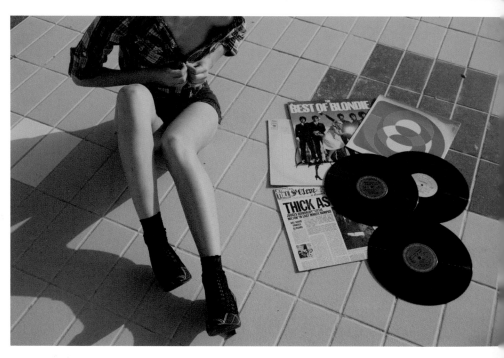

DIARY
OF MELANCHOLY

Most of the photographs I take are autobiographical; inspired by the emotions I am feeling—usually melancholy. These kinds of photographs are partially pain relieving, I can let it all out. I always want to capture the sad situation somehow, but I have never felt the urge to make a photograph that portrays a happy feeling.

In this way, my images are like a diary. I want to commemorate my feelings in my photographs, hopefully so that other people can relate to them as well. This kind of photograph is the most powerful and meaningful to me, because I have succeeded in conveying the situation I was going through. Usually these photographs portray loneliness, and misfortunes in love. There are also images where I show what I like to do from day to day, or images that can describe my personality, for example, self-portraits on the beach. The reason I take photographs at the beach is because of my newfound love of the sea. Growing up, I never liked going to the beach. As I started taking photographs, I started to love and enjoy the sea.

There are also photographs I take that do not portray anything related to me, these are just images that originated from an idea that wasn't necessarily connected to how I feel, or what I love to do. These images might have been inspired by locations, light, movies and a lot of other things that I think might make an interesting photograph—for example, a set of vinyl records in a pool.

I process all my photographs in Photoshop. I mainly alter the colors to make them look vintage. I love everything antique and I wish I lived in the '50s and '60s. It all just looks so much more interesting to me. And since I cannot go back in time, I can create an image of myself that looks as if it was taken in that period. I think it is also the place where I live that allows me to create such photographs, the warm Israeli weather and the beach nearby. My surroundings have an impact on my style. I think if I lived in another country, perhaps I would not make them look vintage, or perhaps only some of them. Photoshop is a very important part of my photography. For me, it is a tool almost as important as the camera itself. Since I like giving my photographs a retro look, Photoshop makes this dream come true.

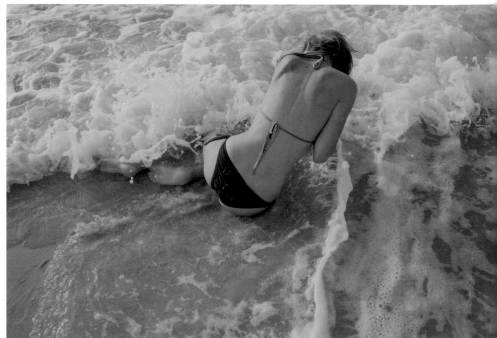

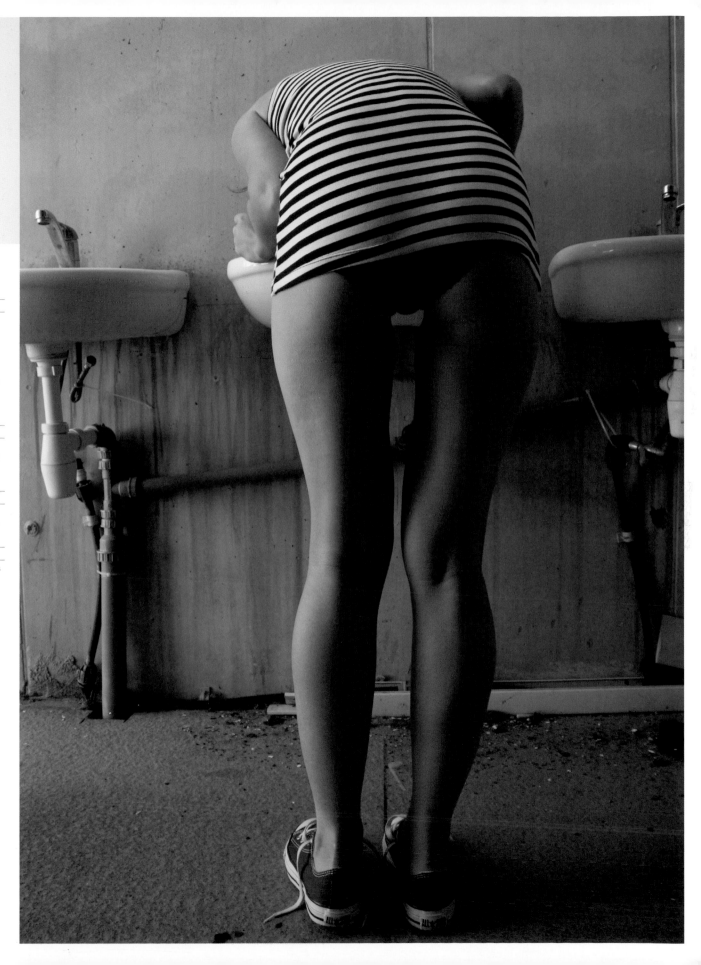

Clockwise from left

UNTITLED

I exchanged my CDs for vinyls at a second-hand shop in Tel Aviv. At first I wanted to take this photograph in my apartment, but the floor did not look interesting, so I decided to take it to a pool under construction that is located two minutes from my house. I think this floor adds to the vintage atmosphere and mood.

UNTITLED

For this image I made use of a new location, my friend's apartment, and the props there.

AWAY FROM HOME

This image was taken in Haifa, at an abandoned paintball center near the sea.

UNTITLED

Shooting this image was difficult—it was so cold! It was taken one late afternoon in February.

HOW I MADE *LOST IN A CITRUS GROVE*

I was inspired to use a bicycle as a prop by some images I saw online a long time ago. I also wanted to shoot an image at a citrus grove near where I live. I don't own a bicycle, but I managed to borrow one from some boys at the citrus grove who were happy to let me use it.

I had no idea what I wanted to actually do, or how to pose. At first I wanted to shoot on the road between the two lines of citrus trees. As I started to position my camera, the boys told me that I had better not shoot on the road because of the guys who ride quad bikes—it could be dangerous for me to stand on the road and shoot. So I moved from the road and started trying a position with the bicycle, but it didn't work, so I changed my positioning and pose. The group of boys watched how I was taking the photograph.

At first I was shooting with my face in the frame, but then I decided to cut off the face to add a little bit of mystery. I used a tripod and a remote controller to shoot this. One of the boys offered to push the shutter, but I refused. I threw the remote on the ground for it not to be seen in my hand. I processed the image in Photoshop to enhance the warm tones and suggest a more summery feel. To me, this image shows a girl riding a bicycle on a hot summer's day somewhere in the countryside, enjoying her free time, perhaps looking for an adventure. She then gets lost in the grove, wondering in which direction to turn.

LOST IN A CITRUS GROVE *(below)*
I used a Canon 400D with Sigma lens 18–200mm, shutter speed 1/400, aperture f/4.5 and ISO 100, all with natural lighting.

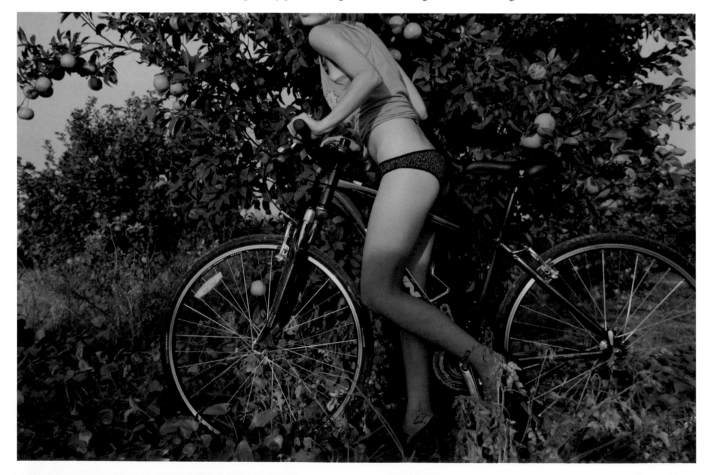

HOW I MADE *UNTITLED*

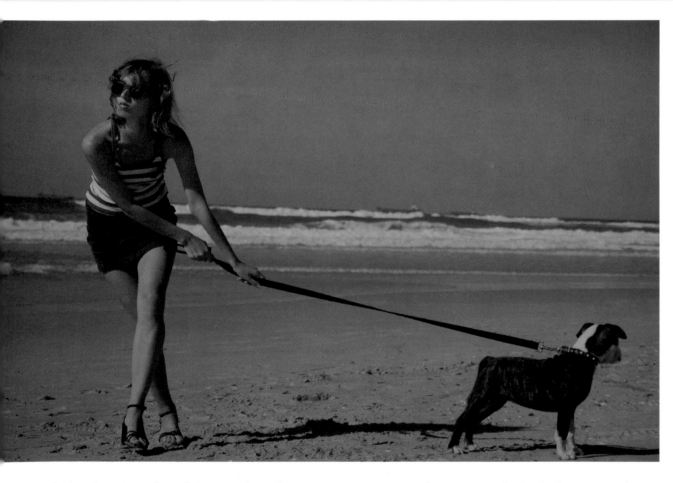

I was asked to shoot a number of photographs at the beach for a magazine here in Israel. On my way home on the second day of shooting, a small dog ran toward me. I asked its owner if I could play with the dog for a while, and they agreed. I did not have a specific idea in mind for this image, so I tried different poses with the dog along the shoreline.

For this photograph I used a tripod and a remote, which I threw onto the sand when I shot each image, so it would not be seen in my hand. Repeatedly picking it off the ground became a bit tiring, and this image took a lot of takes, more than 250 perhaps. The dog was pulling me to the side and it was hard to control him. I also had to go many times to the camera to check whether I was at the right distance and whether I was properly in the frame, because the dog was always moving. However, it was a great experience and showed me the challenge of shooting with animals.

Before I took this photograph I knew for sure that I wanted to give it a vintage look, so it was necessary to work on this image in Photoshop to achieve the final mood I wanted. I warmed up the image to make it look as if it was taken in the summer. I wanted to portray the fictional character of a girl who loves her little dog a lot and enjoys taking it to the beach in the sunshine.

UNTITLED *(above)*
This image was shot with a shutter speed of 1/6000, *f*/5.6, and ISO 100. I used only natural lighting.

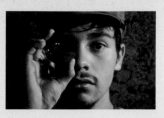

INTRODUCING
Jon Jacobsen

The world of Jon Jacobsen, from Chile, is no ordinary one. His self-portraits, ranging from the playful to the haunting, from the dramatic to the down-to-earth, embody the ambivalence of a young man relating to the reality of the world as much as they suggest the curiosity of a boy desperate to go beyond it. Jacobsen's use of props, makeup and locations is particularly creative, and not being a stranger to the wonderland of digital post-processing, he takes them beyond their raw state to another plane of psychological implication.

Jacobsen's use of manipulation in his self-portraits is always with conceptual intent: from the disturbing illusion of pulling ivy from his throat, or sinking to the bottom of a pool, to representing himself as Siamese twins sewn together, his comfort and ease with using technology to achieve surrealism is second nature. However, his eye for a good shot is by no means compromised by the attention to the otherworldly. His sense of composition, of facial expression, and other facets of photographic practice that cannot be "corrected" in the editing, is all solid; Photoshop is merely the set of paints he uses to materialize his often bizarre visions.

There is a distinct confidence in Jacobsen's work, emanating from his bold color palette that breathes life from the page. However, it is also clear that these are early days yet for the young artist. His self-portraits, whether they are a mere phase or a lifelong commitment, are embryonic of what he can offer art: perhaps not just through photography alone, but other media too. The taster of his abilities that he offers us through his self-portraits suggests all the competence of the eye of a fashion photographer and yet the moving narrative of a cinematographer. The exciting prospect for his audience is watching where he goes next.

THE INNER FEELINGS *(right)*
"The conceptual idea for this self-portrait is to capture internal human emotions, and link these with the graphics of the Rorscharch Test. I edited the colors in Adobe Camera Raw. The stain was made separately with paint, and composited into the image in Photoshop, along with the wallpaper."

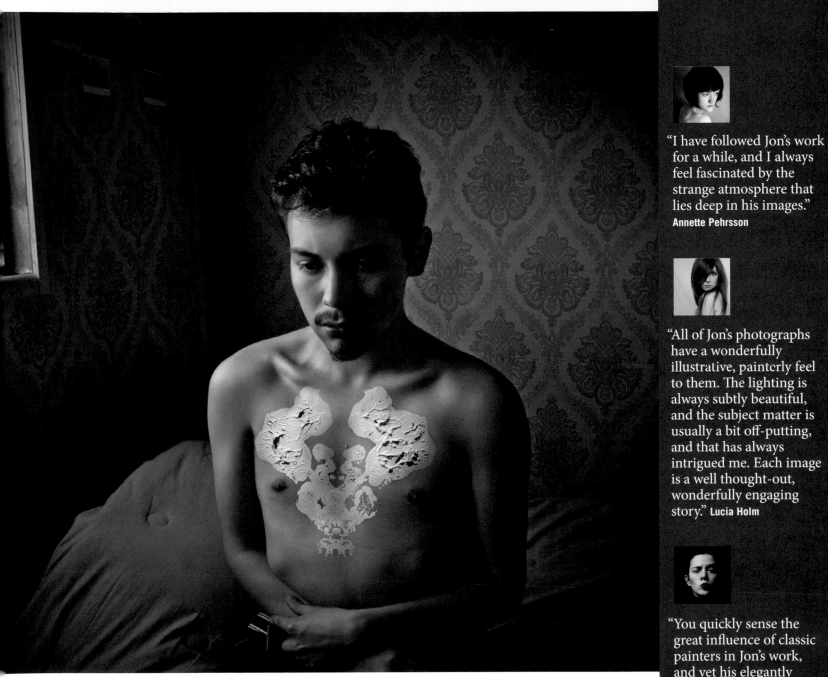

"I have followed Jon's work for a while, and I always feel fascinated by the strange atmosphere that lies deep in his images."
Annette Pehrsson

"All of Jon's photographs have a wonderfully illustrative, paintcrly feel to them. The lighting is always subtly beautiful, and the subject matter is usually a bit off-putting, and that has always intrigued me. Each image is a well thought-out, wonderfully engaging story." **Lucia Holm**

"You quickly sense the great influence of classic painters in Jon's work, and yet his elegantly composed images have a very modern feel to them. They are both painterly and cinematic. It's inspiring to see how Jacobsen's emotions and unlimited imagination come alive in his work."
Rossina Bossio

GRAPHIC AND NOVEL

Everything started when I bought a webcam for my computer, because I wanted to upload images into my Fotolog. At that moment I didn't have a particular hobby. I was searching for something to do during the long afternoons after school; I had plenty of free time and I didn't want to waste it, so I needed to get creative. The small webcam could also be used as a digital camera—it was terrible quality and barely took photos of 640 x 480 pixels! In spite of that, I started to take photographs of landscapes and things that I found interesting.

One day at school, my art teacher talked about my photos and said I should continue taking pictures because I had "a good eye" for composition. Thanks to that confidence boost, I decided to start experimenting with basic photo-editing programs. From that moment on, I secretly committed myself to photography. I started by taking pictures of myself because I was embarrassed to ask someone else to model for me. I tried different post-processing effects such as cloning myself, and created short stories that I uploaded onto my Fotolog.

With time, I became increasingly eager to learn about the possibilities of post-processing. I found the work of LA-based artist Shannon Hourigan. Her work impressed me so profoundly that I started searching for all kinds of tutorials to understand how she achieved such effects in her pictures. One Christmas, my parents bought me a Canon A75. With my new camera, Photoshop and numerous web tutorials, I learned (through trial and error) a lot about photography.

In the meantime my art teacher constantly encouraged me to participate in different photography contests. Although I thought I was still just a newbie, I decided to send a self-portrait into a contest. To my surprise, I won the first prize and the photo was published in a local newspaper. My parents, who didn't really know how passionate I was about photography until that moment, saw the photo and encouraged me to continue. That is exactly what I did, even after school, when I pursued a career in Graphic Design. I have continued to create photographs.

I got into self-portraiture mainly by chance, and because I was embarrassed to ask for models, but it gradually became a special way for me to express personal feelings and experiences. I'm still very interested in landscape photography too. I live in Quintero in Chile, a small town far from the big cities, surrounded by the sea, the woods and the countryside. The landscape I see every day has deeply influenced my work and it's a constant source of inspiration. Other than that, I'm constantly driven to create impossible and surreal situations in my photos. To achieve this, I primarily aim to use color boldly. Color is what drives me to process my images creatively and evocatively in Photoshop.

Self-portraiture allows me to create that surreal world I dream about. At the same time, taking self-portraits makes me feel freer than ever, giving me a sense of inner balance, because in the process I get rid of lots of negative feelings. It's a cathartic experience, a purifying cycle. In that sense, my life exists, metaphorically, in my photography.

THE MIND INSIDE THE MIND (below left)

I used the wire as a metaphor for a state of confusion. I painted my body white and used natural lighting. The day I post-processed this image was the day I discovered the Selective Color tool in Photoshop, so the final result was obtained after treating several layers with this adjustment.

AUTISMO (HIDE AND SEEK) (opposite far right)

I shot this picture on a Canon A75, with 3.2MP. The camera was attached to the ceiling and I used natural lighting from the window. I took two photos that I later composited in Photoshop. The color was achieved by manipulating the Curves and Channel Mixer.

SIDE A (opposite bottom left)

I used my Canon XT for this self-portrait. I wanted to try editing with pale tones—adding layers of yellow to give a slight "analog" effect in Adobe Camera Raw and Photoshop CS4.

UNTITLED (opposite top left)

This was inspired by Botticelli's painting *Primavera*, one of my favorite pieces in art history. I hung a sprig of ivy from the ceiling and let it trail into my mouth, shooting with the timer. I wanted the plant to look as if it was coming out of my throat, which made me retch several times—and actually gave a particular expression to the image. I used natural lighting along with a 200W lamp positioned to the side.

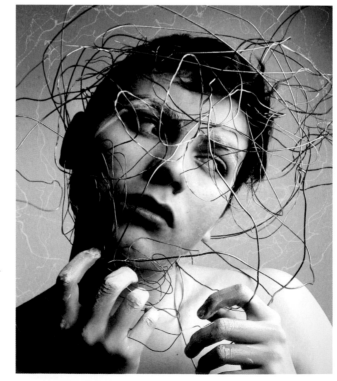

HUMAN NURTURE

I'm still in the process of growing as an artist and I don't want to limit myself to a single style or theme. While I think I'm still very young to have a defined style, I believe I have developed as an artist and have taken what I've learned to continue growing and creating new things. My self-portraits are autobiographic pieces, where a character interacts with a landscape in order to express an emotion.

Before I started doing self-portraits, the most recurrent theme in my work was nature: landscape and flowers predominantly. I've always preferred nostalgic and gloomy landscapes, and I feel this sense of darkness has moved into my self-portraiture.

However, when I'm creating self-portraits, nature becomes secondary, because I'm trying to express myself as an individual: my feelings, my ideas, and everything that stimulates me. I'm generally inspired by my day-to-day experiences. By pushing the meaning of these experiences onto a surreal level, I manage to intensify the concept or original idea that I want to bring forth. In a certain way, the character appearing in my self-portraits is an alter ego, an exaggerated representation, but one that is built up from fragments of my own identity.

Another of my artistic intentions is to create the impossible with what is to hand in the real world. With my camera and the help of Photoshop, I look for a certain surrealism in my images. I want to depict emotions in a metaphorical way, in order to offer a profound meaning beyond the mechanics of the image. I'm interested in communicating messages that are hidden like riddles behind the surface esthetics of the image.

A while ago I did a series of images inspired by films. I was highly attracted to the framing and use of color in film (especially in the work of Wong Kar Wai and Julio Medem in *Lovers of the Arctic Circle*). My aim was to create images that were like movie frames, but cutting out the most important frames and sharing them as independent pieces. In response to these images, my audience—mainly on flickr—offered back a multitude of new stories in return, in their personal interpretations, which was fascinating.

At the moment I'm very interested in Baroque painting. I've tried to achieve a Baroque style in my pictures, which I struggled with at first, but the more I persevere, the more I feel I'm getting results. This, I believe, is as a result of my research into the use of color, lighting, shape and atmosphere in Baroque paintings, and how they reflect a certain emotion of the character being portrayed.

At times there's a religious slant to my work, related to the fact that I went to Catholic school, where I constantly saw religious paintings and statues. I'm not a Catholic, but I appreciate the church for the esthetics of its iconography. I love the golden tones, transparencies and drapery enveloping the icons. I'm fascinated by the surreal element of the Bible, not by the moral lessons, but the way the stories are represented in images.

Far right in clockwise direction

SMILE TO ME ANYHOW

For this self-portrait I was inspired by the work of Asya Schween, who also makes self-portraits. I used only natural light. The idea was to represent a clown that is being forced to smile. I captured the most exaggerated smile I could do. In post-processing I manipulated the white balance to create the green tones, and created several layers of colors. The wallpaper was composited in at the end.

LE GARÇON AUX CHEVEUZ BLEUS

For this image I wanted to experiment with my body, playing with contortions and their relation to light. I made several test shots, searching for body positions that weren't too complicated, but which contrasted interestingly with the light. I duplicated the background and rotated the image 90° to create an interesting symmetry.

HAIR

When I made this image I was developing an interest in Renaissance and Baroque paintings. I also was thinking of cutting my hair, so two ideas that I felt very strongly about at the time came together in an image. I used the black background that is very common in Baroque painting, and played with the idea of cutting my hair. To obtain the warm tones I used natural lighting and did some tweaking of Color Balance in Photoshop.

HUNTER

For this image I was inspired by a program on the Discovery Channel where a group of hunters used special masks to scare tigers away. I took this situation and linked it, with a bit of irony, to the loneliness I was feeling at the time. In post-processing I adjusted Curves and Selective Color.

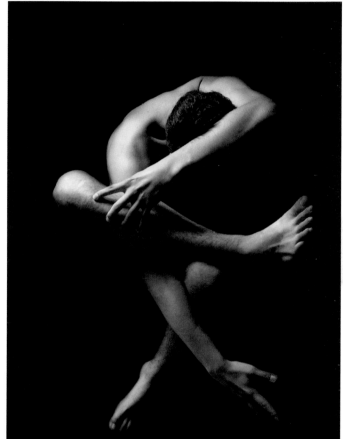

DINNER (WEEK 3) *(below)*

A self-portrait with my favorite food, octopus. I shot this picture with my Canon XT and Kit Lenses, using natural light.

SIAMOIS *(right)*

I shot this image using natural light. I used my Canon XT and kit lens (18–55mm). I wanted to give the characters a sort of "alien" appearance which I achieved by adjusting the colors with green hues in post-processing.

HOW I MADE *DINNER*

This image was a commission for the Lithuanian magazine *Pravda*, to illustrate a special edition dedicated to the subject of food. They contacted several artists from all around the world to ask them about their eating habits and food preferences. It is amazing how this changes from place to place. For me the usual is to drink tea and bread with avocado at 9pm. Aside from that, at my place, there's always plenty of seafood because my father works in the fishing industry. I eat a lot of shrimp, bream, conger, and so on—and the octopus is one of my favorites. I thought it would make a great prop to play with for its viscous texture and tentacles, much more exciting than a random fish.

Preparing this shot didn't take much time. I only had to set up the tripod and defrost the octopus. I also put a little bit of ink on the tentacles. To be honest, the raw taste of the animal was really disgusting, but I managed to pose impassively without expressions of disgust. I wanted to create a neutral portrait that reflected habit, rather than repulsion, and I think I succeeded.

The post-processing stage was essential to make the image's message stronger. I didn't want the scene to look perversely creepy, so I spent a lot of time looking for the right color adjustment to create a more amicable atmosphere. I was also mindful that the image was for a sympathetic article of common interest for a big audience.

In Adobe Camera Raw, I edited the colors and settled for pastel-blue hues. As in most of my photographs, lighting was natural. I choose this because it brings more interesting nuances to my compositions. On the contrary, when I use artificial lighting, the skin and the background tends to look flatter so I find it difficult to manipulate the color palette of the image.

I used the dodging and burning tools to strategically enhance the brightness and shadows in parts: on areas of the octopus, and in my eyes. I pay a lot of attention to the eyes; trying to find the right contrast and brightness for them, because in all of my portraits, I want the eyes to get the most attention in the image, as they can convey all kinds of emotions.

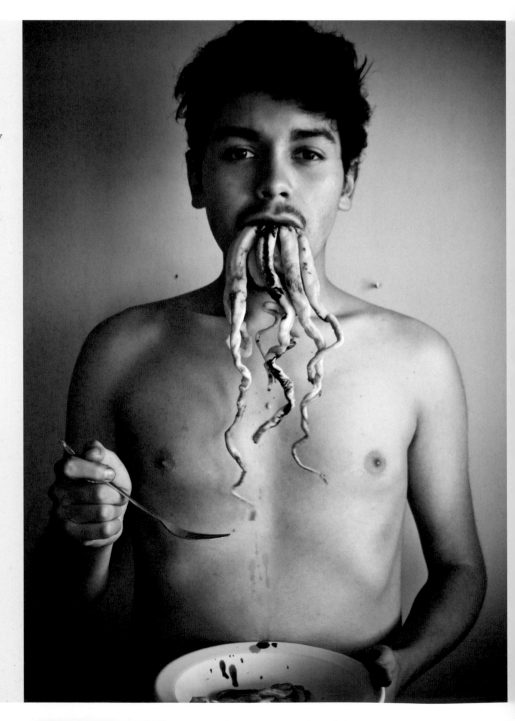

HOW I MADE *SIAMOIS*

Many times I've heard the story that says we are separated from our soulmate before we are born. I had asked myself if there's such a thing as my other "half," somewhere on this planet, and if so, what would my "Siamese soul" be doing?

This question haunted me until I felt I needed to express it through a self-portrait. Siamese twins generally share one organ. In this image, my twin shares my soul. The soulmate is the one we desperately seek and can't find, which is why the characters wear masks and are joined at the back, which makes it impossible for them to see each other.

A very important part of the image is the scar that unites the bodies together. I took pictures of some fabric I had sewed and then imported it into my composition on Photoshop and pasted it over the bodies. I used the stamp tool and cloned a few parts to adequately merge the skin of the characters with the "scar." I wanted their skin to look as if they had just come out of a surgical procedure.

It was hard to find a good angle to shoot from, so I chose a high angle in the end, which distorted the image and created a sort of imbalance, which I thought was appropriate.

I made adjustments to the colors initially through Adobe Camera Raw. In Photoshop I darkened the image as much as I could. I wanted to reduce the most exposed parts, most noticeably the area of the bed where the light is shining. I blended several layers on top to soften the areas of white to gray, to create a dim and moody atmosphere.

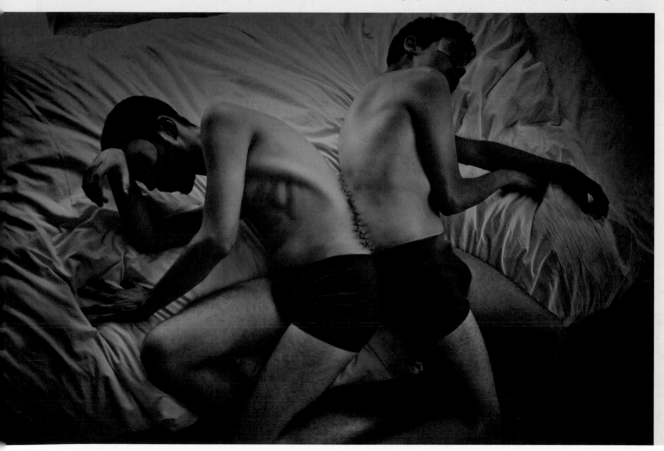

INTRODUCING
Federico Erra

Italian photographer Federico Erra is more often found taking sumptuously-toned images of women in his everyday job as a fashion photographer. However, it is not just through these portraits that he expresses his fascination for femininity, but in his own self-portraits. Through carnivalesque guises, contorted poses, and a striking use of props, Erra presents us with a compilation of characters that range from the disturbed to the sensual.

Erra's images often speak of pain, torment and melancholy—but also sexual lust, passion and exploration. As a young man wearing wigs and makeup, he is at once surprising and provocative, but at the same time his images exercise a genius photographic eye that just happens to cross paths with the creator's own emotions. Usually intimately close to the camera, with hands, eyes and ribs almost within touching distance of the viewer, Erra allows us into his own private world—but even when we get there, we find that it is one he wants riddled with more questions than answers.

A strong hint at Erra's talent with imagery is the way in which both his color and monochrome images—and the muted, desaturated images in between—are immediately eye catching. It is his use of tone that is consistently strong. Erra is also one of those artists whose use of locations is not at once apparent; whether he is laid on a bed, looking into a mirror, or tumbling into darkness, the attention he pays to all the other elements places the focus on the human subject: his own delicate, subversive self.

What is remarkable about Erra's approach is just how spontaneous his photo shoots can be, and how openly he admits to and positively celebrates, the unexpected nature of a particular photographic outcome. It is not a blindness as such, for him, it is normal—the antithesis of the conventional commercial photographer who is taught to rationalize his environment; measure light, size up distances, and wait hours for the right moment. Erra bounds into a self-portrait almost always embracing natural light and an appreciation for unforeseen moments. His success in both fine art and fashion is testament to his passionately visual approach.

UNTITLED *(right)*

"Here I used my Canon EOS 400D with the 18–55mm kit lens. This picture was shot in the afternoon with natural light in my bedroom. I did several takes and still I'm not completely satisfied with the outcome. I wanted to portray myself in a kind of natural manner as though someone were looking in on me."

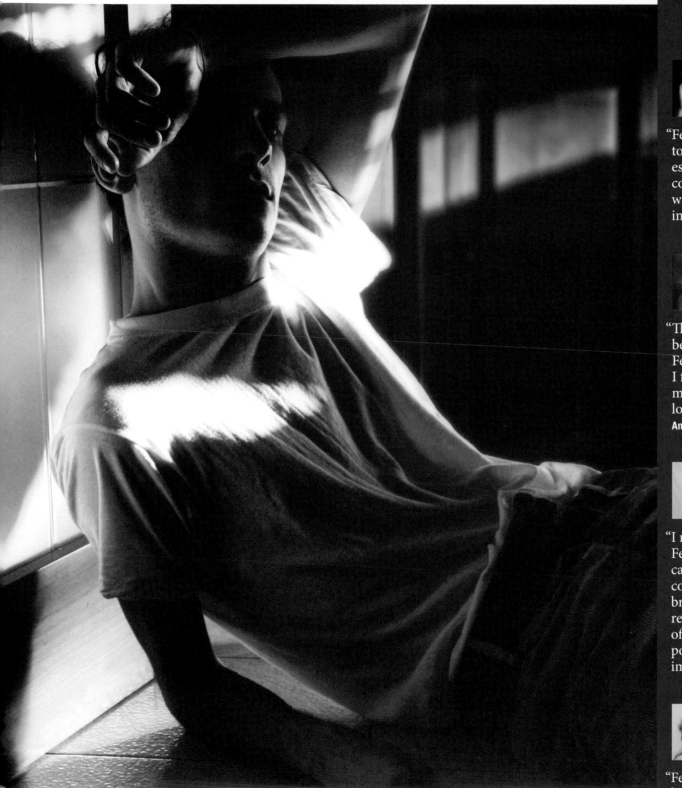

"Federico knows how to capture nostalgia, especially in his use of color. His work connects with my emotions deep inside." **Jon Jacobsen**

"There is so much beauty and calmness in Federico's photographs. I feel completely mesmerized when looking into his world."
Annette Pehrsson

"I really enjoy the way Federico engages the camera. He knows how to confront the viewer and bring forth an emotional reaction, and his use of muted tones adds a powerful resonance to his images." **Lucia Holm**

"Federico's images always leave me in awe. I feel confident that he will have a successful future ahead." **Yulia Gorodinski**

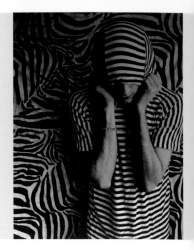

FASHIONING A ROLE

I made my first self-portrait when I was 26 years old, in my bedroom. I had just been in Turin, where a friend of mine encouraged me to shoot a self-portrait because he said I had an interesting face. Back home in Viareggio, I took my brother's compact camera and started. Until then, I had never shot photos of any kind. Since I was a child I was in love with figurative arts, but a camera was a mystery to me. So, self-portraiture became my first photographic expression. My bedroom became my set: every night it became a different exciting location in a new "country."

I studied fashion design, and after art school I studied comics, manga and screenwriting in a private institute. I didn't study photography, but I learned the ground rules about images and composition during this time.

My self-portraits are made during emotional and impromptu moments—an idea might come to me while I am watching a movie, reading a book or listening to a song. I lock myself in my bedroom and just start shooting. Many photographers plan their shots according to specific patterns; I tried to do this but without success. Similarly to when I drew comics, I developed my work from one little spark of inspiration, rather than from a devised plan.

My friends are my greatest fans. At first they criticized my self-portraits because they considered them much too daring. Eventually they understood that I was expressing a hidden part of my emotions and sensibility. I'm an extremely sensitive and taciturn person, but people perceive me—through my self-portraits—to have a certainty and a confidence that I don't think I have in reality. I am acting; I am performing a role. Photography is not always sincere. Through my self-portraits, I express a fantasy of what I'd like to be, but feel that I am not.

I always say that the best way to learn photography is to teach yourself. I have never been shown lighting techniques or other aspects of photography, and I taught myself how to use Photoshop. Self-portraiture became the way to learn the tricks of the trade. Now, even when I'm shooting models or friends, I always try to motivate myself by emulating the mood I get into when I do a self-portrait.

I always use natural light both for self-portraits and other work. I learned how to use sunlight in photography when I attended art school in Florence. There I would paint an object or a portrait of someone outdoors with charcoal. In doing so, I had to take advantage of the sunlight as best I could, by paying attention to my position in accordance to the subject. I love to use the even, flattering light of the early morning. At night, I use my garden lights as "studio" lights when I feel the irrepressible impulse to take some self-portraits.

Self-portraiture forces you to take full possession of everything photography gives to you in that moment. The shape, the color, the mood; everything depends on you. You need time to get used to it, to keep the rhythm for a good result. I'm not still completely satisfied with my self-portraits, but I know I'm taking steps to improve and that it would not be fair or natural to speed up things. I just let things take their course.

The fashion photography world gives you the chance to explore a lot of different facets of photography: the use of face, body, locations and atmosphere, as well as the clothing itself. I am now represented by an agency in Milan, and have started work for various fashion magazines. I have also been commissioned to shoot book covers for a publishing house. In the future I'd like to work in film, photographing movie stars. It would be my dream to photograph Kate Winslet.

WARHOL (far left)

I took this picture for the American magazine *Nerve*. At that time I was not a "professional" photographer, but one of the editors noticed my shots and commissioned a series of self-portraits themed on sex. I called a friend and we did about a dozen shots together, using the ten-second timer on my Canon EOS 400D. This particular image was inspired by Andy Warhol.

RAT POISON (left)

For this image I used a wig to create some mystery over my identity as I didn't want to be recognized immediately as the subject of the picture. I wanted to show my thinness, and especially my rib cage. We are all used to gym-fit models, but I wanted to show that a thin male body can also be fascinating.

UNTITLED (opposite top)

I took this picture in my bedroom, behind the closet. I wanted to express my solitude. I love to occasionally spend a day alone where I don't see anything, or hear anything, but myself.

REMEMBER 20 YEARS AGO (above)

I like male nudes, but I feel they have always been used too conventionally, as straightforward, typically masculine brawn. This image is an example of my attempt to portray the male nude in a way that is more decadent.

LAYERS & MASKS

I feel that my personality is divided into two different categories: masculine and feminine. Some of my self-portraits, which use wigs and makeup, show the most feminine part of me. When I was a little boy I was very androgynous and I believe that even today, at 29 years of age, some of that ambiguity is still within me. In cinema, I am very attracted to films that have a strong quality of femininity. I often see myself in the characters of the films I watch, and I try to convey those emotions and esthetics through my feminine side. I have found that my audience appreciates my androgynous side, especially women.

I find that using masks and makeup helps me represent sexually ambiguous characters. Makeup emphasizes the best of my character and body. Masks suggest a kind of psychological duality, which is why I have something over my face in many of my self-portraits. I do not like pictures that expose everything at once; those that are full of overt details. I think a picture should maintain an aura of mystery to encourage the audience to come closer and try to identify with it. Masks and makeup help to hide the obvious; they act as shadows lurking in my images. I always try to allow my self-portraits to take on a double meaning, to let my viewers daydream in their own imagination. I want my viewers, when they look at my images, to feel an emotional fragility and a strong ambiguity. The observer should have the need and the willingness to ponder over the possible ideas that I might have wanted to transmit.

I do not use a remote control. To take a shot of myself, I just put the camera on a tripod and put a pillow in the place where I will be positioned, so I can set the focus. Then I shoot—I have ten seconds to remove the pillow and put myself in front of the lens.

I always take my self-portraits indoors mainly for fear of being seen. If I am not alone, I fear I would appear too artificial or mechanical because of feeling embarrassed. Now that I often have to travel for work, when I feel like taking a self-portrait I take advantage of my hotel room in the best way possible. Recently I went to Rome and stayed in a beautiful Victorian-style room with red walls and dark brown wooden furniture. I took three self-portraits while I was there, including *Shattered* taken in the bathroom.

To photograph models I prefer to use my own room, or seaside locations in Viareggio, my hometown. I like to use woods and forests too.

My photographs and self-portraits are all digital, but esthetically I try to make them as similar as possible to analog or even to Polaroids. I often deepen the blacks, mitigate the lighter parts, and I work a lot on colors—sometimes I change the hue of the entire image. Then I use Curves to give the effect of a cinematographic imprint to the photograph. I have sacrificed entire nights working on my images to achieve a satisfying result. My post-production often feels like an emotional release. After taking a photograph, when I start working on it in Photoshop, there is a step-by-step journey to "discovering" the effect I want to create and deciding how to interpret an image I have shot. Nothing is pre-arranged, nothing is planned, everything is instinctive.

Clockwise from right

OUTRAGEOUS

For this self-portrait, I was alone in my bedroom and the light was filtered by a curtain, creating a beautiful and pure effect. I used the timer, with the camera mounted on a tripod. I can't see any particular meaning in this picture; I take pleasure in the fact it was born simply and spontaneously on a lazy afternoon.

AS ELEGANT SUICIDE IS THE ULTIMATE WORK OF ART

I have always been fascinated by women who have suffered a violent death, such as Virginia Woolf, Sylvia Plath, and Diane Arbus. This image is my attempt to represent the theme of suicide: a "self-death" in a self-portrait. I took this picture in my mother's bedroom, and did not notice the towels when I shot it, but thought afterwards that they enhanced the narrative. I chose to make this image black and white to heighten the cinematic tone.

ROBESPIERRE'S LOVER

This is inspired by my passion for manga comics, especially one entitled *Lady Oscar*, a story set at the time of the French Revolution. I wore a mask that alluded to the court parties of the 19th century. I softened the shot in Photoshop to give it an aged effect.

SHATTERED

I am fond of using mirrors in my self-portraits; the mirror represents the duality inside myself and of everyone. The mirror can be good and evil, beautiful and ugly. This simple self-portrait was shot handheld, in a hotel while I was traveling for work.

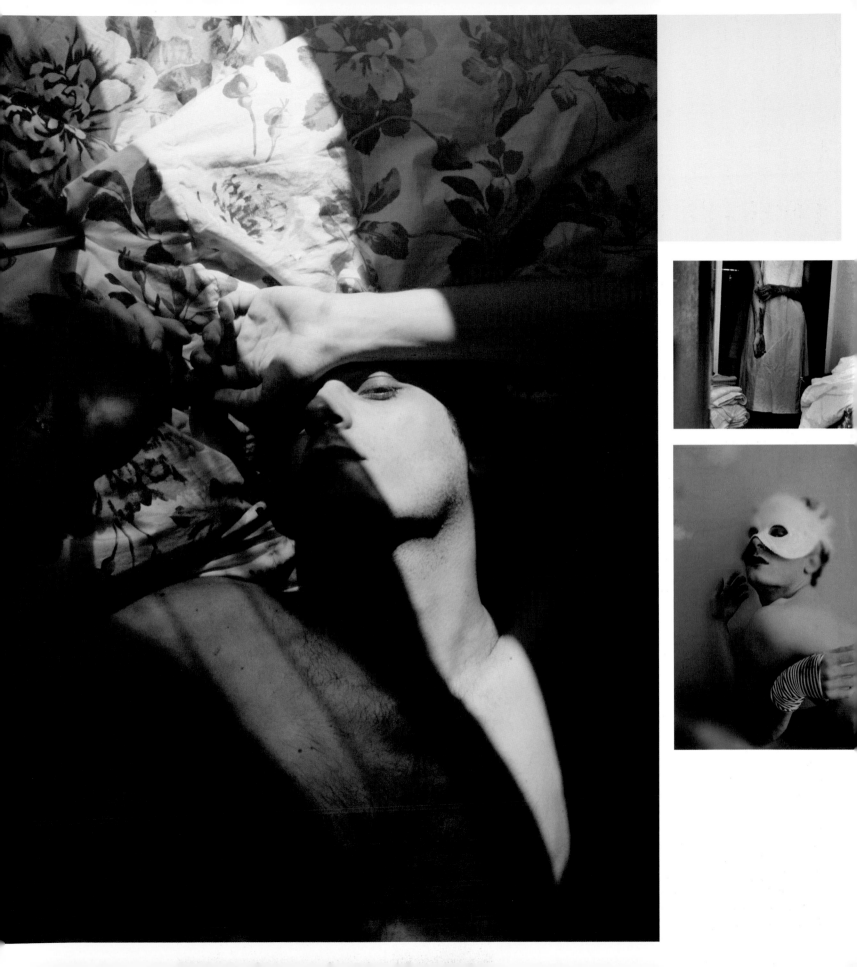

HOW I MADE *UNTITLED*

This image represents a character who does not know what to do with his own body and face; as if hesitating whether to live as a man or as a woman, with the face about to be uncovered to reveal a transformation. At the time I took this self-portrait, I was fascinated by the work of German director and actor Rainer Werner Fassbinder, whose roles commonly took on a subtle sexual duplicity.

Bored, I was alone in my house and wanted to shoot. The veil was a gift from some friends of mine. They gave it to me knowing I would use it for some strange picture. I used my Canon EOS 400D with the 18–55mm kit lens. Technically, there is not much to say about the process of shooting, as I always use automatic settings on the camera. To achieve the focus on my hands, I placed an object in front of the lens before shooting, and then placed my hands in the same position as the object.

I only did a few shots, because I was just experimenting. I did not know what I wanted to do before I began shooting. I just had a vague idea about how to use the makeup, but then everything came quite naturally. This is one of the few pictures that I have shot with continuous fixed light (a simple garden spotlight, which I picked up at a supermarket) instead of natural light. After the first two or three shots, I had the idea to bring my hands near my mouth. My self-shooting process is always very whimsical.

In Photoshop, I wanted to give the outcome a gothic appearance, so I cooled the tones with blue hues and deeper blacks in Levels, and desaturated the image almost to monochrome, for a deathly pale effect. In color, it seemed to me that the image had too much "glamour" in it, instead I wanted to make it more dramatic and unusual.

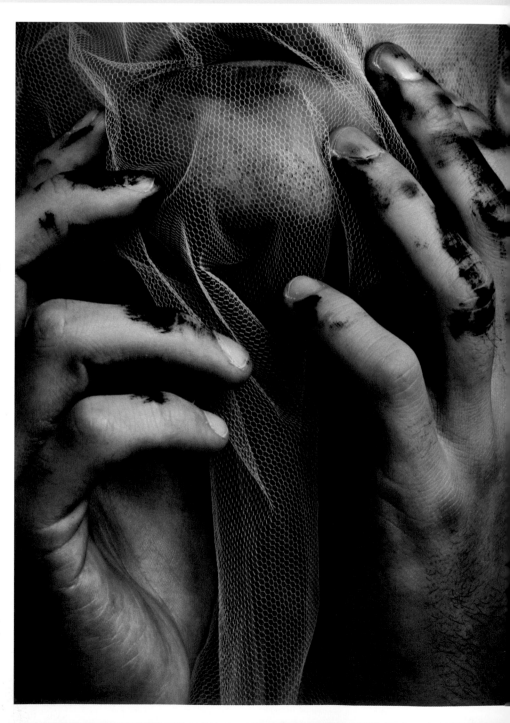

UNTITLED (right)

I used dark makeup to give a dreamlike state to my appearance in the image, to make it become a form of caricature. This image took about 20 minutes to produce.

HOW I MADE *YOUNG BOY BAD MAN*

This self-portrait was taken in my bedroom, using natural light from my window. It was sunset, which meant that the light was soft and diffused.

I often use this wig in my images because I have always had thinning hair, and when I have wanted to shoot a self-portrait, the wig is one of the first aspects to my "dressing up" element of posing.

Oddly I don't remember exactly what my initial intention was for the meaning of this image. There are many photographs I take that have no specific meaning, they were born merely for their esthetics, as a spur-of-the-moment exercise. A lot of people that view the resulting image can then see something deeper beyond the simple appearance. This is something that I am most proud of with photography: touching peoples' emotions on different, unexpected levels.

Since I was a child I have never overly liked the image I saw of myself in the mirror. Through photography I have tried to exorcise that weakness to seek a new "version" of myself that somehow could give me more confidence and self-esteem. This image was vaguely inspired by Oscar Wilde's novel *The Portrait of Dorian Gray*. Instead of the painting, there is a mirror.

I think that every self-portraitist has a strong ego. The mirror accentuates this ego and transforms it into another being. I feel that I have two "selves" inside me, and they are represented best in my self-portraits reflected in the mirror. A mirror leads to two faces, two emotional states, in turn, to a lack of clarity, to just an "image." That is what I am.

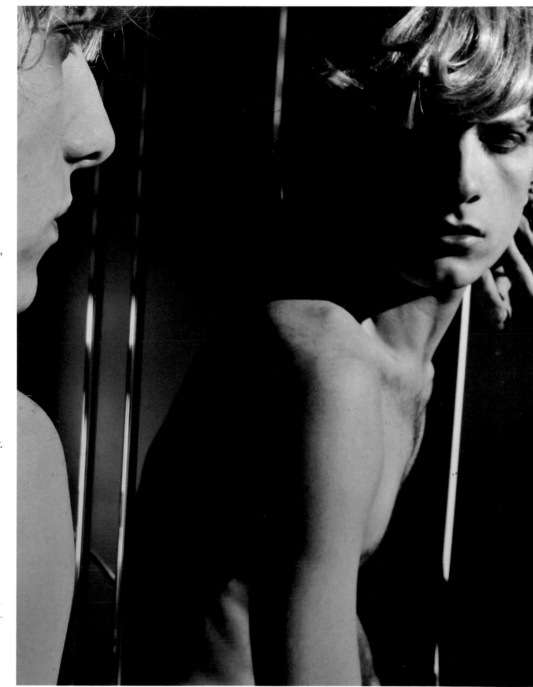

YOUNG BOY BAD MAN *(right)*

I often use wigs and mirrors as props in my images. I did very little post-processing to this image other than to crop and to subtly adjust the colors.

INTRODUCING
Lucia Holm

"Lights, camera, action" are three words that come to mind when one regards the work of Lucia Holm, from New Jersey, USA, but not just because her work is notably cinematic. Holm's attention to all three elements of the aforementioned movie-speak form the basis to her burgeoning technical expertise as a young woman who approaches photography from the angle of both fine-art student and movie fan.

Holm's whimsical desire to use self-portraiture as a way to enhance and fix an ideal image of her "self," like a lot of other self-portraitists, soon grew weary, and led her to pursue photography on a more profound level. An increasing sophistication with the technical side of setting up her shoots, as well as a desire to think more conceptually about the narratives and *mise en scène* in her images, Holm's images become glistening, miniature movie setups. In the manner of an embryonic Gregory Crewdson, one of Holm's own inspirations, the larger the viewer can see the images, the more rewarding and meticulous detail there is to behold.

Whether bereft of models, or imbued with a Sherman-esque desire to act in her own frozen movie stills, Holm's self-portraits convey a desire to transcend the banality of the everyday, of the "real" and autobiographical, and present herself as a character within a colorful and filmic environment. There is a strange merging of the utopian and dystopian, however, while the grass is green and the sky's blue, there is a distinctly post-modern, Lynchian vibe that everything is not quite as it should be. Unsmiling, sometimes smudge-eyed, or ill at ease on the telephone in a dark house, Holm's fascination with unsettling the viewer is evident.

UNTITLED *(right)*

"This photo was the second half of a two-part concept inspired by a character from David Lynch's *Twin Peaks*. The idea was to capture a sense of loneliness and emptiness one might feel as the result of some form of abuse, whether it be physical or mental, or both. The wounds might heal, and the dirt might wash off, but she'll never be quite herself again."

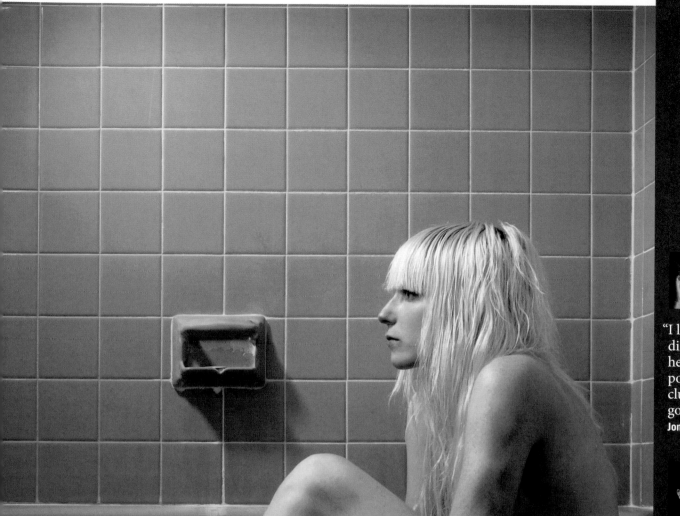

"I like how Lucia plays different characters in her illuminating self-portraits. I'm always clueless as to what she is going to do next!"
Jon Jacobsen

"Lucia Holm's work is an original and fantastic combination of impeccable technique and pleasurable themes. It's a joy to see her images, so fashionable and tasteful, created with great attention to detail and top-quality lighting."
Rossina Bossio

SUBJECT MATTERS

Self-portraiture has always been a passion of mine, no matter what the medium. My undergraduate studies at the Rhode Island School of Design were based in fine art with a focus on illustration. Later, as a graduate student at the New York Academy of Art, my focus changed to drawing. Throughout my six years of degree study, I always felt that I was my own best model for several reasons. Using myself was far more practical than trying to recruit others, and there was no other person I knew better than myself, physically and emotionally. Also, I had no fear of embarrassing myself if the outcome of the project was not what I hoped it would be, so I had the freedom to experiment.

After receiving my Masters Degree, I felt the need to go on hiatus from fine art, but the desire to produce creative works never left me. I decided to explore photography because it was something I had never attempted before, and that was quite refreshing. Once again, self-portraiture became the dominant theme of my work. Because I had never picked up a camera in any serious manner before, I only felt comfortable experimenting with myself. Initially, my attempts at a photographic self-portrait were feeble, and lacked any kind of real content. Since I worked digitally only, I didn't have to worry about pre-planning and I got a bit caught up in post-production. I relied solely on my Photoshop skills to put together an image, rather than thinking it through beforehand. Eventually, I began to apply my fine-art education to my photography, and started planning the arrangement of subject matter as I would a drawing or painting. Later on, I felt the desire to add more of a narrative to my photography, and began experimenting with storylines and concepts.

Because I was using myself as the main subject matter for the majority of my photographs, I received flattering comparisons to other contemporary female self-portrait artists. However, I also began to receive unkind and presumptuous feedback about why I was using myself as the focus of most of my photography. Words like "egotistical" and "vain" were used on a number of occasions, by people who mostly wished to remain anonymous. Although I was initially angered and dismayed by such remarks because they had nothing to do with my reasons for using myself as a model, I began to realize that my self-portraitist peers were receiving similar commentary. I felt a common bond with these photographers, and that strengthened my confidence to continue self-portraiture.

Through this photographic journey, I've learned a lot about my strengths and insecurities both physically and mentally. It has allowed me to experiment and to express myself to the public in a very personal way. Although I now also pursue non-self-based portraiture, I will continue to use myself as a subject every spare moment I get. I stand firm in my belief that we are our own best models.

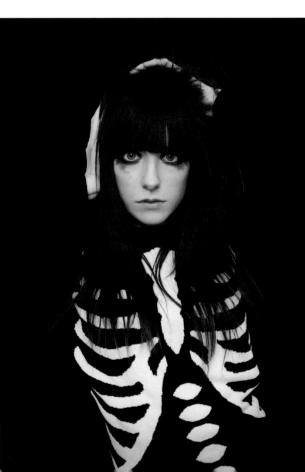

UNTITLED (left)

This photograph is meant to be more of a portrait image and is essentially free of a narrative concept. I wanted to do an "in your face" portrait, and have the clothing and makeup accentuate the wildness of the shot. I used one strobe for this shot, positioned head-on, slightly above camera. I chose a basic black backdrop so the sweater would blend in and the bones would then create the body shape.

UNTITLED (right)

This was shot through my dining room door some time after midnight, and was achieved by setting the timer and running quickly into position. The concept was to give the viewer a "snooping" vantage point, and to show my surprise at the realization that I'm being watched. I used one strobe, which was positioned to my right inside the dining room.

UNTITLED *(below)*

The original concept for this shot was to show a girl collapsed in front of the front door, phone in hand, as if she was in fear of what lurked behind the door. The composition wasn't working properly for the shot, so I decided to simplify it and depict a girl receiving a call from an unwelcome caller. The shot was created with one strobe, positioned to my left (camera right), angled from above.

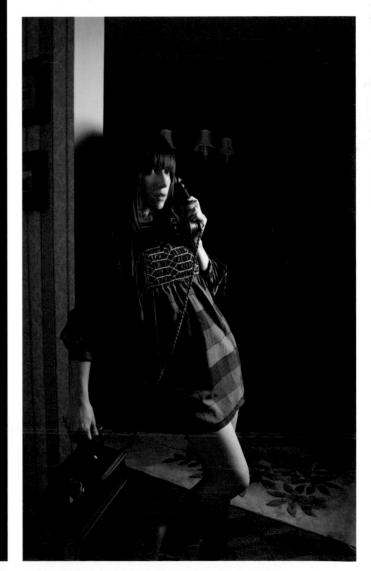

CREATING A GENRE

When I first began experimenting with photography, I showed little concern for the content of the images. Because I was my own model every time, my main focus was to capture an esthetically pleasing shot of myself. I paid little attention to composition, lighting or concept and focused more on what angles made me look taller, or my nose look smaller, and so on. Although I considered it a success to end up with a "pretty" shot of myself, the artist within me was soon yearning to create something more substantial and worthwhile. As a fine-art student I constantly drew inspiration from books, movies, and other fine artists. These influences always motivated me to give my own work an actual "point of view," and I found myself desiring to do that once again with photography.

Once I made the decision to begin branching out conceptually and experimenting a bit more with narrative themes, I found myself quite limited by my equipment or lack thereof. I decided it was time to put aside the point-and-shoot camera I had been using and invest in something a little more professional. Because I had no formal training in traditional photography, I decided to focus on digital. My first "real" camera was a Canon Digital Rebel XTI, which was perfectly suited to my needs. I also purchased some strobe lighting and a wireless remote control that gave me more freedom to pose without the constraints of the camera's ten-second timer.

As I began teaching myself how to use my new equipment, I started applying what I had learned in my fine-art studies to the images as if they were canvases. I began to pay closer attention to composition, negative space and color. This wasn't always easy as there is usually some guesswork involved with posing oneself in front of the camera. Once I realized I had more control over the outcome of my images (and that photography wasn't really about getting a lucky shot, which I had originally thought), I had the freedom to start really experimenting with putting narratives and themes into the photographs.

I have always been drawn to classic books, vintage films and the macabre. I started to reread some of my favorites such as *Little Women*, *Jane Eyre*, *Wuthering Heights*, and *The Great Gatsby* as inspiration for my photographs.

UNTITLED (left)

The idea of dressing up twin children in exactly the same attire has always seemed a little bizarre to me, but it is certainly very interesting visually. I have always been intrigued by Diane Arbus's *Identical Twins*, and the twin girls in the film, *The Shining*. Both accentuate the strangeness of seeing two people that are mirror images of each other. I wanted to create a photograph that uses a similar concept, but I turned my back to the camera to be vague with regard to the identity of the characters. I created this image using basic Photoshop cloning techniques and one strobe positioned above camera.

The female characters in these books are strong, but also filled with imperfections, and I felt a connection to them. Similarly, I revisited some of my favorite films, examining not only the storylines, but also the way that each scene was set up and how it was lit. I have a fondness for anything with a strange and unusual quality, so the directors David Lynch, Stanley Kubrick, Roman Polanski, Alfred Hitchcock, Tim Burton, and Wes Anderson have all strongly influenced me throughout my fine-art studies. The offbeat and unsettling themes, strong camera angles, set design and costumes found in their work have been particularly inspiring, especially when I started focusing more on photography.

I knew I wanted to have a strong female presence in my images, and using myself as a model made that possible, but I also found it a bit difficult to capture the proper emotions through my posing. Modeling for the camera can be a bit unnerving, but because I was the photographer as well, I had the freedom to experiment without worrying about the judgement of others. I ultimately decided my slight awkwardness in front of the camera only enhanced the unsettling vibe I wanted to achieve. I was hopeful that I could engage the viewer and inspire them to want to see what would happen next. I also decided I wanted to give the shots a bit of vagueness in the hope that the viewer could invent a storyline themselves.

As I continue with self-portrait photography, I find that I learn something new about myself with each picture I take. Although I was not formally trained in this medium, I feel confident with all that I've taught myself through trial and error. I feel inspired nearly every day, sometimes from the most unexpected sources. Acting as my own model allows me the freedom to pursue any idea that formulates in my mind however unusual it may be.

UNTITLED (below right)

The idea for this shot was loosely inspired by a scene in *The Wizard of Oz*, where the witch's legs appear trapped under the house. I used one strobe to highlight the legs, allowing darkness to surround them and complete the framing.

UNTITLED (below left)

The main reason behind creating this shot was for me to experiment with different lighting techniques. I had recently received a boom arm for my strobes and purchased a vintage dress, and I wanted to introduce a hair light into my usual lighting style. I decided to make use of an old bench in my yard. I find the outcome of the shot particularly unusual because of the way in which the lighting makes the outdoors look more like a set or backdrop.

UNTITLED *(below)*

The purpose of this image was to experiment with lighting and to incorporate some actual movement into a self-portrait, something which I had started to develop an interest in.

UNTITLED *(below right)*

This was taken one late April when, after winter, it was finally warm enough to shoot outside. By using a strong directional light source, I wanted to convey a curious sense of eeriness.

HOW I MADE *UNTITLED*

This photograph started out like a lot of my self-portraits, at about 1am when I should have been asleep in bed. I had recently dyed my hair red, which was quite a change from my three-year love affair with platinum blonde. I decided I wanted to create a photograph that combined my new hair color with some recently purchased gel filters. I didn't have most of my studio equipment with me, so I had to make do with a wrinkled old black bedsheet, a cramped bedroom, and a broken umbrella!

I began the setup by hanging the black sheet above my closet doors. I then placed one AB800 strobe directly in front of the sheet facing the camera, fitted with a red gel filter, and a second AB800 strobe across and above, stationed behind the camera. This was improperly fitted with the broken umbrella, which I don't necessarily recommend doing, but I've found myself in the position of using broken gear several times in the past. I normally begin any shoot with the camera (in my case, a Nikon D300) positioned directly opposite, head-on facing the subject matter. I've always been a fan of Wes Anderson-like symmetry, so I usually begin with that type of balance to the setup. Unfortunately, my camera's remote control wasn't cooperating, so I was forced to set the timer, then run quickly into position. The red gel was much too intense, so I switched it to orange, resulting in a lovely sunset effect. I wanted to add some movement to the shot, so I began a 45-minute jumping, dancing, cheerleading frenzy in front of the camera.

Out of about 200 shots, I found a couple that were worthy of editing. I try to rely less on Photoshop these days, but I still find it more than necessary for making a great photograph. Here I added some extra movement by duplicating the layer, and using the motion blur tool to have the back of me trail off into the blacks of the photograph. This shot was personally successful because it was one of my first attempts with the gel filters, something that is certainly not easy to use properly. Normally my posing is more stabilized, so I enjoyed the fact that I was actually moving in front of the camera. The uncertainty and spontaneity of this type of posing was quite refreshing, and I've since used this method with other models.

HOW I MADE *UNTITLED*

This photograph was taken in the spring of 2009, during a period of considerable self-exploration. I was becoming increasingly fascinated with narrative photography, and wanted to veer away from my usual reliance on post-production. I had recently acquired a new set of AlienBees strobes and a Vagabond portable power system (quite an exciting step for me, as I was used to being restricted to my deck's outlet to power my outdoor lighting setups). It was around dusk when I decided to make use of the barn-like shed in my backyard, and a vintage clothing package from a client.

I knew immediately that I wanted the main lighting source to come from within the shed, hopefully creating some interesting light and shadow patterns, to give the picture a somewhat unsettling feel. Because I did not yet have the trigger and receivers for my strobes (meaning the lights had to be connected to my camera by sync cord), I had some trouble positioning my camera far enough away to get the proper composition, while still remaining attached to the strobe contained inside the shed. With my strobe precariously perched on the edge of the shed entrance, and night coming much too quickly, I finally managed to get the proper setup, and shoot this scene in under five minutes. The main purpose for Photoshop in this instance was to lighten up the sky just enough to get a strong saturated blue (matching my dress), change the shed door colors from cream to red, and to add shadow to the shed walkway, adding an additional presence to the image.

This photograph remains one of my favorites. I feel that the lighting, saturation of color, and the simplicity of my pose tie together quite nicely. It was one of the first times I had a vision of exactly what I wanted to achieve pre-shoot, and was successful in following it through. I have been told by others that this image tells a story, leaving them wondering what happened before and what will happen directly after this scene unfolds. That, in my opinion, is the ultimate gratification.

CHAPTER SIX
MARKETING YOUR SELF-PORTRAITS

Creating art is one thing, but sharing it enhances the whole experience and gives purpose to the artistic messages you encode in your work. Sharing your work in showcase or exhibition form with an audience can allow you to grow as an artist as a result of interaction and feedback. Exhibiting your work can be a big step and one that requires you to have a strong body of work to present confidently to an audience, however, sharing your work online is something you can do right now.

This chapter starts by looking at what you could gain from sharing your work online. Photo sharing on sites such as flickr has furthered many amateur photographer's careers. It is important, however, to understand your rights as a photographer—protecting your work on the Web and being aware of copyright should someone approach you to use your imagery. This chapter will cover these issues.

The chapter will also detail how you might go about putting together an exhibition of your work, as nothing virtual can truly compare to seeing your work physically hanging on a wall. Discussed are limited editions, color management, printing considerations—from paper choice to mounting and framing—and dealing with galleries and clients.

How you choose to make money from your work really depends on the direction you want to take your photography in. Photographers find themselves involved in lots of different things: selling prints, supplying stock image libraries, self-publishing books, or holding workshops, as well as carrying out conventional paid commissions. Sometimes the hardest thing is to accept that the world is literally your oyster: there may be challenges facing the modern photographer, but the first thing to realize is that your work can become its own brand, answerable only to you and that you must believe in yourself. As I have stressed throughout this book, getting up and creating is the most important thing—working for your art. Now, make your art work for you!

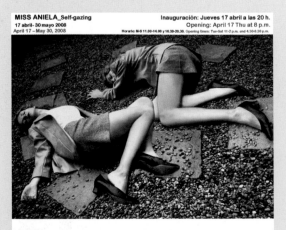

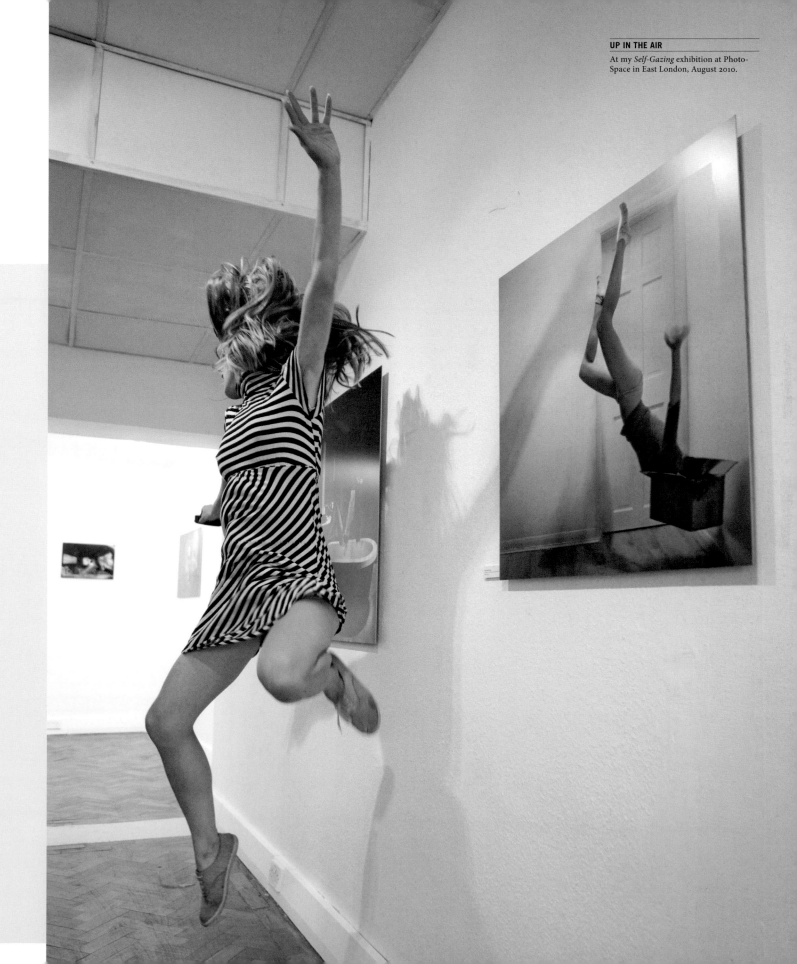

PHOTO SHARING

I highly recommend using the Internet from day one, in particular photo-sharing sites. The exposure it'll give your work is invaluable. Photo sharing can be geared to your needs, regardless of the branch of professional photography you aspire to—indeed, you may only be interested in sharing at an amateur level initially.

Putting your self-portraits onto a photo-sharing website is, arguably, a way to grow as an artist—the feedback you receive can contribute to the direction you take with your work. The way I began creating my self-portraiture most definitely utilized the community aspect offered by photo-sharing websites, albeit unintentionally at first. I shared my first few "multiplicity" self-portraits on flickr in 2006, and the feedback I got from other people encouraged me to keep making more, and to actually develop as an artist. Within a year I had my first local exhibition and two years later, after graduating, I was working professionally as an artist/photographer. I have been approached by clients such as Microsoft and *American Photo* magazine through flickr, and lots of other opportunities have spun off, or originated from, the exposure I have had on the website. I am still on flickr, photo sharing to this day. In terms of getting started, I owe a lot to the photo-sharing community.

The community you engage with online can help in the following ways:

• Having your work appreciated by other people can bolster your self-belief. While you should always try to grow and challenge yourself as an artist, self-worth is equally important, and you should determine the kind of audience your style is best suited to.
• You have the opportunity to view other people's work and be inspired. This can lead to interaction and even collaboration with others, and you can build a network of like-minded friends/artists around the world.
• You can share tips, advice, and experiences easily. There are thousands of groups on flickr for every topic imaginable and user-friendly discussion boards for your problems or queries that have likely been asked before.
• There is ample scope to advertise yourself as a photographer/artist to a potentially global client base, even directly selling your prints (be very careful, however, of each website's rules on commercial use).

A photo-sharing site offers you a way to organize your work, view it in one place, and see it grow. It can help you structure your material and create portfolios. For me it became a kind of journal, sharing my life and thoughts in this manner, and therefore as much a part of the introspective "self-portraiture" experience as the images themselves. "Miss Aniela" was an alter ego (using my middle name) that I thought of relatively whimsically in order to name my flickr account.

One of the most noted observations of photo sharing is the tendency of communities to saturate images with often vacuous or meaningless praise once an artist reaches a certain level of "fame" or notoriety on a website. I have certainly questioned which of my images are more "popular" than others on flickr, why this is so, and whether the number of views, ratings or comments should bear any relevance to the direction I take my work in. I have tried to remain detached from pandering to crowd-pleasing and always produce work that appeals first and foremost to myself as an artist. However, I also appreciate that the same eye-catching image that is popular online can go on to make money through print sales, which is advantageous to my livelihood as an artist. My belief is that as long as you are creating what you feel passionate about, and not giving in primarily to what you believe the mainstream audience online will favor, then you have maintained integrity as an artist.

How do I start photo sharing?
Some of the most popular photo-sharing sites include flickr (www.flickr.com), Ipernity (www.ipernity.com), deviantART (www.deviantart.com), RedBubble (www.redbubble.com) and Snapfish (www.snapfish.com). Simply search "photo-sharing site" for an up-to-date list online of the sites available. Most offer some form of free service, some with payable upgrade options for further features and more space. Some are more art-based, while others encompass a wide spectrum of amateur and professional photography. Some have an elitist structure, like One Exposure (www.1x.com) where approval of your images by an anonymous panel of judges is required. Some, like Artbreak (www.artbreak.com) are multimedia, welcoming images of other art forms from sculpture to paintings; and RedBubble allows you to share creative writing. Other sites, such as Facebook (www.facebook.com), are not advertised as photo-sharing sites as such, rather social-networking sites, but they are still a place to legitimately share and promote your work. Most will have rules on the content of imagery—be sure to check before uploading nudity, for example, however subtle or you may find your account terminated, even if you've paid for it. Flickr asks you to moderate your own content with appropriate filters, while Facebook does not allow nudity at all.

How do I put my work online?
Make sure you produce appropriate web versions of your images—never upload your original files, unless you are keeping them private and therefore for your own archival purposes. On your computer, it is sensible to make a new

folder in which to save small JPEG versions of all your images for web uploads. I never upload an image bigger than 700 pixels on its longest side: go to Image > Image Size in Photoshop to resize your image. You can also use the File > Save for Web & Devices function, to create a compressed file specifically for the Internet, but choosing this method will remove the metadata from the image. Keeping metadata is important in order to trace your images on the Web. As soon as you put your images on the Web people are able to save them and potentially steal them. You can make it harder for your images to be used illegitimately by making sure you add metadata to your image by going to File > File Info in Photoshop, and saving the file. Some photographers also add a watermark to the image as a text layer with their name, copyright and logo, on a low opacity. Depending on how big and central the watermark is, it will be difficult to remove or obscure it.

On flickr you can create sets, collections, add tags, send your images to groups, have your image added to people's galleries and favorites, and have people add you as a contact so they can view whenever you upload a new image. You can tag, geotag, and license your images (photo-sharing sites are collaborating with stock agencies so you can sell your work directly to clients through the photo-sharing interface itself). You can also archive your images if you want a place to store your original high-res files. I only recommend doing this if the images can be kept private.

I have personally found flickr to be the most user-friendly and attractive place to share my work. I have invested a lot of time over the last five years to maintaining my presence on the site, building my contacts and herding visitors to my stream from external links. Sharing your work on the Web does not necessarily lead to results overnight—you have to spend time integrating into this new community. You might begin by taking the time to comment on other people's work and inviting reciprocation. Flickr has a page called *Explore,* which by a combination of hits, comments, favorites, or simply what it thinks is "interesting," promotes selected images from users on the front page in rotation, giving images immediate exposure to browsers for a few hours. Overall however, the best tip I can give for cultivating an audience is simply to concentrate on your work and strive to be different. It is also worthwhile observing that because images are viewed as thumbnails until they are clicked, the inherent nature of "popular" work on flickr is often colorful, dramatic images that are striking at thumbnail and postcard size. Square-cropped images often have more impact. An image that looks amazing blown up huge in print won't necessarily look as good online, simply because of the different viewing experience. Certain photographers' styles work better on the net than others, which is why you shouldn't stop at photo sharing.

Technology shaping art

The crucial thing to note is that modern progression is as much about linking technologies as it is about creating new ones. With the advent of gadgets like the iPhone and the iPad, information is becoming more mobile and instant, and social networking is no longer an exclusive domain or even identifiable as a specific term. We are all encouraged to share our lives, views, and indeed, our everyday movements, through the likes of Facebook and Twitter. The opportunities that the Internet presents you with to share yourself and your livelihood are mind-boggling. The Internet is a place of communication, not merely a showcase. Maintaining a good Internet presence involves more than simply putting your images onto a website, it is about building an empire and giving it regular attention; about devoting time to the whole world that lives online.

HAVING YOUR OWN WEBSITE AND BLOG

Photo sharing is a great way to develop your work and to network with an audience, but its tone is more akin to that of a studio, of works in progress, than a portfolio to which you can send potential clients. Once you have produced a significant amount of work, and if you intend to pursue photography professionally, it is essential that you have a space where you can showcase a refined portfolio. The first thing is to decide who you are marketing yourself to. You need to think about all the aspects of your business, and indeed, to begin thinking of yourself as a business, even if you are more inclined to the fine-art side of photography. What will you call yourself (or your "business"), and what are you offering or selling? How much can you pay for a website upfront and in running costs over time?

If you are competent in coding HTML, or have the time to learn, there is no reason why you can't make your own website. I would personally recommend that unless you are happy to spend the time learning the skills, leave the web design to someone else. You can use a basic template website, which will allow you a space to share your work within a website, where your page will have the same template as everyone else's. These are often available for free. Paying for a pre-designed website with a monthly or yearly subscription will generally give you more options, but without the hassle of hiring a designer. This means that your site won't be that unique, but it'll be quick to set up and go live. LiveBooks (www.livebooks.com) offers a set of pre-designed Flash websites payable per month, with a free trial to begin with. Do look for a service that enables you to be able to edit your text and images yourself, as this is a great freedom. Paying for a custom-designed website is the most expensive option. Websites can cost thousands of pounds, but it is unlikely that your

site in its first stages will have so many areas or pages to necessitate such a charge.

Check online for the availability of your ideal domain name, which may simply be your name. The domain name is also important for SEO (Search Engine Optimization) making it easier for people to find your site when they look for a keyword like "photography" or "art"—adding a relevant word can help your visibility online.

Photographers generally have a gallery, an "About" or "Info" page, a "Contact" page, and often a blog, or blog link. There are also other things you might give separate pages to, such as press clippings, your CV/client list, shop, and client access. The images are the most important aspect of your website so build your website around the display of your images. You want to make it as easy as possible for a viewer to view your images clearly (as large as you can) and as fast as possible. Choose a refined selection of your best images and decide on how many galleries/portfolios you will use in which to arrange them. Even the simplest, image-led website should have some text about the artist. Ideally, have a specific 'About' page, on which you can promote yourself and your photography. It is important that you have contact details somewhere on your site, at least an email address. Ideally have a "Contact" page, and links to other places where people can connect with you: Twitter, Facebook, and any photo-sharing sites you show your work on. Showcase your press clippings too, including links to any interviews or features you have had online, to give viewers a chance to learn more about you.

Blogging

While your personal website is a place to display your work and information about yourself, your personal blog is an optional extra that you can keep updated with news. Blog entries can relate

to anything linked to your photography: images from latest shoots, essays on topics you choose, promotional pieces about your services, and so on. Your blog offers an ability to interact with your viewers, which makes it the central part of the online presence of many photographers and artists. One of the most popular free publishing services is WordPress (www.wordpress.org). You can then use social networking sites to draw visitors through to your blog, and your individual blog entries. For example, when I post a new entry on my blog, I will post a link on Twitter and on Facebook. People can comment on it through those sites as well as on the blog post itself. The key is to tap into the interconnectivity of social media sites and to make it easy for people on one site to follow you through to another.

Website traffic analysis

You can track your website statistics using website analysis solutions, some available for free. On here you can view traffic sources, informing you of the most popular links people have followed through to your site, and what keywords people entered into search engines to reach your site. Try Google Analytics (www.google.com/analytics).

Email marketing

It is also a good idea to save the details of anyone who has bought your work, or shown interest in buying your work, in a specific list so that you can get in touch again with those people personally. To send out mass emails, however, it is important that you embark on email marketing in a proper manner, and do not send unwarranted emails to a collection of email addresses. Examples of mailing marketing services include www.mailchimp.com and www.constantcontact.com.

SELF-EMPLOYMENT

PUBLICITY & IMAGE RIGHTS

As a result of the Internet reshaping our communication and ways of sharing images, the line between "amateur" and "professional" is no longer clear. You may set out to use photo-sharing websites to share your images with the intention of simply getting feedback, but find yourself asked, for example by a magazine, for one of your images to be published. Unfortunately, a lot of people who are put in this position fail to see that their images are worth payment because they do not consider themselves professional. In my view, you should consider yourself a "pro" photographer (or at least partly) as soon as you are asked for one of your images to be used commercially. In fact, as soon as you put your work publicly online in any capacity, you should be aware that it can easily become a commodity to some degree, and the way you choose to engage with anyone seeking to use your image will impact on the photography industry as a whole. You should be thorough and questioning about every situation involving someone using your work, and recognize that most opportunities, from licensing to exhibiting your work, are essentially business transactions.

If you do start making money from your art, it is important that you operate legitimately according to the tax system in your country. The rules in the UK and the US are similar: you must register as self-employed as soon as you start to make money from your side profession, regardless of whether you are a student or even employed elsewhere, full-time or otherwise. If you earn below a certain threshold (check each tax year as this figure will likely change) you won't have to pay any tax, but you still have to declare those earnings on your tax return. Remember that being self-employed allows you to take into account all the expenses that have been incurred through your business.

These might be more than you think. As my work is often so personal, there are so many things to consider that I find it better to work by deduction: to keep receipts for everything I buy, and then discard the expenses that aren't photography related. As a sole trader it should be easy to do your own bookkeeping. Even with an accountant, you still need to be responsible for keeping all of your receipts.

When you start to deal with paying clients, you will need to produce invoices. I also recommend setting up a PayPal account (www.paypal.com), which allows you to securely make and receive payments online without having to share your financial information such as bank or card details.

If photography is your main income source, it is very likely that you need specialist insurance to cover the use of your equipment. It can also cover public liability, professional indemnity, and particular cases where you might suffer a mishap or contingency in your everyday profession. Once you start to become professionally involved with photography, it is important to consider these needs.

Magazine features

Having your work featured in a magazine for the first time can be a great feeling. There are dozens of opportunities to submit your images to art and photography magazines, with the goal of both exposure and possible payment/rewards. Photography magazines regularly ask for readers' images to be showcased on their pages. Art magazines have calls for entries when they ask for images on a particular theme. In the context of a piece of publicity about you as an artist, receiving a payment is uncommon, especially if you are an amateur or starting out (but contexts, and indeed budgets, vary massively). A lot of the time it is a reward in itself to have the exposure, and certainly the first few times it happens, it will feel particularly exciting, but be sure to query a payment if your work becomes more in demand.

When communicating with a potential publishing source, be friendly but professional. If they ask to feature your work but they do not mention a fee, take the opportunity to simply ask whether a fee is payable. There is no one-size-fits-all standard rate for image use because of the different circumstances from one publisher to the next. The price they offer is usually the best they can give, but there's no harm asking, and they should respect your professionalism for it.

SELLING STOCK PHOTOGRAPHY

Your rights

First it is important to establish that we all have the same rights as photographers, whether you are an amateur having your work published for the first time, or an artist who has had their work featured in countless places. Being the creator of the work, the image is inherently copyrighted to you. The online world is a vast space of regurgitated text and imagery. People can blog each other's work from photo-sharing sites, share and re-share via a multitude of sites and feeds, so it is not easy to keep control of where your work appears once you put it online, and even if you set limits on particular sites, there are always loopholes through which people can access and use your images. Policed sites like flickr enable you to file a Notice of Infringement (NOI) by email to Yahoo to remove images of your work that are being used illegitimately by others. On independent sites and blogs, however, this is not possible, though often a simple request to the owner of the site to remove the image, will be fulfilled more often than not.

What would you do if you saw your image being used without your knowledge in a publication, but with credit to you? This is a situation that is open to interpretation and also depends on the particular circumstances. It is not right for your work to be used without your permission, even with a credit, especially by a profit-making publication. They may have sourced your image through a photo-sharing source, but that does not make the usage legitimate, as all your images' copyright strictly belongs to you. Write a polite letter of complaint to the newspaper or magazine, stating clearly where the image use occurs and giving proof that it is your work, and follow up with phone calls. Some photographers will send an invoice to request payment for the image use, with a premium added to cover the inconvenience.

Selling your imagery through a stock photo library can be a highly lucrative choice for some photographers, and for many others, useful as a side income. Selling stock involves being paid for a license to use your images in print publications and online. Stock agencies provide a visible outlet for your work, and will look after your rights and take care of all of the legalities. Examples of stock agencies include iStock, Getty, Corbis, and Shutterstock. There are also specialist stock agencies that deal with fine art photography, such as Trigger Image (www.triggerimage.co.uk) and Crestock (www.crestock.com). These agencies purport to sell only exceptional creative imagery and to supply to elite clients looking for tasteful fine-art images.

Before signing up to any stock agency, first read the proposed contract carefully. There will likely be a fixed term within which the agency has licensing rights over your images: this can be 18 months, or even more. You need to clarify with the agency exactly which images are in question (always ideal to hand over only a portion of images), and exactly what you can and can't do with those images during that term. For example, are you allowed to send the images to be used in magazine features, and will they want a cut from any received fee if so? Are you allowed to self-publish the images in your own books?

Don't be afraid to ask questions – make sure someone from the agency communicates with you to answer all of your queries, and take some time to go over the contract preferably with a second opinion from a friend or contact. Also, if you can, I highly recommend speaking to someone who is already signed up with that agency. Ask them how many images the agency has sold and how much money they have made from that business, and also about the agency's communication skills (you'd be surprised how communicative they can be when they want something from you, and then how they can disappear into obscurity once you have signed up with them) especially concerning pending payments, and whether they would truly recommend them. They will have little reason to be partial. You do not want to be in the position in a few months' time where you are obligated to pay your agency a cut of your own profits from a certain project you are involved in, if you do not feel that the agency has offered a significant return to you.

Selling stock images independently

If you don't want to sign up with an agency, you can always deal with licensing requests yourself. It's likely that your exposure to potential clients is nowhere near the scope that an agency provides, but at least you have complete uncompromised control of your own images, something that I have always found important for my own work.

Deciding on a fee is the tough part, especially if you are approached for the first time by someone wishing to use your image, and particularly if they do not suggest a fee at all. The amount depends on various factors: the nature of the publication, its distribution, whether it is commercial or charity/non-profit, how your images will be used—on an internal page or on the cover, and at what size.

A few years ago I was sent an email asking to use one of my Christmas clone images in a seasonal advertising campaign for a shopping center in Scotland, to be displayed on the sides of bus stops and shelters, in printed guides, and online. When queried about rates, the marketing co-ordinator simply offered to display a credit and to give me copies of the publications, a method that they said had worked in the

SELLING YOUR WORK AS ART

past. Because I had just started out, I was very tempted by the prospect of having my image appear in public, but I consulted a friend for his advice. He advised me that the company would have a large budget for this kind of campaign. It became clear that the company had made an assumption that I would be happy providing my work for free, purely for exposure. I replied to the company, thanking them for their interest, but stating that I am a professional photographer and that I required a fee for the use of the image, giving a request for an amount that was still a rather modest one. I received an email a while later, saying that they had decided to go down a different route with the campaign, which I suspect involved using another more willing photographer's work for free.

Take your work and profession seriously. If you are not happy with any aspect of someone's proposal, or have any suspicions that your work might not be used in the way you want, don't do it. Use your instincts—are the emails articulate and professional, with a company name in the email footer? Is there a phone number you can ring to talk to them directly? Even if they're in another country, if you are unsure about them, phone them.

Selling my work as fine art has been the single biggest income-earner in my photography profession so far. However, it's also the most difficult and problematic to talk about, when it comes to advising other photographers on how to make a success of selling prints. If you want to sell prints of your work, there are some decisions to make that will depend on your intended direction. Do you want to sell lots of prints of your work, cheaply, to a mass audience? Or, do you intend to focus on fine art as a direction, and sell your work at a higher price to buyers who consider the purchase to be, or partly be, an investment in your future success? Not everyone aims to pursue fine art as a career direction with their photography, and it may be more apt for some photographers to aim their prints at a wider audience. There are many photographers, in both the online and the physical world, who successfully make a living or at least a good side-income from mass-selling their work at relatively cheap prices. It is your decision, but it is very important to note the implications of your selling decisions: there is a substantial risk that the more you embark on mass-selling cheap prints, the harder it will become for you to enter the fine-art market later. Also, if you sell cheap unnumbered prints, you technically cannot go on to make limited editions (see more below about these) of those same images. Start as you mean to go on.

It is best not to get hung up on the idea of getting an exhibition. The first rule to learn is that you can make an "exhibition" anywhere in a physical space, to expose your work to the public. Getting your work into a fine-art gallery, however, is a way to benefit from their contacts, their publicity and exposure, and their reputation. They can also represent you long term, to promote you and gain you more exhibitions further afield.

Limited editions

It was important when I started selling prints, that I cottoned onto the notion of limited editions. This is the "proper" way to sell photography: by making a limited number of prints, each numbered on the back (and optionally signed) and only producing the number of prints that you state are in the edition. So, for example, you could make an edition of a hundred, or an edition of five. An edition is a particular print at a certain size: so for the same image, you might have an edition of five at one size, and ten at a smaller size. There are no rules, only conventions. However, it is commonly acknowledged that an artist should not make too many editions of the same image, and the sizes should be significantly different from each other. Per edition there will also commonly be a subset of print(s), the "artist's proof" (AP). The AP can be sold at the discretion of the artist, often after the edition has sold out, and at a higher price of 10–30% more than the editions themselves.

For a lot of artists, including myself, deciding on an edition and pricing structure only comes about when arranging an exhibition for the first time. To get into fine art, it is necessary to sell your work as limited editions, rather than cheaply en masse, even if you are just starting out. In my experience, most buyers want to know they are purchasing something limited and therefore of value. Moreover, selling your work as limited editions encourages you, and positively allows you, to put a much higher price tag on your images.

EXHIBITING

When should you think about exhibiting your work for the first time? I would start thinking about the prospect as your body of work gets larger as it is best to have as much work as possible to choose from.

Approaching/responding to galleries

When approaching a gallery, it is usually best to visit the gallery in person, to get a feel for the house style and decide whether your work is appropriate for that gallery. Most fine-art or funded galleries have their exhibitions booked for the season in advance, and have pre-apportioned their annual budget accordingly. Smaller, and/or commercial galleries are often more approachable. Ultimately, for most galleries the aim is to make a profit from your work. Galleries are essentially businesses, so if you can show that your work has the potential to sell, then there could be an opportunity. They will want to see your work, so a personal website is almost essential, and it is ideal that they can see a physical body of your work. A lot of artists have a professional artist portfolio (or "book"), which can be expensive. A self-published book is cheaper and can work just as well, and you can choose to leave one with the gallery.

Acquiring your own exhibition space

Making your own exhibition in what might be an unconventional space is also an option, which gives you more control but more responsibility. You could approach a café, a restaurant, a shop, a hotel, the owner of an empty commercial space, and so on—wherever you see art already exhibited, or, the potential for it to be exhibited. I had an exhibition of my work in the basement of a lingerie shop, Apartment C, in Marylebone in London. It is even better if you can seek synergy between the space and your work—my prints worked well there. Don't neglect the importance of having an agreement with the gallery space, even if the arrangement is straightforward. Also, you might consider having a group exhibition. Sharing a space with other artists is a way to cut costs and collaborate with other creatives.

Creating an agreement

The factors below should be addressed in a written agreement and signed by both parties before you spend any money, decide on dates or take any action. It is imperative that this is done, in order to avoid misunderstandings later, even if the relationship with the gallery is amicable.

Production and sale of prints

Galleries have different approaches to selling work. Establish what their system is: who pays for the printing production, and for framing and mounting the prints? Are costs split equally, or is it the artist's cost? Can the gallery help pay the upfront production costs and deduct the money owed from sales? What will your images retail at? Are all of the production costs deducted from the retail price of a print before determining commission? What percentage commission will they take? Will they charge VAT on top of your prices? Who will make upfront costs for extra printing, if a buyer wants an edition that is yet to be printed? How soon will you be expected to produce and deliver it? When do you get paid after a sale? How will you be paid? Will you need to submit an invoice?

Sales outside of the gallery

After the main business costs have been covered, this is one of the most crucial things to discuss, especially if you have a significant online presence. What about sales interest made by buyers via other methods, most prominently online, direct to the artist? Does the gallery expect a commission? What if a buyer visits the gallery, then contacts the artist online? The way I approach this issue is thus: I agree with the gallery that it must be my own responsibility to query any sales enquiries made to me personally, where I will ask the buyer how they heard of my work, and decide on the basis of their reply whether the gallery is owed a commission, full or partial. It is important that a gallery takes only the amount they are owed for making or having aided a sale. Make sure you are clear with a gallery on whether they will represent you long term, or whether the exhibition is a one-off.

Sales

The aim of your exhibition will be to sell prints, but your exhibitions, especially to start with, might not make a great deal of profit—they may only just break even so you shouldn't be disappointed if you don't sell as much as you would like. Exhibiting is an overall investment into your fine-art profile.

Saleability: art vs. the commercial

The notion of "saleability" is an extremely problematic one: the conflict between art and the commercial. As an artist your goal should not be to produce images that are deemed purely "saleable." First and foremost, your work should be about you. You should be passionate about it and happy with it. However, to make money or a living from your work, it is also vital to take a step back and to understand that what you consider your best work won't necessarily be the best work in the eyes of others. Your favorite images won't necessarily sell the most. Your choice of images for an exhibition might not be the most lucrative selection. It all boils down to the subjectivity of personal taste. Buyers' habits and tastes vary massively according to country, region, and culture.

OTHER WAYS TO MAKE MONEY FROM YOUR SELF-PORTRAITURE

Teaching

An increasing sector within photography that can offer photographers a sustainable income, especially in a time of change and unease in the industry, is selling services to other photographers. This can be in the form of teaching: through workshops, classes, and presentations, either in a physical environment or online. It can also be in a written format: published and self-published books, and articles and features for magazines and blogs.

Photographers are often multi-skilled and you may find that you enjoy writing about your photography, or that you have a skill in verbally teaching budding artists how to use equipment and how to approach the whole process of creating an image. Why not take advantage of your other skills and make some money out of teaching photography to students? You could either do this through a company who will host your workshops, take care of administration and organization of location hire, get people onto your course and pay you an agreed fee. Alternatively, you could go it alone, organizing your own events and advertising them independently. This means more responsibility, but more control—and possibly more money. You could advertise locally in schools and colleges, photography clubs, in magazines and other publications, and also online through your blog and email marketing. The content of your courses and the targeted audience all depend on what you want to teach.

Consulting

All companies involved in the photography industry, from Apple to Zenit, want their products to be used and showcased by real photographers. They will either pay photographers an agreed fee per event, or sponsor a photographer, under an agreement where the photographer receives free equipment in return for promoting the products and speaking for the company at events. Every situation with consulting work or sponsorship is unique; generally a relationship with a company involves mutual promotion, with a photographer receiving free products, or payment, in return for their endorsement. Sometimes you will be involved on a casual basis, at others you will sign a written contract. To get involved with this kind of work you usually need a personal introduction to the necessary person.

Self-publishing

Self-publishing a book of your work is a great way to see your work in print and it can be used as a portfolio. You can also add a mark-up and sell it to the public. As a result of modern technology you can affordably produce your own self-published books, which despite not having the economic advantages of large print runs and wide-scale promotional campaigns that would come with a commercial publishing deal, still represent a published work and so can carry a great deal of kudos. Self-publishing companies such as Blurb (www.blurb.com) are a good place to start.

Other ways to promote yourself

Business cards needn't be boring and conventional. Check out MOO (www.moo.com) where you can import your images from flickr, Etsy or Facebook. You can also make mini cards, postcards, greetings cards, and stickers, which are useful for sealing the paper around prints and other purchases to add an extra touch to your presentation. Entering your photography into competitions can also be potentially rewarding not only for exposure, but also for prizes of cash or equipment.

Portrait commissions

You may have come to this book already as a photographer, interested in trying self-portraiture as something new. Or, you may be a complete beginner to photography pursuing self-portraiture to leverage your confidence and skills in making images, as in my case. If you are the latter, then you will be faced with the pivotal point where you turn your camera onto other subjects. Whether your self-portraiture is a matter of autobiographical intent or simply convenience, you will likely want to embrace shooting other subjects as paid commissions. You might want to go into portrait photography, wedding photography, or fashion. Use your website to advertise the services you most want to offer.

Doing work for someone else, after only having to rely on yourself can feel like a very new and possibly unnerving experience. It might be a good idea to try some unpaid collaborations first, sometimes known as TFP (time for prints) where a model, photographer, and optional others such as stylists and makeup artists collaborate on a shoot. The aim is to produce images for everyone's portfolios. This is a great way to diversify your portfolio with images of other models.

Don't forget that even if your model-oriented, commissioned photography work becomes your everyday profession, that your self-portraiture could still be your most expressive personal work that marks your style out from the rest. Look out for opportunities to shoot yourself in new locations especially if you are traveling for work. I learnt very quickly that the possibilities for self-portraits are limitless. If you enjoy self-portraiture, keep doing it!

GLOSSARY

ARTIST'S PROOF (AP) A term handed down from traditional lithographic printing, to identify a subset of prints in an edition that has been produced to test printing equipment. The number of APs made is at the discretion of the artist, but they are numbered and usually limited, traditionally selling for a higher price than the edition.

AUTO-BRACKETING A camera function (AB or AEB), which takes multiple exposures of the same scene automatically, commonly one exposure on either side of the settings: 0, -2 and +2. This enables the creation of an HDR image or exposure fusion.

CALIBRATION In photography this usually refers to color calibration, the act of making color consistent across monitors and printers.

CLONING A term that has been used to refer to making multiples of the same subject in an image, by the use of compositing images as layers in Photoshop.

COLOR MANAGEMENT The process of identifying color spaces and their characteristics, to optimize color reproduction in printing. For digital photography, this process is from camera, to display device (computer), to final print.

COLOR SPACE A means of identifying and specifying a color; which differs from the human eye, to what the computer sees, to what the printer sees.

COMPOSITE An image that is made up of several photographs, put together as layers in photography post-production. The technique can be used to create clone and trick images.

C-PRINT A type of print that is made on a laser or lambda machine. Prints are exposed using LEDs on light-sensitive photographic paper.

DSLR A digital single-lens reflex camera. Single-lens reflex means that by a careful setup of mirrors and a pentaprism inside the model, you see exactly what the camera sees when you look through the viewfinder. A digital SLR records images via an electronic image sensor.

GICLÉE From the French "le gicleur" meaning "to squirt, spurt or spray," these are prints made from digital files using inkjet printing as opposed to laser.

HDR High-dynamic-range photography is a technique where several exposures are made by auto-bracketing a shot and combining in computer software, to reveal a wide array of luminance of light and dark areas of an image.

INVOICE A numbered document sent from a business to a client requesting a payment; which includes the details of the work or sale, the contact details of the business and of the client, the purchase order number or job number, the amount owed, and the payment method.

ISO International Standards Organization, referring to the origin of a devised light sensitivity specification. In traditional film photography the ISO measures how sensitive the film is to light, and in digital photography, it measures the sensitivity of the electronic sensor. The lower the number, the finer the grain or noise.

JPEG FILE An image file type with a "lossy" compression file algorithm, keeping an image's file size relatively small so it can efficiently be shared through printing and web sharing.

LAMBDA A type of printer that produces laser C-prints, or a print that has been produced on this kind of laser printer (*see* C-prints).

LIMITED EDITION A way of selling artwork by making it exclusively available only in a certain number such as 5 of 20, with each artwork labeled. The last in the edition is usually more expensive.

MULTIPLICITY A term that has been used to refer to the compositing method whereby a subject is multiplied in an image (*see* Cloning).

RAW FILE An unprocessed image in its raw state, uncompressed by the camera, with the extension .NEF on a Nikon, and .CR2 on a Canon, for example. The file must be interpreted using conversion software on a computer, like taking a film negative to be developed. They must be saved out to common file types (JPEG, TIFF, etc.) to be printed or shared. Some image-preview programs cannot read RAW files as visual thumbnails, or need to be updated with a downloaded plug-in.

PHOTO-SHARING SITE A website where a community of account holders upload files of their images to the Internet, either for personal storage or to share with the public.

PRIME LENS A lens that is fixed at a certain focal length, as opposed to a zoom lens, giving it superior quality.

PROPS Short for "properties" and used in film and theatre, these are any articles or objects that can be used to accessorize an image, such as a phone or a scarf.

ARTISTS' DIRECTORY

PSD FILE Acronym for "Photoshop document." This is Photoshop's version of a TIFF file, where layers and other editing data pertaining to a file can be saved and worked on later. PSD files can nowadays be read by most image-preview programs (viewable as visual thumbnails).

REMOTE SHUTTER A device used to remotely trigger the shutter of a camera, usually by a cable device or by wireless infrared.

RSS FEED A vocabulary that specifies a means of sharing content between websites via feeds.

SELF-PUBLISHING Creating and publishing one's own book, commonly by using a specialist online service that allows users to design and buy a bound book, and sell to the public by print-on-demand.

SEO "Search Engine Optimization," the process of improving the volume or quality of traffic to a website, and the ranking in search engines such as Google.

TEXTURE A picture, usually of abstract content, that is used as a decorative layer over another photograph by use of compositing and layer filters in post-processing. The result gives a "texture" of varying sorts to the photograph.

TIFF FILE Tagged Image File Format: A "lossless" (uncompressed) file format usually larger in size than a JPEG. Can contain layers and also be saved with JPEG, ZIP and LZW compression.

ZOOM LENS A lens that can perform at different focal lengths, allowing the photographer to take a closer image of a subject without moving their position. Inferior quality to a fixed, prime lens.

CONTRIBUTORS

Annette Pehrsson
www.annettepehrsson.se

Rossina Bossio
www.rossinabossio.com

Noah Kalina
www.noahkalina.com

Joanne Ratkowski
www.flickr.com/drjoanne

Yulia Gorodinski
www.yuliagorodinski.com

Jon Jacobsen
www.flickr.com/loganart

Federico Erra
www.flickr.com/federico_erra

Lucia Holm
www.luciaholmphotography.com

FURTHER SELF-PORTRAIT ARTISTS

I would also like to recommend these artists/photographers whose work features self-portraiture:

André Bernardo
www.andrebernardo.com

Ashley Lebedev
www.bottlebellphotography.com

Bee Brady
www.beebradyphotography.
blogspot.com

Bogna Altman *"Quizz"*
www.exquizzite.com

Brooke Shaden
www.brookeshaden.com

Bronwen Hyde
www.bronwenhyde.com

Carmen Gonzalez *"Soleá"*
www.carmengonzalez.org

Carolina Guzik
www.flickr.com/caro_guzik

Dana Ashton France
www.flickr.com/daneliphoto

Elle Moss
www.ellemoss.blogspot.com

Eva Moreno *"Ligeia"*
www.flickr.com/ligeia_scabbia

Heather Evans Smith
"HSmithPhotography"
www.heatherevanssmith.com

Ilina Simeonova
www.ilinas.com

Joanne Cruickshank
www.flickr.com/haggischick

Katie Lee
www.eyenex.us

Katie West
www.katiewest.ca

Kevin Meredith *"Lomokev"*
www.lomokev.com

Leah Johnston
www.leahjohnston.com

Lucy Nuzum *"Solarina"*
www.solarina.org

Marico Fayre
www.mfayrephotography.com

Mattijn Franssen
www.flickr.com/mattijn

Megan Horsburgh
www.meganzii.com

Michelle McRae
www.flickr.com/mmaeb

Ola Bell *"Oladios"*
www.oladios.com

Paul Armstrong *"Wiseacre"*
www.flickr.com/photos/wiseacre

Pierre Beteille
www.pierrebeteille.com

Rebekka Guðleifsdóttir
www.rebekkagudleifs.com

Roderique Arisiaman
www.dracorubio.com

Rosie Hardy
www.rosiehardy.com

Sabina R
www.flickr.com/sabinar

Sarah Wright *"Sarah Schloo"*
www.flickr.com/schloo

Salomé Vorfas
www.flickr.com/vorfas

Sophie Charlotte Niekamp
www.flickr.com/-ladybird-sophie

INDEX

A

Adobe Photoshop 16, 30, 36, 38, 52, 54, 62–95, 104, 105, 112, 113, 122, 128, 133, 134, 137, 140, 142, 145, 148, 152, 156, 165
 functions 68–9
 see also post-processing
Ancient Egypt 10
Ancient Greece 10
aperture 26
artist's proof (AP) 169

B

Bacon, Francis 12, 13
Balthus 58, 60, 61
banding 54
Beckmann, Max 12
blogging 67, 166
Bossio, Rossina 38, 96, 106–13, 115, 123, 131, 139, 155

C

cameras 24–5
 bridge camera 24
 Canon 24–5, 45, 54, 82, 84, 90, 93, 105, 128, 140, 152, 158
 compact camera 24, 76
 Fuji 24
 full-frame 24
 Hasselblad 24
 lenses 24, 26-7
 medium-format 24, 42
 Nikon 24–5, 160
 Pentax 24
 Phase One 24, 42
 point-and-shoot 14, 24, 100, 120
 Polaroid 101, 150
 Sony 16, 24, 30, 54, 61, 76, 80, 84
 Yashica 120
 Zenit 104
Camus, Albert 129
Capture One 30, 67
Caravaggio 11, 54
CF (CompactFlash) cards 25
Chadwick, Helen 14
chiaroscuro 54
cloning 16, 18, 29, 36, 54, 56, 76–81
 see also multiplicity
clothing 36
collaboration 19, 85, 98, 171
compositing 64, 65, 68, 72–5, 76, 82
 extreme composites 88–9

trick images 82–7
 see also cloning; multiplicity
computer 24, 29, 30
consulting 171
copyright 162, 165, 168
Crewdson, Gregory 54
crop factor 24

D

Dali, Salvador 12
De Bray, Jan 10
depth of field (DoF) 26
digital noise 54, 69
Dijkstra, Rineke 112
Dürer, Albrecht 10–11
dynamism 38, 49, 70, 75

E

email marketing 166–7
Emin, Tracey 14
equipment 16, 18, 19, 20, 21, 22–33, 46, 101, 104, 128
 see also cameras; lenses; remotes; timer; tripod
Ernst, Max 12
Erra, Federico 33, 96, 146–53
exhibiting 19, 162, 164, 169, 170

F

facebook 164, 166
fashion photography 146, 148
Fassbinder, Rainer Werner 152
film 24, 46, 64, 70, 92, 98, 101, 103, 104, 120
fixed lens 24
flash
 external flash units 33
 fill-in flash 33
 in-camera flash 32–3
 see also lighting
flickr 18, 19, 20, 42, 59, 124, 133, 162, 164, 165, 168
 see also photo sharing
focal length 26
Freud, Sigmund 12
Fullerton-Batten, Julia 86

G

Gauguin, Paul 11
Gerstl, Richard 12
Goldin, Nan 14
Gorodinski, Yulia 6, 41, 96, 99, 130–7, 147
Grün, Jules-Alexandre 80

H

hair 38
HD movie function 25
HDR 92–5
Hockney, David 12
Holm, Lucia 33, 96, 99, 107, 123, 131, 139, 147, 154–61
Hourigan, Shannon 140

I

insurance 167
iPhone 29, 165

J

Jacobsen, Jon 6, 21, 38, 96, 138–45, 147, 155
Joby Gorillapod 29
Johnston, Leah 17
JPEG file 66, 67, 165

K

Kahlo, Frida 12, 14–15
Kalina, Noah 20, 96, 114–21
Kar Wai, Wong 142
Kauffman, Angelica 10
Kokoschka, Oskar 12

L

Lee, Ahree 116
lenses 24, 26–7
lighting 22, 26, 32–3, 38, 68, 75, 80
 flashlights 32, 54
 improvised lighting 32
 ISO 26, 32, 54
 low light 26, 27, 32, 49, 54
 natural lighting 32, 41, 148
 strobes 160, 161
 see also flash
limited editions 169
literary inspirations 52, 129, 153, 158–9
locations 40–2, 46, 50
 home 40–1, 59
 outdoors 41–2, 44–5, 59
 shooting nudes 59, 60
Lucas, Sarah 14

M

magazine features 167

makeup 38–9, 138, 150
Mann, Sally 14
marketing 162–71
Medem, Julio 142
memory cards 30, 66, 67
Michelangelo 11
Middle Ages 10
Miller, Lee 12
mirrors 56, 153
"Miss Aniela" 18, 19, 164
monochrome conversion 70–1, 129
multiplicity 18, 29, 50, 54, 76–81, 164
 see also cloning
Munch, Edvard 11

N

nudes 44, 58–61, 164

O

online storage 67
outdoor locations 41–2, 44–5, 59

P

Pehrsson, Annette 20, 24, 33, 96, 98–105, 115, 131, 139, 147
photo sharing 16, 59, 162, 164–5, 166, 168
 see also flickr
Photodraw 16
Photoshop see Adobe Photoshop
Picasso 12, 106
planning a shot 46–7
portrait commissions 171
posing 48–50, 59
post-processing 21, 39, 52–3, 60–1, 62–95, 129
 see also Adobe Photoshop
prime lenses 26–7
prints 169, 170
processing *see* Adobe Photoshop; post-processing
promotion 19, 171
props 42, 50, 52–3, 60, 82, 138

R

Ratkowski, Joanne 21, 56, 96, 122–9
RAW file 66, 67, 70, 80, 92, 95
recovery spyware 67
reflector 32
Rembrandt 11, 20
remotes 22, 25, 29, 136, 137
Renaissance 10
Renoir 11

S

Samaras, Lucas 12
Saville, Jenny 14
saving images 66–7
Schiele, Egon 12
self-employment 19, 167
self-expression 8
self-publishing 171
selling stock photography 165, 168–9
selling work as art 169, 170
Shaden, Brooke 29
Sherman, Cindy 12, 14, 35, 36, 50
The Simpsons 6, 114, 116
sketching 46
smiling 50
social networking sites 19, 164
software 30, 67
 see also Adobe Photoshop
Spence, Jo 12
sponsorship 171
storage 66–7
Stuart, Roy 130
styling 38–9, 46, 50, 52, 56, 59
surrealism 12, 21, 122, 138, 140, 142
swivel screen 30

T

Taylor-Wood, Sam 14
teaching 171
telephoto lens 26
television 30
test shots 46, 66
tethered shooting 30, 46
TIFF format 66, 67, 70, 72
timer 22, 25, 46, 82
trick images 82–7
tripod 22, 26, 29, 46, 72, 80, 85, 136, 137, 144, 150

U

urban exploration (UrbEx) 42

V

Van Eyck, Jan 10, 13
Van Gogh, Vincent 11, 106
Van Hemessen, Caterina 10
Varo, Remedios 12
Vigée-Le Brun, Élisabeth-Louise 10

W

Warhol, Andy 12
website 19, 166
Wilde, Oscar 153
Wilke, Hannah 14
Woodman, Francesca 14
WordPress 166

Z

zoom lenses 26, 27

ACKNOWLEDGMENTS

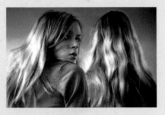

I would like to first thank the people who have made this book the best it can possibly be. Thanks to all the contributors: Annette, Lucia, Noah, Rossina, Jon, Yulia, Federico, and Joanne. It is a privilege to have your work in this book and to have been permitted to introduce each of you with my own literary interpretation of your images. Thanks must go to Adam Juniper for initially proposing this book idea to me and everyone at Ilex Press, particularly Managing Editor Natalia Price-Cabrera and Editorial Assistant Tara Gallagher, for their hard work throughout its production.

Thanks to the people who translated Jon and Federico's words for me: Rossina Bossio, Luca Cepparo, Mauro Contrafatto, Pietro Santachiara, and Nico Ruta. Thanks to Paul Burgess for help with writing about websites, and to Trey Ratcliff, a.k.a. Stuck in Customs, for casting his expert eye over my HDR spread. Thanks also to Simon Ghahary and John Freeman for their impartial opinions and advice in the beginning stages of this project. I would also like to give kudos to the people who have supported me, helped me, or believed in me along my journey so far. There are too many people to list, but I would like to mention in particular: Juan Curto, Paul Burgess, Don Thornhill, Joanne Cruickshank, Juliet Greig and Rachel Holland for their consistent support over a long period of time. Thank you to the sponsorship and support from: Microsoft, liveBooks, Blurb, Canon, MOO, Phase One, and Spectrum Photographic.

Lastly I would like to thank Matthew "Wolfy" Lennard for giving me on-tap help and a notoriously honest opinion, and being everything from "Miss Aniela advisor" to human tripod, from chaperon, to artistic collaborator and "UrbEx" partner in crime. In knowing you, I have experienced the kind of true happiness and real love that allows one to reach their personal potential. You have brought only goodness into my life, and—even though you will cringe!—I dedicate this book to you.

My work can be seen at www.missaniela.com and blog at www.missanielablog.com